COMPLETE PHOTOGRAPHY PROJECTS

Learn the professional secrets behind the perfect photo

John Garrett & Graeme Harris

Collins

I dedicate my part of this book to my Laurence and thank her for all the support and inspiration. She was with me when I made many of the pictures. She was my muse.
John

I dedicate the book to my wife Margaret for being a long-time helpful companion. She is the main inspiration for most of my photo projects – without her I would be wanting.
Graeme

HarperCollins*Publishers*
77–85 Fulham Palace Road
Hammersmith, London W6 8JB

www.harpercollins.co.uk

First published by HarperCollins*Publishers* 2013

13 12 11 10 09
9 8 7 6 5 4 3 2 1

Text © John Garrett and Graeme Harris 2013
Photography © John Garrett and Graeme Harris 2013
except for *The Silver Goblet*, c.1768 (oil on canvas), Jean Baptiste
Siméon Chardin (1699–1779) / Louvre, Paris, France / Giraudon /
The Bridgeman Art Library; and *Discobolus* (marble), Myron,
(fl.c.450 BC) (after) / Victoria & Albert Museum, London, UK /
Ancient Art and Architecture Collection Ltd / The Bridgeman Art
Library.

John Garrett and Graeme Harris assert their moral right to be
identified as the authors of this work.

COMPLETE PHOTOGRAPHY PROJECTS

contents

Introduction 6

1 Photography Basics 8

2 The Great Outdoors 36

3 Sightseeing and Cities 52

4 Out and About 66

5 Capturing Action 84

6 Still Life 98

7 Portraits 114

8 Body Beautiful 136

9 Celebrations 148

10 Children 160

11 Animals 174

12 Patterns 188

13 After Dark 200

14 Perfecting Your Images 214

Conclusion 248
Resources 252
Acknowledgements 254
Index 255

INTRODUCTION

In our first book together, Collins Complete Photography Course, we tackled the complexities of modern digital and film cameras, taking an in-depth look at their controls and the techniques needed in order to start producing great pictures. The next logical step, it seemed to us, was to apply the knowledge learned in the first book to the great themes of photography in this second book.

While it would benefit you to study our earlier book if you're a novice, *Complete Photography Projects* stands alone, with a concise technical section to bring you up to speed. For those of you still using film, this book is equally valid, showing you how to deal with the many subjects you may want to shoot. Each chapter is devoted to a different genre, with most of the photographs shot especially for the book.

The book is written with a view to the facts of real life. We know that you may have to pack much of your photography into the odd weekend and annual holiday. We have travelled the world with small children and know how frustrating it can be to miss a great shot because the kids are hungry or tired, but we are also grateful that we did have that wonderful photographic subject on hand – the children. Finding ourselves in the right place at the wrong time has always been a dilemma too, perhaps bedevilled by awful weather or scaffolding on the great cathedral we'd been waiting a long time to shoot, and so on. We could probably make a list of problems that would fill a page.

However, our aim is to help you to turn those negatives into positives. The first section of the book will help you get to grips with that amazingly sophisticated machine that you bought. It's basically a computer,

so anyone familiar with those will not have much of a problem navigating around its menus. The job of this section is to make you become master of your machine rather than, as is often the case, the camera intimidating the photographer and blocking the creative process. This book is not for equipment geeks, but we must all get to know our cameras so well that we can just concentrate on the subject rather than struggling with our equipment. We discuss technique as related to creativity, for there is not a single technical decision that is not in fact a creative one.

When one starts out in photography the problem is not just how to take pictures, but what pictures to take. This issue delays the learning process for many novices, because to progress you need to shoot, shoot, shoot. We offer lots of themes to help you find inspiration and our photographs will show the process involved in the making of an image. So, with your new-found confidence, we hope you'll soon be raring to get up and go under your own steam.

GABRIELLA
You don't need a lot of equipment to take a professional-looking shot. I just used the available back light and a gold reflector to create this publicity portrait of singer Gabriella Cilmi. **1/1000 second at f5.6, 150mm, 200 ISO. JG**

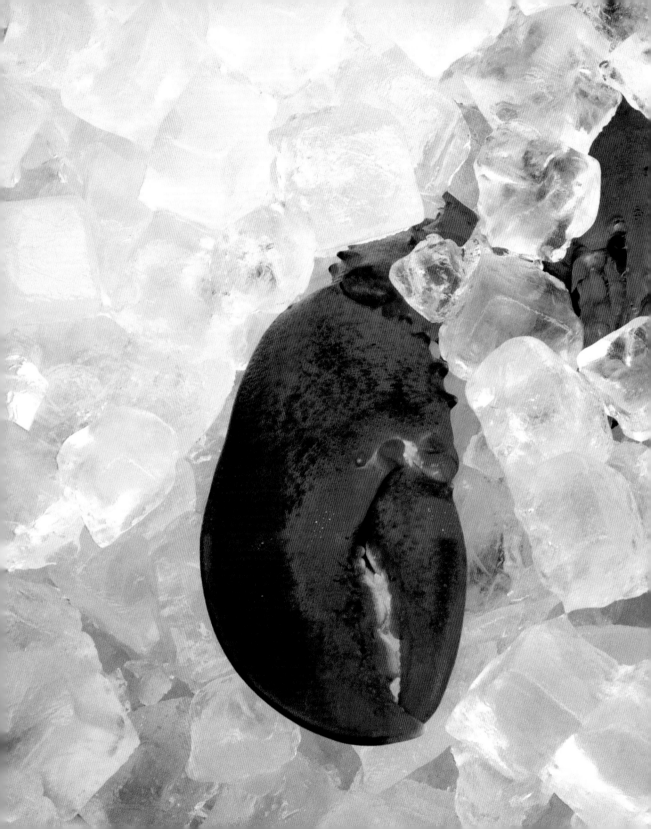

PHOTOGRAPHY BASICS

Whether your camera is old or new, you will only take really good photographs if you know how to create strong images – the saying 'cameras don't take photographs, photographers do' is right. You should certainly not get hung up on needing the latest camera on the market, especially in these digital days, when there will be an even newer one out next week.

We feel that the push for more megapixels and ever-bigger sensors is largely driven by the industry's need to sell us more gear. All this technology is not going to make your pictures any more creative; many of our favourite pictures – those that inspired us to take up photography ourselves – were made on far less sophisticated cameras than even the average point and shoot camera that you can buy today. To quote the American photographer Chase Jarvis, 'The best camera is the one you have with you.'

You will no doubt have read through your camera manual; if you had trouble understanding it, this chapter will help to make it clearer. If you still feel in need of more detail, you will find it in our first book, *Collins Complete Photography Course* (HarperCollins, 2008).

Although this book is more about pictures than equipment, it is essential that we photographers get to know our cameras like a best friend. Our aim is to show you how to take better pictures no matter what your camera may be, just using it as a tool with which to transform your creative ideas into exciting images.

 QUICK TIP

Your camera manual is vital if you are to understand the controls and functions of your camera. Don't be embarrassed about carrying it around with you – today's cameras are so complicated that few people can remember everything they do.

HOW JOHN CHOSE HIS NEW CAMERA

Just before writing this book I bought a new camera because I was feeling the need to simplify my travel photography and lighten my load. I wrote a priority list of features that I regarded as essential in a new all-round camera and spent a great deal of time finding exactly the right camera for me. This list might be helpful to you when you are choosing your next camera.

• Size and weight: small enough to fit in a coat pocket, light enough to carry all day without causing fatigue.
• Instant focus without shutter delay, for people and action.
• A viewfinder – I don't like trying to compose pictures on the LCD screen as I often can't see the image when the light is bright.
• Improved performance at high ISO speeds.
• An articulated screen – I find it very useful for shooting above my head or from ground level, or for shooting people surreptitiously.
• Interchangeable lenses to give me more choices, with the addition of an adaptor ring so that I can use my beautiful analogue Nikon lenses, which are creatively interesting.
• The feel and balance of the camera – I need to regard it as a part of me and I want to enjoy shooting with it.
• A menu system that makes sense to me.

CAMERA

After weighing up all the pros and cons I decided on this interchangeable-lens lightweight mirrorless camera. It has a large APS-C sensor and an electronic viewfinder, making it easier to use than trying to compose on the screen. It will fit comfortably in my coat pocket and accompany me wherever I go. JG

LOBSTER (previous page)

I found this lobster outside a restaurant in Copenhagen, where the bright overcast light really made the red zing out against the cool blue ice. I stopped the aperture down to f11 to make sure the lobster was sharp from front to back and placed him right in the centre of the viewfinder to make a symmetrical composition. **1/125 second at f11, 30mm, 400 ISO. JG**

DIGITAL CAPTURE

In digital cameras, the sensor and memory card have replaced the film we used to shoot our images on. It is the pixels on the sensor that record the image gathered by the lens. Via the camera's computer, the sensor then conveys the image as electronic signals to the memory card for short-time storage.

FILE FORMATS

Digital cameras have two different means of writing and storing image information onto the memory card, each with their own advantages.

JPEG format

This type of file contains all the settings that you have selected via the camera's menu, such as image size and quality, colour balance, contrast and noise reduction. The camera applies these settings to the image and compresses them onto the memory card. The most popular format, JPEG produces images processed by the camera, ready to show on the computer or to print.

The JPEG file can be reprocessed with image-editing software such as Adobe Photoshop at a later date, but the settings applied by the camera cannot be completely reversed. Always work on a copy of the original JPEG, as repeated opening and saving will degrade the image.

RAW format

This format stores all the information from the sensor in an unprocessed and uncompressed form. It is the pure information of the picture and can be likened to a film negative. Once downloaded to the computer it has to be processed, with the photographer applying settings of brightness, contrast, colour balance and so on. After the interpretation has been made it is saved as a separate TIFF or JPEG file, leaving the original RAW file untouched and available for a new interpretation at a later date. TIFF files are not compressed like a JPEG file and provide better quality, so they are the option to choose if you plan to do extensive retouching.

Raw files are large and take up a lot of space on the memory card, but this has become less of a problem now as the price of memory has dropped considerably in recent years.

MEMORY CARDS

These are available in different sizes to suit the system your camera uses. Many of the DSLR cameras use large CF cards, but in order to make cameras more compact, recent models accommodate the smaller SD cards. Some cameras are able to use two cards, usually two SD cards on the newer models. You can buy cards in a variety of memory capacities and they also have different image transfer speeds, affecting how fast you can shoot.

Memory cards are quite fragile and should be protected from moisture and extreme temperatures; take care not to drop them, too. The images on the card should be copied to a computer as soon as possible, since many people have lost their pictures as a result of card failure or loss of the camera. Use the format feature in the camera to erase the card and set it up for shooting again. Once it is reformatted the previous images on the card will be lost.

Memory cards are quite stable and don't give many problems, though it's good practice to buy the best quality. While it has been recommended that they be replaced after about two years, we have been using the same cards for many years without problems – so far.

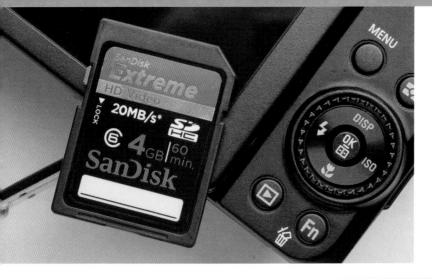

◄ CARD
Memory cards hold all your precious images. Buy good-quality cards and treat them with care.

FORMAT ►
Once your pictures have been transferred to your computer and/or other safe storage places, reformat the card in the camera, which will set it up properly to be used again on your next shoot.

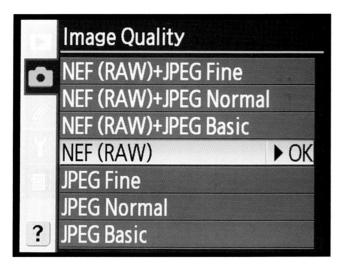

◄ RAW
Use RAW if you intend to do extensive retouching on your pictures. If using JPEG, make sure you set the image size and quality to maximum, since you may want to make large prints from the pictures at some time in the future.

EXPOSURE MODE DIAL

Most cameras have an exposure mode dial on top of the camera, though it's becoming more common to set the exposure modes from the menu instead. Today's cameras offer a wide choice of modes.

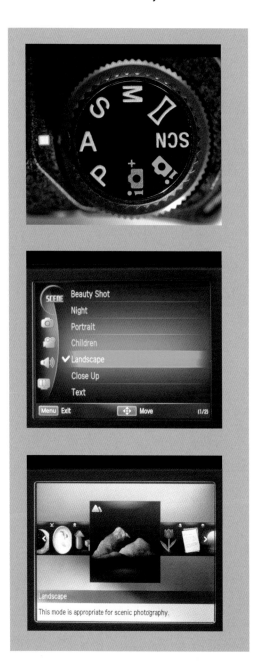

AUTO (Automatic mode)

This is the camera in complete control, making all the exposure decisions, including whether flash is necessary. It is the mode that is recommended for first-time users.

P (Program mode)

The camera is still in automatic but you can override it using exposure compensation and flash. Some cameras will allow flexible program and auto exposure bracketing. This mode is intended for snapshot shooting.

S or Tv – TIME VALUE (Shutter priority mode)

Shutter priority is a semi-automatic setting; you set the shutter speed and the camera sets the aperture for the correct exposure. Use it when the choice of shutter speed is most important for your photograph.

A or AV – APERTURE VALUE (Aperture priority mode)

Aperture priority is also a semi-automatic setting, but this time you set the aperture and the camera sets the shutter speed for the correct exposure. This is the mode to set when the choice of aperture is most important for your photograph.

M (Manual mode)

Here you are completely in control of both shutter and aperture. You need to use this mode if you want to make long exposures on Bulb setting or shoot with studio flash, where shutter speed and aperture are set independently.

PRESET SCENES

The preset programs are the result of an enormous amount of information that has been programmed into your camera. They set up the camera functions to match the subject you have selected, choosing combinations of shutter speed, aperture, flash, colour balance and focus that the camera decides is ideal. These programs are useful when you are starting out, but you will probably want to move on to take your own decisions as your knowledge increases.

Cameras vary in the style of the graphics and menu for the presets, and in the presets that are available – some offer a wider choice than others. The following are among the most common.

Portrait mode

On the assumption that you want the face to stand out from the background by making the background soft, the portrait mode sets the camera to the largest aperture possible in the lighting circumstances.

Landscape mode

This sets the camera to the smallest possible aperture that the lighting conditions will allow in order to get as great a depth of field as possible.

Close up

For close up, the camera sets a medium aperture of around f8, depending on available light, to ensure some depth of field to the subject with the background slightly out of focus. It also sets centre focus area. It is advisable to use a tripod, since this preset may give slow shutter speeds.

Sports

In order to freeze motion, this mode sets the highest shutter speed that the lighting allows. Focus is set to continuous while the shutter release button is pressed halfway. The built-in flash is turned off.

Night landscape

The camera selects slow shutter speeds for night shots. For speeds slower than 1 second, set noise reduction if your camera has it. When using this mode you will probably need to put the camera on a tripod to avoid blur from camera movement.

Night portrait

Here the camera balances the flash on the subject with the existing light in the background. You have two choices here: keep the camera and subject still to render everything sharp, or move the camera slightly during the exposure if you want a blurred background. The high speed of the flash will freeze the subject, while the slower shutter speed will allow the background to blur.

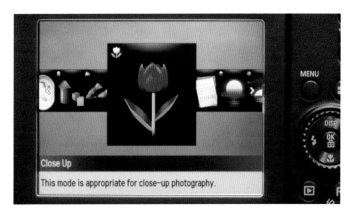

Close Up
This mode is appropriate for close-up photography.

THE ISO SETTING

Before you start shooting pictures with your camera you must select the ISO setting, either from a button on the camera body or via the menu.

The ISO (International Standards Organization) index is a system for calibrating the sensitivity to light of film emulsions and digital sensors; the higher the ISO number, the greater the sensitivity. On most cameras the ISO settings go from 100 to approximately 3,200, though the latest digital sensors allow settings of up to ISO 25,000.

The lower the ISO number, the finer the quality of the image, whether film or digital. As the ISO number rises so does the amount of noise in a digital image and grain in a film negative, breaking up the image and reducing sharpness and detail. Noise reduction can be turned on when shooting at higher ISOs, but it tends to soften the image somewhat. It has no benefit at low ISOs.

Grain and noise are not necessarily a bad thing – they can be another creative tool, used to enhance subjects such as misty mornings and night shots, for example, and often most effective in black and white shots.

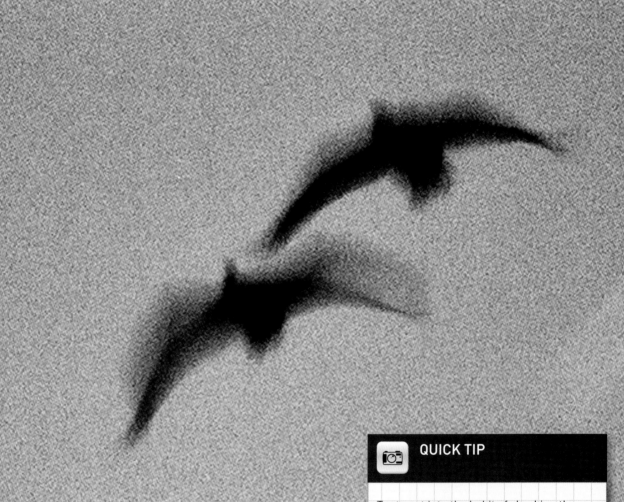

◀ LOW ISO

This is a small section taken out of a portrait to demonstrate the quality of image that is possible on a digital camera with a low ISO setting.

▲ HIGH ISO

The section here is proportionally the same size in an image as the eye from the portrait, but the shot has been taken with a high ISO setting. While great effort is made by manufacturers to reduce grain and noise, it can be really attractive on some images.

📷 QUICK TIP

Try to get into the habit of checking the ISO setting each time before you start shooting or you may end up with a lot of pictures on a setting that does not suit the subject. Remember you can change your ISO at any time during a shoot – for instance, if the light drops suddenly and you find the shutter speed has become too slow for a hand-held camera, just turn up the ISO and retain your higher shutter speed.

EXPOSURE

For most of our careers, correct exposure was the most important technical decision that we had to make because most of our work was on colour transparency film, and the quality of the image was greatly affected if it was overexposed by even +½ stop. It was safer to be –½ stop underexposed to give a rich, saturated transparency for reproduction.

Today, photographic technique is equally divided between the camera and the computer, so if you find your pictures are under- or overexposed you can usually correct that later with image-editing software. However, you do still have to be very careful not to overexpose a subject that has inherent bright highlights. As with transparency film, those highlights 'blow out' and lose all detail, and you will never retrieve any detail no matter how much you darken the area on the computer.

Underexposure of a subject with dark areas is not such a problem, as it is possible to retrieve an image underexposed by as much as –2 stops without adding much noise to the shadows.

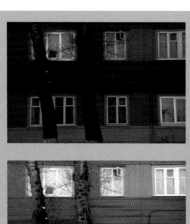
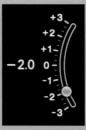

UNDEREXPOSURE

This picture is underexposed by –2 stops. However, underexposure can often be used for effect – this exposure, for instance, could be used for an evening effect. If it is a mistake, this amount of underexposure can be corrected to almost normal.

CORRECT EXPOSURE

Here the correct exposure for this subject has provided detail from the darkest tones to the lightest highlights. Correct exposure is the ideal starting point to either use as it is or to add your own interpretation to on the computer.

OVEREXPOSURE

This picture is overexposed by +2 stops. Although it can be partially corrected later, the highlights, where they are pure white, will retain no detail as they are totally blown out and cannot be corrected.

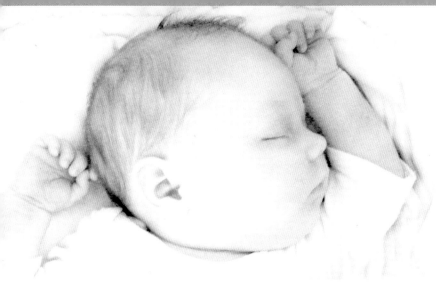

◀ **HIGH KEY**

The high-key effect is traditionally a black and white technique used for babies, children and glamorous women, giving a romantic interpretation of the subject. The lighting is as close to shadowless as possible. It is a good idea to have some small dark areas in the picture to contrast with the overall white tones. This baby picture is lit with soft overhead daylight that has eliminated most of the shadows, giving a soft, dreamy quality. It was overexposed by +1 stop to keep the highlights bright, using exposure compensation. **1/250 second at f5.6, 50mm, 400 ISO. GH**

THE TECHNIQUE

The term 'stop' is used for referring to exposure. If you step up one stop you will halve the exposure, while if you step down you will double it. For instance, by moving the shutter speed up from 1/125 second to 1/250 second the exposure has halved (–1 stop). Moving down from 1/125 second to 1/60 second doubles the exposure (+1 stop). The same also applies to the aperture and ISO settings.

Your camera gives you the option of moving between stops in fractions of ⅓ or ½ of a stop. You will probably find that setting the camera to ½ step between the stops makes it a bit less confusing when using the shutter, aperture and ISO dials since it relates more easily to the doubling or halving effect of a whole stop.

LOW KEY ▶

Traditionally used for masculine subjects to make a dark, moody interpretation, the low-key effect can be applied to many subjects. In this case the backlight encouraged me to underexpose the picture to get a dark, romantic feel, letting the backlight be used only to separate the lovers from the background. I used a 500mm mirror lens, which has made 'doughnut rings' out of the background highlights. I exposed for the highlights here, letting the shadows underexpose by –2 stops. **1/1000 second at f8, 500mm, 400 ISO. JG**

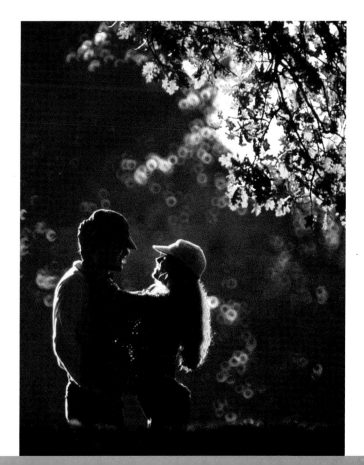

UNDERSTANDING APERTURE

The aperture is one half of the exposure partnership. Together with the shutter, it controls how much light is exposed onto the sensor to form the image.

If you are new to using aperture and shutter speed controls, it's a good idea to start with aperture priority (A or Av) mode. This will let you choose different apertures and you can watch the camera automatically select the shutter speed to produce a normal exposure. Find a subject with an object close to you in the foreground, one further away and another in the background. First shoot a picture of it with your widest aperture – f4.5, for instance – then stop down the aperture progressively to f16 for your next pictures. This will give you an illustration of how the aperture controls the depth of field – the amount of the subject that is in focus. Aperture is not only an exposure tool; the aperture we choose greatly affects our creative interpretation of the subject.

SHALLOW DEPTH OF FIELD ▶

To demonstrate the shallow depth of field that a standard lens will give when set at f2.8, I focused on the zebra. The animals in the foreground and background are out of focus, which has the effect of keeping our attention on the zebra.

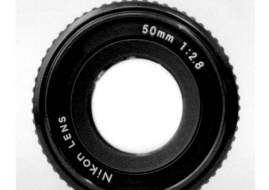

◀ WIDE APERTURE

Here you can see a lens at its widest aperture – in this case f2.8.

WIDE DEPTH OF FIELD ▶

This is exactly the same subject, photographed from the same distance, but stopping the aperture down to f16 has made everything sharp, from the cheetah in the foreground to the background tree. Every element in the picture is now vying for attention.

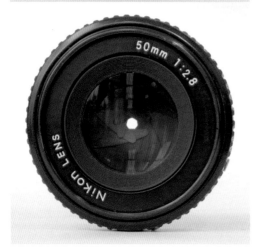

◀ NARROW APERTURE

Stopped down to f16, the aperture through which light passes is now greatly reduced.

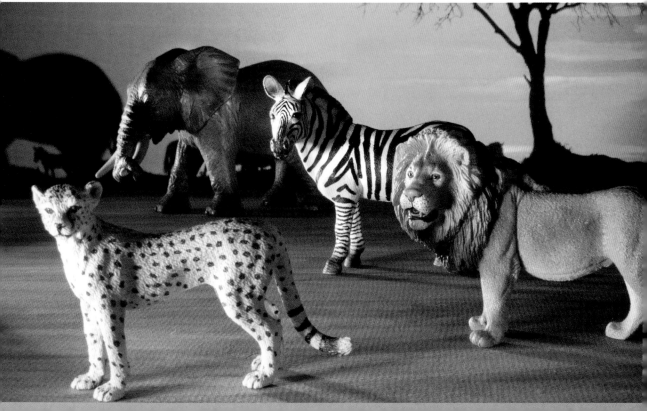

THE SHUTTER

The speed of the shutter is the other half of the exposure partnership, acting in tandem with the size of the aperture to control how much light reaches the sensor or film to form the image.

To get to grips with the function of the shutter, set your camera to shutter priority (S or Tv). The available shutter speeds will go from about 30 seconds to 1/4000 second. There is one more shutter setting, called Bulb (B), which can only be used when you are in manual mode (M). Here the shutter will stay open as long as the shutter release is kept pressed – a facility generally used for long night exposures.

Practise shooting at different shutter speeds, focusing on moving objects so that you can observe whether they are frozen in action or blurred. With speeds slower than about 1/60 second any camera movement will start to show as blur in the overall picture, so if you want sharp pictures at slow shutter speeds you will

need to support the camera on a tripod or some object such as a wall or table. For hand-held telephoto lenses, assign a shutter speed that is at least as fast as the telephoto setting you are using – for example, a 200mm lens needs a speed of at least 1/200 second to avoid blur from camera movement. If you are using an APS-C sensor camera, you need to increase that to 1/300 second.

When you look at the photographs carefully afterwards, you will see that there is a considerable graphic difference between a picture in which a fast shutter speed has held hard-edged colour and shapes and one shot on a slow shutter speed, where the colour and shapes have become soft-edged.

FAST SHUTTER SPEED ▶
The cyclist rode past the stationary camera, which was on a tripod. Exposure at 1/1000 second has frozen his movement.

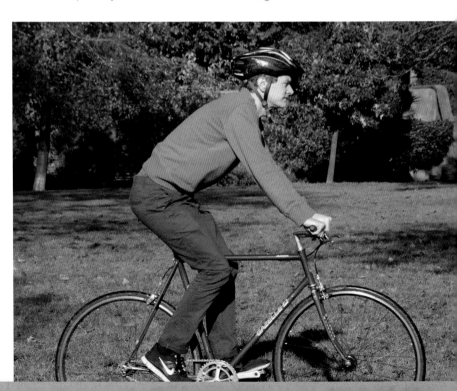

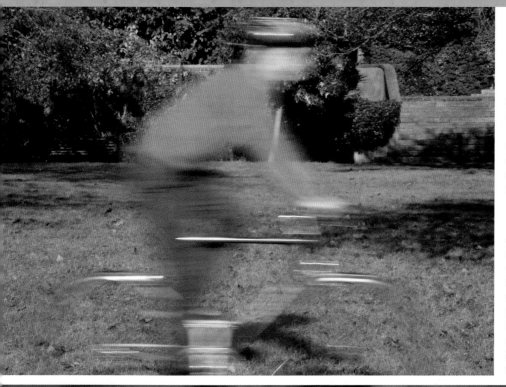

◀ **SLOW SHUTTER SPEED**
Here the exposure was 1/30 second as the cyclist rode past the stationary camera; the slow exposure has blurred the subject.

▼ **PANNING**
Again the cyclist rode past and again the exposure was 1/30 second. This time the camera moved to follow his action, a technique known as panning. The result is that the cyclist is sharp and the background is blurred.

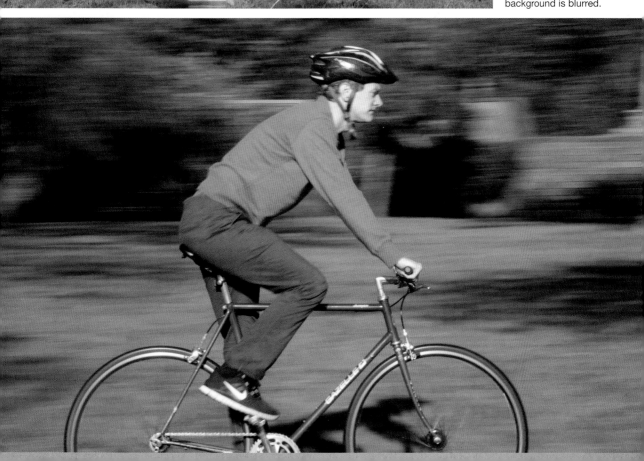

LENSES

The primary function of a lens is to focus the image onto the film or sensor. It also controls the angle of view and houses the aperture diaphragm.

You have a choice of using fixed focal length (prime) lenses or zoom lenses. The latter are designed to provide a range of focal lengths in one lens, with wide-angle zooms providing the shorter lengths and telephoto zooms covering the longer ones. Zoom lenses are almost universally used now because they reduce the amount of equipment you have to carry around. The advantage of prime lenses is that they have larger apertures and are the ultimate in optical sharpness. However, most of us would not be able to tell the difference in general application.

The decision as to what focal length you select for a photograph should not just be about encompassing more of the subject with a wide angle lens or getting closer with a telephoto. It is a creative decision based on the fact that lenses control perspective and also, linked with the aperture, dictate how much is in focus in front of and behind the point of focus – the depth of field.

The majority of the pictures in this book have been taken on DSLR cameras with APS-C sensors and the focal length stated in the captions applies to those, except where it is stated that the picture has been shot on film. To find the equivalent APS-C digital angle of view for the film images, divide the focal length by 1.5.

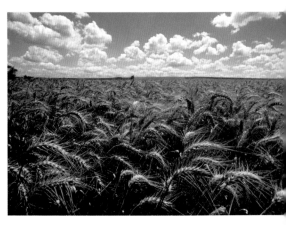

▲ **WIDE-ANGLE LENS** This is an example of a wide-angle lens at work. It has enabled me to get very close and look right into the ears of wheat in the foreground while still showing that this is a vast field of grain. Stopping down the aperture to f16 has kept the picture sharp from the foreground back to infinity. **1/250 second at f16, 24mm, 100 ISO film. JG**

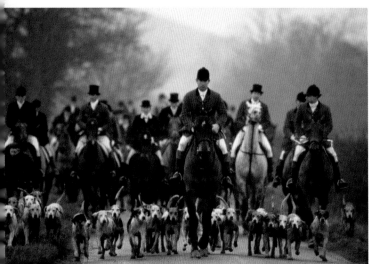

◀ **TELEPHOTO LENS**

This is an example of a telephoto lens helping me to interpret the hunting scene the way I felt it looked. The long focal length has compressed the perspective, making the rear riders appear closer to those in the foreground than was the case. Shooting with a wide aperture has made the leading rider and dogs sharp, separating them from the out-of-focus background. **1/350 second at f3.5, 400mm, 400 ISO film. JG**

CLOSE-UP PHOTOGRAPHY

This is a genre that some photographers get hooked on and it particularly attracts people with a scientific bent, because it is all about making discoveries. Most new-generation cameras will enable you to see your object at a ratio of 1:1 – that is, the object at its real size. If your lens won't focus this close, you can buy either a macro lens or a close-up filter to attach to your existing lens.

AUTUMN LEAF ▶
Close ups focus our attention on something that we don't usually notice, in this case the beautiful structure of this leaf. Many modern cameras are able to get this close without a macro lens. **1/15 second at f11, 55mm macro, 200 ISO. GH**

THE MACRO LENS ▼
This is a demonstration of how I photographed the autumn leaf, using a 55mm macro lens. The selected portion of the leaf is life size, and it is backlit by a lightbox – a great method of shooting translucent objects. **GH**

POCKET WATCH ▶
I shot this pocket watch using backlight from a window and my 55mm macro lens, with the camera on a tripod to prevent any camera movement. As we get closer to a subject we have an increasingly shallow depth of field, which means that on a picture such as this the lens must be stopped right down to a small aperture to maintain sharp detail over the area of interest. That requires a slow shutter speed to achieve a normal exposure, hence the tripod. **1 second at f16, 55mm macro, 200 ISO. GH**

WHITE BALANCE

The white balance (WB) technology in digital cameras was developed to make every colour picture you shoot look as if it has been taken in neutral white light without a colour cast.

If you set the WB to Auto that's exactly what the camera will do. However, this means that you will lose the golden cast of sunset light and the blue glow of dawn, and that's certainly not desirable.

Today, we consider white balance adjustment in the camera as not particularly important, because it is so easy to adjust the colours in the camera or on the computer. We generally leave the WB set on Daylight and fine tune on the computer later. However, if you wish to match your WB to the light as you go along, here are your options.

Incandescent

Your normal household tungsten light is classed as incandescent. It is much warmer (yellow/orange) than daylight and requires the camera to add blue to balance it back to neutral. This gives a more neutral colour balance than Auto, which often tends to be too warm. Incandescent bulbs are being phased out, replaced by low-energy bulbs. The light from these bulbs is in a variety of tones of white, so you need to do a test shot to check the colour balance. One of the fluorescent settings may work best.

Fluorescent

When you are shooting in fluorescent light, one of the fluorescent settings will possibly give a better colour rendition than the Auto WB. Fluorescent tubes and low-energy bulbs come in a variety of colour temperatures. The Fluorescent WB setting usually gives you two or three choices; do a test shot with each and choose the best one for the light you are shooting in.

Direct sunlight

Like daylight-balanced colour film, this setting gives a neutral colour balance in direct sunlight in the middle of the day.

Flash

The light from a flash tends to be slightly cooler than daylight, so this WB setting warms up the light a little.

Cloudy

On overcast days the light is cooler. This setting warms it up slightly to match direct sunlight.

Shade

Light in the shade is much cooler than bright sunlight, because shade light is mainly indirect blue sky light. This setting warms the light to that of direct sunlight.

THE WHITE ▶ BALANCE MENU
Choose the appropriate setting to match the light you are shooting in, or use Daylight and correct any colour cast with image-editing software.

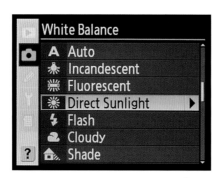

White Balance
- **A** Auto
- ❋ Incandescent
- ❋ Fluorescent
- ☀ Direct Sunlight ▶
- ⚡ Flash
- ☁ Cloudy
- 🏠 Shade

◀ DAYLIGHT WB

The musicians were shot in a subway lit by incandescent light, with the WB set on Daylight. As you can see, the light has photographed with an orange cast. **1/20 second at f5.6, 38mm, 400 ISO. GH**

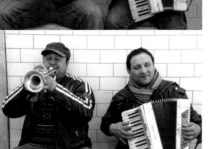

◀ INCANDESCENT WB

Using the Incandescent WB setting has neutralized the orange cast, making the light look realistic.

DAYLIGHT WB ▲

This portrait was taken in the shade, with the sky providing the blue cast. With the WB set to Daylight, the picture is far too blue. **1/125 second at f5, 24mm, 400 ISO. JG**

◀ SHADE WB

Here the Shade WB setting has added some warmth to neutralize the blue colour cast.

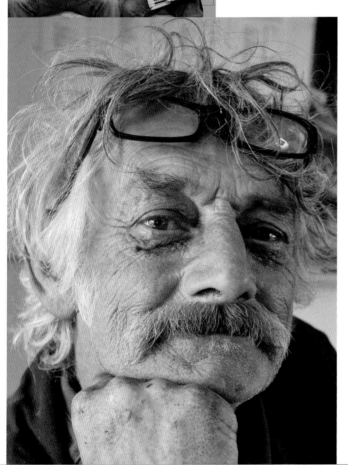

📷 QUICK TIP

It's worth playing around with each of the WB presets to see the effect they have on a single light source. Choose a subject and take a picture of it with each WB setting, then repeat with another subject in a different light source. Note which setting gives the most neutral balance and which one could be used for an effect.

FILTERS

In the pre-digital days of shooting on colour transparency film, professional photographers carried around a large selection of light-balancing filters to correct the colour casts in single and mixed light sources.

With the technological advances in digital cameras, those filters attached to the front of the lens have largely become obsolete; most cameras now have built-in digital filters to simulate the effects they gave. Generally, these can only be applied via the retouch menu after the picture has been taken. Post-processing on the computer also provides the ability to adjust colour casts.

The two on-the-lens filters we still recommend you carry are the graduated neutral-density filter and the polarizing filter, especially when you are shooting landscapes. The 'grad' filter, which is available in varying densities and colours, will allow you to retain detail or exaggerate the sky tone in a landscape where the sky would be overexposed. This effect can also be done in the computer using Photoshop, but it requires some skill. Using a grad filter on the lens will give you an instant result. A 2-stop neutral density (grey) graduated filter is a good one for general use.

The polarizing filter is often used to darken blue skies and thus make the cloud formations more prominent. While that can also be achieved in Photoshop, where the polarizer comes into its own is in reducing or eliminating unwanted reflections from water, glass and non-metallic surfaces, which cannot be done on the computer.

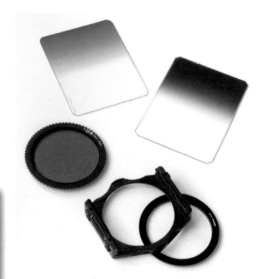

▲ **FILTERS**
Shown here are a polarizing filter (bottom left), graduated filters (top left and right), and the lens mount (bottom right).

◉ QUICK TIP

Adding a diffusion or softening filter on the lens can be flattering for portraits, giving them a glow and smoothing detail. A similar effect can be added later in Photoshop or in Lightroom using the Clarity tool. Also try breathing on the lens to mist it up before you shoot – it can produce a very soft effect.

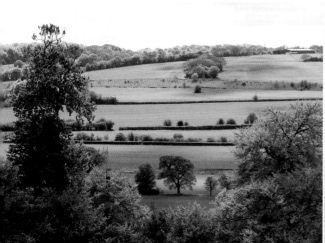

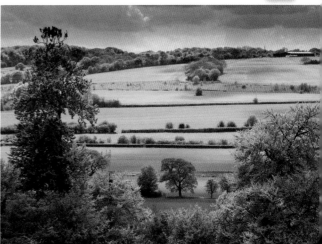

UNFILTERED

In this unfiltered landscape shot, the sky has been overexposed because the landscape, which occupies most of the picture, is darker than the sky. The camera is unable to handle the major difference in exposure. **1/250 second at f11, 75mm, 400 ISO. GH**

NEUTRAL DENSITY FILTER

Here, the neutral density filter has been slid over the sky area, slightly cutting into the horizon line. This has enabled the capture of detail in the sky that was visible to the human eye. **1/250 second at f11, 75mm, 400 ISO. GH**

UNFILTERED

In this photograph taken without a polarizing filter, the sky is reflecting in the water. The water is impenetrable, resembling opaque glass. **1/250 second at f6.3, 29mm, 400 ISO. GH**

POLARIZING FILTER

Here a polarizing filter attached to the front of the lens was rotated to a position where it cut out the reflections of the sky, allowing us to see below the surface of the water. **1/30 second at f6.3, 29mm, 400 ISO. GH**

USING FLASH

While the newer digital cameras with high ISO speeds enable photographs to be taken in low light conditions that would previously have required flash, it can still be used as a creative light source even where it's not essential. However, it should be employed with care to avoid ruining the beauty of natural light.

Most cameras have their own built-in flash, and all manufacturers also make dedicated flash guns for their cameras. These have more power than built-in flashes and because they have their own battery power they don't drain the camera's batteries. They fit onto the camera's hot shoe and, unlike built-in flashes, they have a swivel head so they can bounce light off the wall or ceiling, which can produce a softer effect than direct flash. You can also hand-hold them or use a separate support; the new flash guns can be used off-camera remotely, while older models require a cable to synchronize with the camera.

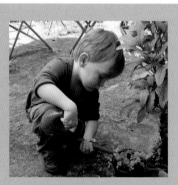

AVAILABLE LIGHT
The available light version of this young gardener is charming, but his face can't be seen as clearly as a mother would like. **1/60 second at f9.5, 26mm, 400 ISO. GH**

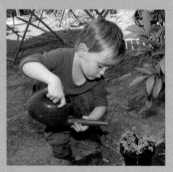

FILL-IN FLASH
Here the camera has balanced the built-in flash with the available light, giving a 'fill' light so his face is no longer lost in shadow. **1/100 second at f9.5, with fill-in flash, 26mm, 400 ISO. GH**

▲ BUILT-IN FLASH
This is a portrait made with the built-in flash. It is important to underexpose direct flash pictures such as this by about −½ stop to eliminate that bleached-out, pasty look that you see on many direct flash portraits. **1/60 second at f2.8, 6.1mm compact camera, 400 ISO. JG**

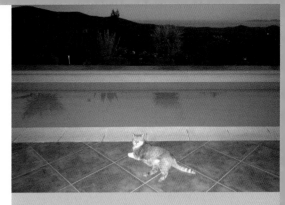

◀ DIRECT FLASH

This portrait of Jen was taken with the flash gun on the camera pointed directly at her. The direct front light has flattened her face and the highlights are bright. Because the background is further from the light than her face, it is underexposed. **1/180 second at f8, 46mm, 200 ISO. GH**

◀ BOUNCE FLASH

With the flash gun still on the camera, I tilted the flash up to bounce the light off the ceiling. I pulled up the white bounce card in the flash head, which has added a little front light to fill in the shadows and put a sparkle in her eyes. This gives a more natural look and the bounce light has lightened the background, too. **1/180 second at f8, 46mm, 200 ISO. GH**

TURNING DAY INTO NIGHT

This cat portrait was taken with built-in flash. It was afternoon, but I wanted to create a surrealistic feeling of night. Using aperture priority mode, I set the aperture to f10, knowing that I was close enough to adequately light the cat with the flash. To get the dark background I needed to underexpose, which I did by setting the exposure compensation to –3. **1/250 second at f10, 19mm, 500 ISO. JG**

◀ OFF-CAMERA FLASH

I removed the flash gun from the camera and held it to the left, giving more modelling to her face. I set the flash to remote mode to synchronize it to the camera, but an off-camera cable would also have done the job. The background and shadows are very dark. **1/180 second at f11, 46mm, 200 ISO. GH**

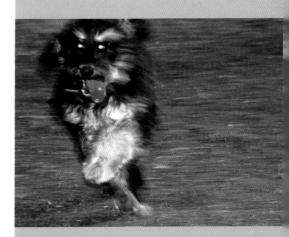

◀ OFF-CAMERA FLASH AND DOME

With the flash still off-camera, I added the diffusing dome to the flash head. The diffuser has spread some light around the room, which has filled in the shadow on Jen's face and lightened the background. **1/180 second at f8, 46mm, 200 ISO. GH**

USING RED EYE FOR EFFECT

The 'red eye' that we all normally try to eliminate can be used as a fun effect. This shot of my little dog makes her look like a devil dog running out of the darkness. Flash also freezes action and can be used solely for that reason, but in this shot I combined the built-in flash with a slow shutter speed to add some movement. **1/60 second at f6.3, 95mm, 400 ISO. JG**

COMPOSITION

The basics of photography aren't just a matter of getting to grips with your equipment; you also need to understand the aesthetic values that will turn your photographs into something much more than everyday snaps.

When you admire a photograph or painting you may at first believe that it is the subject matter that is appealing to you. In fact, once you understand the dynamics of the picture's composition, you will know that you are being influenced just as much by that.

The early photographers were mostly painters experimenting with this new technology, so they continued to use painterly laws of composition such as dividing the picture plane into thirds and placing focal points where the thirds intersect (see facing page, top left). However, the

development of wide-angle and telephoto lenses changed photographic composition forever. Although classic composition still formed the basics, photographers could now play with perspective and manipulate colours optically.

The basic compositional possibilities shown here will be demonstrated time and again throughout the book. Composition is the way that photographers look at the world. It is our style. It is how we recognize a photograph by one of our favourite photographers – we know how he or she sees the world.

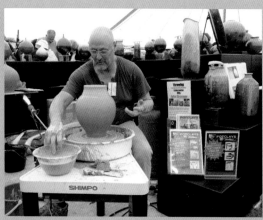

RECORD SHOT
This picture, taken at an art fair, is what I saw when I first walked by. It's taken as a record of the place without thinking of the content at all. **1/180 second at f4.1, 6.5mm compact camera, 400 ISO. GH**

CHANGING THE FORMAT
Taking a closer viewpoint and using a vertical format has allowed me to exclude most of the unwanted detail. However, the picture still looks distant and unconnected with the subject. **1/125 second at f4.3, 15.6mm compact camera, 400 ISO. GH**

LOW-ANGLE CLOSE-UP
By moving closer still and coming down to a low angle I have isolated the potter and I can see his technique. The relationship of the round pot and his head holds the picture together. **1/125 second at f4.3, 15.6mm compact camera, 400 ISO. GH**

RULE OF THIRDS ▶

A classic rule of composition is that for a strong visual impact, the focal point of a picture should be near an imaginary intersection of two lines that divide the picture into thirds horizontally and vertically.

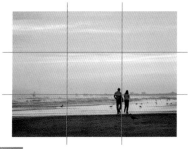

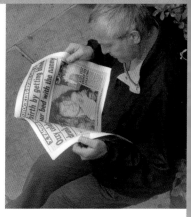

▲ HIGH VIEWPOINT

Most pictures are shot at eye level – the photographer just stands there and takes the picture. Varying the camera height gives a different view of the world. In this case I was able to walk up some stairs and join the man reading his newspaper. **1/500 second at f5.6, 200mm, 200 ISO. GH**

◀ FINDING A FOCAL POINT

Most landscapes are greatly improved by the inclusion of a focal point. Here I found a white farmhouse to give the viewer a point to fix on and to form a story about the farmer and his land. **1/500 second at f6.7, 200mm, 400 ISO. GH**

▼ USING PERSPECTIVE

Perspective is one of the most important compositional tools for the photographer, and our huge range of focal lengths allows us to play with this for graphic effect. In this picture of sailors calling home the wide-angle 24mm lens has exaggerated the perspective, making a nice graphic shape. **1/30 second at f8, 24mm, 100 ISO film. JG**

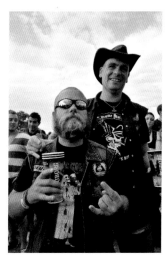

▲ LOW VIEWPOINT

I dropped down to a low camera angle so that I could look up at the heavy metal fans, separating them from the rest of the crowd and making the sky their background. With the help of an 18mm wide-angle lens I was also able to really emphasize the rock and roll gesture. **1/1000 second at f8, 18mm, 400 ISO. JG**

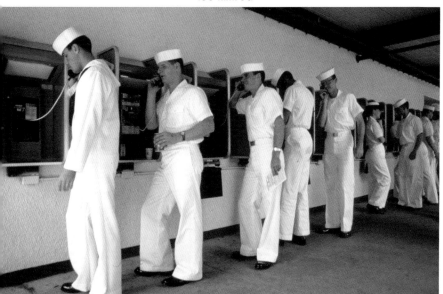

BLACK AND WHITE PHOTOGRAPHY

Photographs were basically monochrome for about one hundred years, though alternative printing processes and handpainting could inject some colour for the dedicated photographer.

In 1935, Kodachrome was born and really took off. For a comparatively low price, everybody could now record their colourful world on colour slides. From there, the production of colour films grew rapidly and before long colour negative films meant that instant prints were available from every chemist in the high street.

Yet black and white photography remains a very popular medium. Black and white prints are a major art form and digital cameras plus computer software have made them so much more accessible than traditional analogue black and white. The quality of the papers, inks and printers is now incredible, making digital black

and white photography an exciting alternative to really go for.

However, traditional black and white technology has been making a comeback. The craft of the darkroom and the magic of the image coming to life in the developing tray continue to fascinate, and if you wish to learn how to pursue this form of photography you should be able to find a course near you on which darkroom technique is taught.

The decision as to whether to go for colour or black and white used to mean being able to visualize how a subject would look in tones of grey before choosing which film to put in the

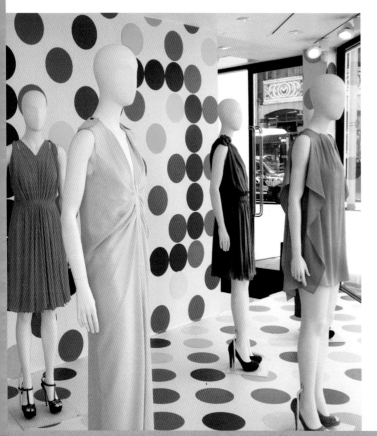

◀ **SHOP WINDOW**
This picture is all about colour – it is of course what attracted me to take the picture in the first place. **1/200 second at f5.6, 20mm, 400 ISO. GH**

▲ **ASSESSING MONOCHROME**
There are colour subjects that don't work in black and white and this is one of them. If I had been walking around taking black and white pictures I wouldn't have given the shop window a second look. As your experience increases with monochrome you will learn to recognize the colours and light that will translate into strong black and white images.

camera. With digital, we can switch from colour to black and white in a second to check whether the colour is converting to black and white successfully. We also have the added possibility of being able to shoot in colour and then convert to black and white later.

We highly recommend that you explore monochrome; you will be looking purely at light, tone and texture, and you may find meaning in your photographs that you might have missed, distracted by the presence of colour. It's good practice to look at the same pictures in both colour and black and white, assessing which works best and analysing why; you will soon develop a feeling for the look that will be most suitable for the image.

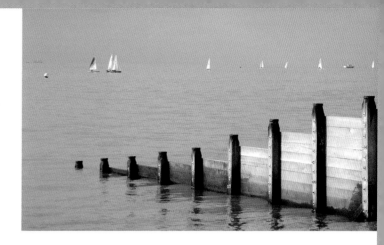

▲ SUMMER AT THE COAST

In colour, this seascape is like a pleasant watercolour painting. The boats and clouds have merged into the blue, giving a soft, summery look. **1/750 second at f6.7, 85mm, 400 ISO. GH**

▼ CHANGING THE MOOD

Translated into black and white, the picture has gained a dramatic atmosphere. The boats and sky now become the subject, which in the colour picture was the wall.

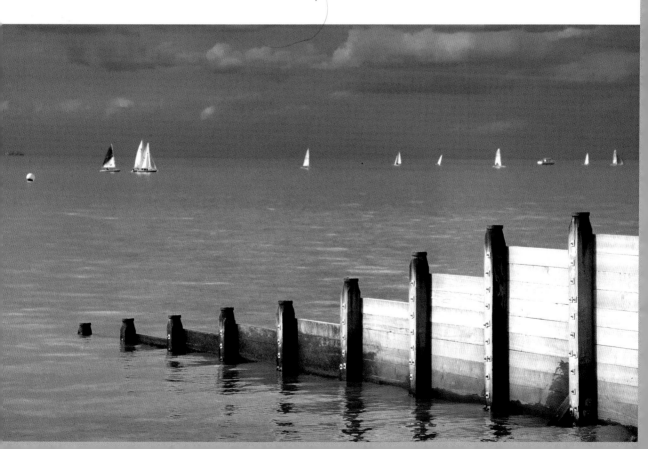

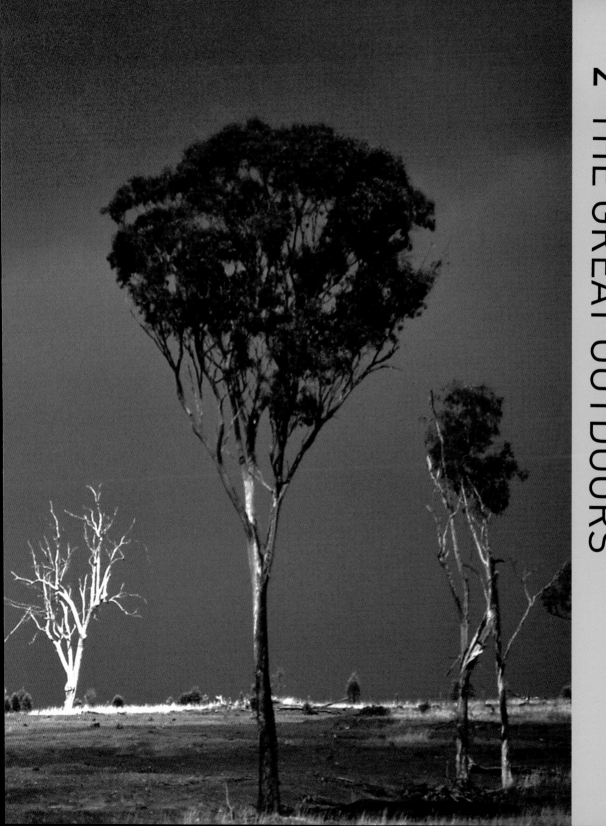

THE GREAT OUTDOORS

Landscape is a huge subject, and
although it's one of the most popular
areas for photographers you may find
it the most difficult in the book –
partly because you have no control
over the weather and the elements in
the landscape, but also because of
that popularity.

In these days of easy-to-use digital cameras,
photo-sharing websites and microstock
agencies that accept work from amateurs,
the proliferation of photographic images has
been staggering. The result is that most
people now look at pictures with a more
sophisticated eye, and a pleasant landscape
shot among thousands competing for
attention isn't enough to satisfy a
photographer who wants to be truly creative.

So this chapter is about learning ways to
make your pictures stand out from the
everyday shots. We shall demonstrate how
landscapes are dramatically affected by
changes in the light, and how you can use

FINDING INTEREST IN FLAT LIGHT

The day was overcast and misty, so the light was flat – not at all my usual landscape light, but I decided to try out a roll of Ilford infra-red film I had with me. This cut through the haze and gave an almost etched look that amazed me, given that the situation had looked so unpromising. I added a sepia tone in Lightroom to give an antique feel. For a similar look, try infra-red film, the IR setting in the menu of your camera or the infra-red preset in the Lightroom Develop module. **1/125 second at f16, 35mm, 125 ISO film. JG**

◀ USING A FILTER TO ADD PUNCH

This crazy little atomic-looking cloud drifted past when I was sitting on a beach in Brittany. I had my camera with me, wrapped in a freezer bag to keep it sand-free, and thought the cloud so cute I had to photograph it. I used a polarizing filter to darken the blue sky and make the cloud stand out. Keeping your camera with you at all times means you don't have that awful 'if only' feeling when something picture-worthy crops up. **1/1000 second at f11, 180mm, 200 ISO. JG**

FINDING A FOCAL POINT

Unless a landscape has a dominant feature or a very strong pattern that can hold the eye in the picture it will tend to be just an ordinary scene that doesn't detain the viewer for long.

Most landscape photographs benefit from a focal point such as a white farmhouse, a lone tree or, as shown here, a small boat – in this case added with Photoshop, in the absence of a focal point in the landscape itself. For a landscape with a natural focal point, check out the opening spread for this chapter – your eye goes straight to the white ghost gums because they are so much brighter than the surrounding landscape.

For this assignment we want you to go out and find a landscape with a prominent focal point. You don't need a magnificent sweep of mountain or moorland – part of the business of being a photographer is finding visual interest in subjects that a casual observer might pass without a glance. The viewer's eye is always drawn to signs of human activity, so a deserted tractor in a field, a barn or a house will usually work well, but you might choose to use a natural feature instead.

SEARCHING FOR THE LIGHT

Think about the possibilities of the angle of light in relation to your focal point, and whether you could make it more important in the picture at a different time of day. If the answer to that is yes, plan to come back rather than just settling for second-best. A compass is invaluable to a landscape photographer – they are not expensive, and you may even have one on a smartphone. On a sunny day, it's not hard to work out that if your focal point is lit from the front in the morning sun and you want it backlit you need to come back in the evening, for example, but if the weather is dull you'll be glad of a compass to tell you which way the light will fall when the sun is out.

Once you have begun to think about focal points you will soon look for one as second nature. However, while you should always search for the perfect photograph, a little digital help can be the answer where you have a lovely scene but the crucial point of focus is missing. So, for the second part of this project, shoot a landscape that needs a focal point, then find one in your archive and put it in; you'll find details on how to do this in Combining Images on page 234. Again, remember the light – if your photograph is taken on a sunny day with strong shadows, a house, boat or tree with the light coming from a different direction will be an obvious fake.

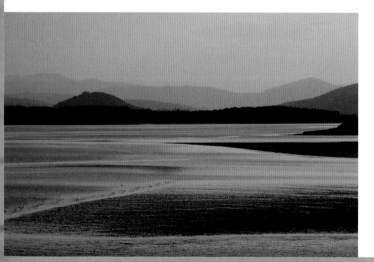

◄ **EVENING SEASCAPE**
I shot this seascape very late in the evening in the Highlands of Scotland. I like the warm light and the composition and I underexposed it by −1 stop to make it more dramatic. At the time I was thinking, 'A little boat would be great,' but none was to be seen. For your own photograph, find a landscape with a broad view that pleases you, but no specific focal point; estuaries, forests and agricultural land are good places to look. **1/350 second at f11, 120mm, 400 ISO. JG**

◄ A FOCAL POINT FROM THE LIBRARY

This boat picture is a perfect match because it was shot in very similar light conditions to John's seascape. It's a good idea to collect pictures such as moons, boats, clouds, cottages and so forth for inserting into landscapes that just lack that little something. **GH**

▼ RETOUCHING THE SHOT

The colour of the boat has been changed using Hue/Saturation in Photoshop to match the colour in the original shot; this made the retouching easier because we didn't have to cut out the boat too accurately. I think it has improved the seascape, and it's fun to see your picture transformed like this. If you take care to match the colour, light and tone, your own added focal point should sit comfortably in the landscape. **JG**

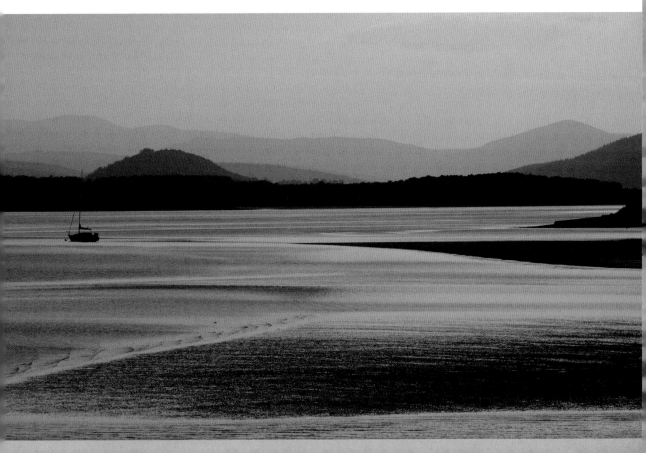

WOODLAND AND WEATHER

There's a tendency to think that bright sunlight and strong colours are the ideal conditions in which to take attention-grabbing landscape photographs, but this is far from the truth.

One apparently fine spring morning I set out to photograph some bluebells – but luckily I had packed wet-weather gear, for after I had been walking and shooting for half an hour the weather turned bad. Rather than race back to the car, I covered the camera with a plastic bag and hid under the small umbrella I had with me. I also had a large plastic bin bag so that I didn't have to kneel on the wet ground. I kept shooting, the rain smudged the details in the woods and it looked great. I had to mop the camera often with tissues, but it survived the session.

It was a poor season as far as bluebells were concerned, but a photographer who has travelled to a certain spot in search of a picture has to make the best of what he or she can find. This was where a telephoto lens and a low angle could help – the flattened perspective that the lens gave meant that I was able to compress the bluebells and make them look more dense than they actually were.

The first picture for this assignment is a rainy-day landscape such as some woodland. Put on your wet-weather gear, cover your camera and use the rain to capture the atmosphere – here you are looking for misty effects rather than angles of light.

For the second task, shoot with both front and rear focus using a wide aperture such as f4 or f5.6, then focus in the middle of the subject, stop the aperture down to about f16 and get the whole scene in focus. There's no better way of gaining an almost instinctive grasp of the aperture that will give you what you want. If you have a telephoto lens, use it for this project as it will emphasize the shallow-focus effect.

By focusing on the flowers in the foreground I have created a descriptive shot which has the emphasis on the bluebells, showing that they are in a woodland setting. The long telephoto setting on the zoom at widest aperture has enabled me to isolate the flowers in the foreground and throw the rest out of focus. You may not find flowers in your woodland, but leaves, mushrooms, pine cones and so on will perform the same function of giving your own shot something of interest in the foreground. **Camera on tripod, 1/80 second at f5.6, 200mm, 400 ISO. GH**

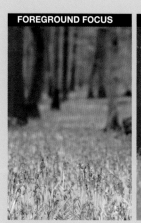
FOREGROUND FOCUS

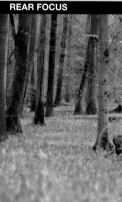
REAR FOCUS

Changing the focus to the trees in the background has altered the mood of the picture completely. Now we have a woodland scene with a blush of flower colour in the foreground leading the eye to the trees beyond. Once again the telephoto lens has done its job, this time throwing the bluebells out of focus and emphasizing the background. As the foreground is now out of focus and is no longer the main point of the shot it should not occupy too much of the picture, so tilt the camera upwards slightly to place it lower in the frame. **Camera on tripod, 1/80 second at f5.6, 200mm, 400 ISO. GH**

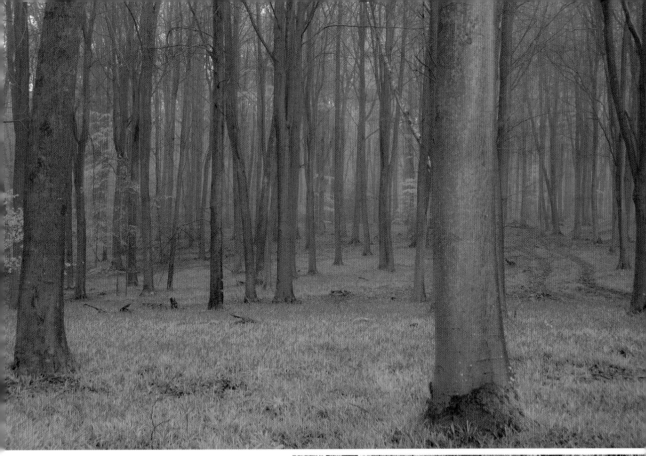

◀ SHOOTING IN THE RAIN

Weather conditions can greatly affect the way our pictures look. This photograph was taken in the pouring rain, giving it a soft, dreamy quality, very atmospheric and quite like an Impressionist painting. Use a slower speed to prevent the raindrops being sharply caught, turning them into a mist instead. **1/8 second at f8, 40mm, ISO 400. GH**

SUNLIT WOODLAND ▶

Later in the afternoon the weather improved and the sun came out. This is remarkably different from the rainy picture; it's just a nice shot of the woodland that doesn't evoke any atmosphere, whereas the other is more a work of art, with a much greater degree of interest to be found in it. Although good weather may be more comfortable to work in it doesn't necessarily produce the most eye-catching shots, so be prepared to get a bit wet and cold sometimes. **1/200 second at f8, 46mm, ISO 400. GH**

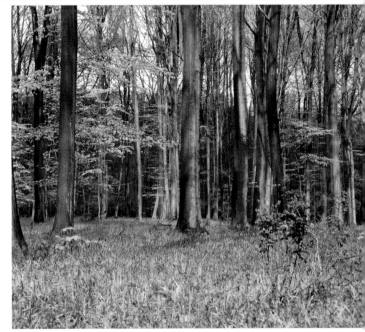

THE MAGIC OF LIGHT

Throughout the book, we talk about light as that magic ingredient. Staying with friends in Provence, I was lucky enough to have a bedroom that looked over the hills to the Mediterranean Sea. This view provided a perfect demonstration of how light transforms a landscape.

This is a good project to do on holiday when your time is your own and the chances are you will have some beautiful countryside or seaside to shoot. Find a landscape you like near where you are staying and photograph it in different light conditions. The most interesting light will probably prove to be in early morning or late afternoon, or during stormy weather conditions.

On a fine day, it's a good idea to start at dawn, taking shots periodically as the light gets stronger and the sun rises. The light will be clear, and there will be long shadows because of the low angle of the sun. Around midday, when the sun is directly overhead, shadows will be minimal, the light will be harsher and generally speaking there is less of interest for the photographer until the shadows of late afternoon lengthen, giving graphic shapes. As the day moves into evening, the reddening of the sky caused by atmospheric conditions creates a warm, mellow light quite different from that of early morning.

You can manipulate the colour balance either in the camera using WB or with the computer, but the highlights and shadows in the picture may make it obvious that the picture was not shot at the time the colour implies. It is better to let the natural time of day provide the colour balance.

Stormy weather will give you the drama of strong tonal contrasts, with heavy cloud and gleams of sun lighting up parts of the landscape. Where the clouds are scudding fast, you'll be able to get a range of shots showing different light in a very short space of time. Don't forget to take some sky shots – they may be useful for Photoshopping into another scene where the sky isn't so interesting.

THE BASIC SHOT ▶

This is the view from my room on an overcast day. It's flat and grey, lacking in interest, and I only shot the picture to use as an example here. While extra shots don't cost anything on a digital camera, it's still worth exercising some discipline as you would be more inclined to do if you were paying for film and processing: they still have to be sorted through and thrown away, and it's far better to just keep your finger off the shutter release button and wait for a more interesting shot. **1/500 second at f8, 105mm, 400 ISO. JG**

THE LANDSCAPE AT DAWN ◥

This is a dawn view out of the window. The light is now quite romantic and worth a picture, but this doesn't make the grade as a really strong landscape shot; the composition lacks interest and there's nothing in particular to catch the viewer's eye. Given a broad view like this, look for interesting areas within it rather than just letting it fill your frame. **1/20 second at f5.3, 105mm, 800 ISO. JG**

LIGHT AND COMPOSITION COME TOGETHER ▶

The next night was stormy with dark cloud cover; the sun was piercing through the clouds and the sea looked as though it had been lit from on high with huge spotlights. The magic of light had transformed that view into a spectacular landscape. I used a neutral density graduated filter to keep the clouds dark and underexposed by −1½ stops to help the highlights stand out from the darker water. This is also an example of how to pick out one small area to make a beautiful picture; I used my longest telephoto setting to find the most interesting part of the landscape and discovered a rhythm in the contours of the hills. Using a wide angle to get everything in is tempting when you have a lovely scene occupying your vision, but it just reproduces a view rather than making a strong image. **1/3200 second at f8, 200mm, 400 ISO. JG**

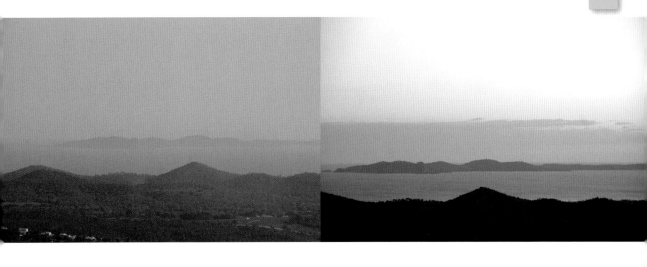

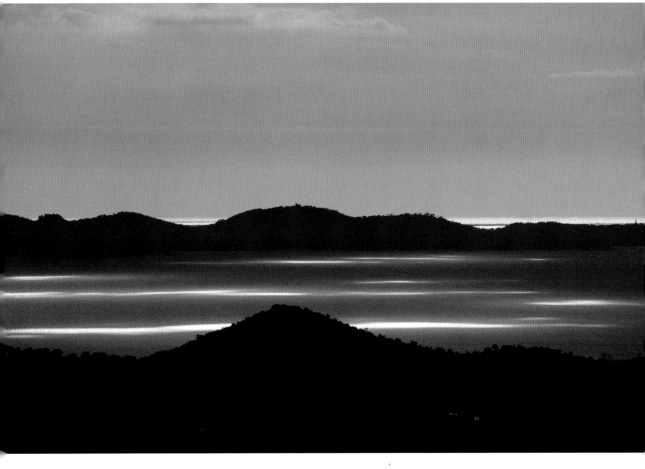

GARDENS

The great outdoors can be closer than you think, so don't feel you have to go traipsing over the countryside to find some satisfying pictures – they may be right around the corner.

Keep your eyes peeled when you are out and about, since there will be images to be had close by; familiarity often blinds us to possibilities. You may have a garden of your own that you find quite mundane, but a set of three pictures taken at different times of day and framed together may give a more interesting look than you could easily obtain from a single shot; alternatively, try a single plant photographed at three stages from bud to full bloom and then skeletal seedhead.

For this project, see how many different approaches you can take to a single planting of flowers, trying close ups and more straightforward views. Secondly, shoot a garden in the evening and try to capture that magic time when the flowers glow in the dusk. Take a series as the light falls, using a stable surface such as a table on which to rest your camera if you don't have a tripod. Choose the best, and if it lacks the colour and glow you are looking for, make some digital adjustments (see Hue and Saturation on page 226).

ISOLATING A FLOWER
Here I zoomed to telephoto and placed a flower in the centre of the frame. I used a wide aperture to isolate it, with the flowers in the foreground and background thrown out of focus. When you focus on a particular flower in this way, make sure it's an undamaged one – it's surprising how the eye can overlook signs of caterpillar damage, for example, which will be the first thing the viewer sees in the photograph. **1/250 second at f5.3, 95mm, 400 ISO. GH**

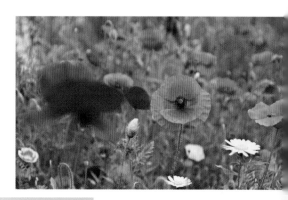

FINDING THE SUBJECT
Walking in my neighbourhood, I found myself in an unfamiliar street and passed this beautiful display of poppies. Here was a neat suburban house, but when I looked into the garden I was able to find pictures that could have been made in the countryside. A portrait of the owner leaning out of the window would have looked great, but unfortunately there was no one at home. Keeping your eyes peeled for a shot always brings rewards, even if you are in apparently unpromising surroundings. **1/500 second at f5.6, 22mm, 400 ISO. GH**

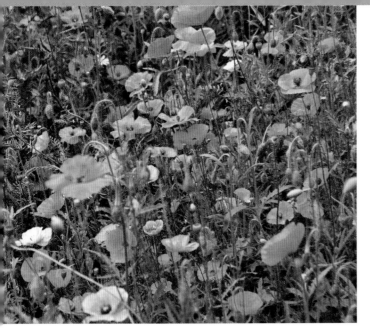

◄ POST-PRODUCTION ADJUSTMENT

This is my interpretation of the poppies – as you can see from the other pictures, they were actually bright red. A botanist would probably hate this, but I was after an artistic impression rather than reality. I cropped the photograph into a square then played about with the Hue and Saturation sliders in the Lightroom Develop module, decreasing the red, green and yellow to make a more muted picture. If you're photographing flowers for identification they obviously have to look like they do in reality, but for your own creative purposes you can choose to influence their colour. **1/160 second at f6.7, 65mm, 400 ISO. GH**

MIDDAY GARDEN ►

This picture shows how my garden looks in the middle of the day, with soft, cloudy light, normal colour and tones as you would expect in the middle of the summer. **1/125 second at f8, 5.2mm compact camera, 200 ISO. GH**

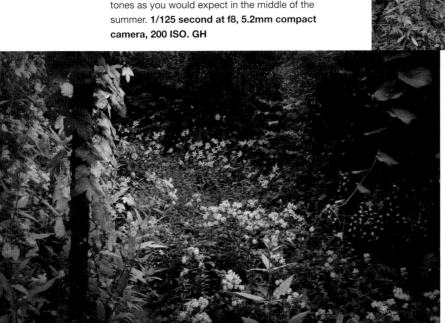

◄ THE GARDEN AT DUSK

As the daylight faded and was replaced by the soft light just before dark, everything seemed to have a bluish-purple glow. I set my camera on the tripod to try to capture that. The pictures certainly look different to the daylight one – they are darker, with more contrast, and look like an evening shot, but they don't have that magic glow. **1 second at f6.7, 5.2mm compact camera, 400 ISO. GH**

FINDING THE COMPOSITION

Establishing a strong composition can be a progressive thing; I often take several pictures where the elements are present but they are just not working together to make a really good landscape.

I know it is there somewhere and I just keep moving and looking until it all comes together for me. This takes perseverance and concentration, and often that last special element to complete the composition has to be waited for as it might be a cloud or a shaft of light. Sometimes you just have to be very patient.

For this assignment, take a black and white photograph. Find a landscape that has one strong feature, such as a great sky, then move around looking for a strong shape to put in the foreground to balance the composition. Conversely, find a beautiful foreground subject then explore different angles until you find a background that is sympathetic to it.

◀ THE START POINT
I first spotted this mountain with the summit framed in a circular-shaped cloud – very promising, but not really enough. For your own project, you can choose any feature that appeals to you and then build on that. **JG**

◀ FINDING A SECOND ELEMENT
About 100m (110yd) to my left I found the church spire, also an interesting element. I then tried to get myself into a position where the two elements came together. You may strike lucky and find a suitable element in just the right place, but it's more likely you'll have to move your position and rethink the angle from which you will shoot your main feature. **JG**

THE FINAL COMPOSITION ▶
I was anxious to get the shot before the light and the cloud changed, but I was aware that I was looking at a series of triangles and shifted my position until they all made a pattern that I found pleasing. My final decision was to wait for the white cloud to move behind the church spire to isolate the cross. I set the camera to black and white and used a polarizing filter to darken the blue sky.

This composition is perfect for me – in fact it's one of my favourite landscapes. The cloud looks as if it has been painted in, rather like the backdrop in some old movie. Even in a beautiful place like Chamonix in the French Alps you have to put the work in, so keep on looking for strong patterns and juxtapositions of shapes until you are satisfied that you have made the photograph as interesting as you can. **1/1500 second at f8, 100mm, 400 ISO. JG**

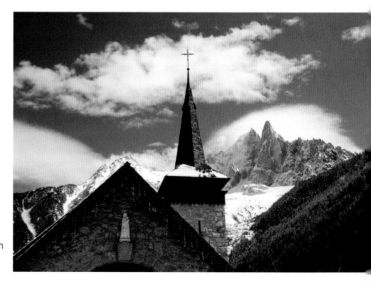

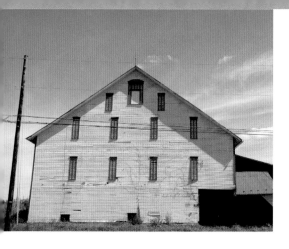

▼ TRYING A DIFFERENT ANGLE

I moved to my left to show the silo, which meant the pole was now in front of the building. I knew that I could remove it later, but decided that in fact the pole and the wires worked in the composition and were an important part of the character of the building. Elements that might easily be judged unsightly sometimes speak volumes about the history and purpose of a building. **1/1000 second at f8, 30mm, 320 ISO. JG**

▲ WEATHERED BARN

I love the old barns in Pennsylvania, and here the angle of the light brought out the texture in the weathered walls. At first I tried to avoid placing the telegraph pole in front of the building, but that meant leaving out the corn silo which is so much a part of buildings such as this. I shot in colour but checked it out in monochrome as I went along, keeping the colour and the black and white options open. If the colours in reality aren't particularly exciting, bear the possibility of black and white in mind – but remember that you will need graduations of tone to make an interesting photograph. While you may still have the mental image of, say, a grey roof and mid-brown wooden walls when you look at the shot in black and white, that may look tonally very flat rendered in monochrome. Try to banish colour from your mind while you judge the potential for black and white. **JG**

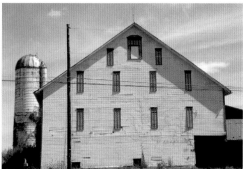

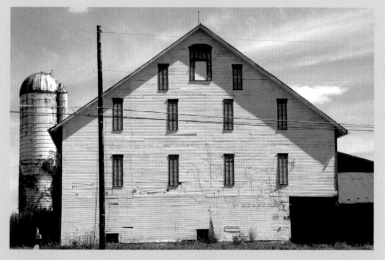

THE FINAL SHOT

In the end I preferred the black and white version as it looks more in keeping with the period of the barn. The slightly wide-angle lens had converged the verticals slightly so I corrected that in Lightroom. Don't just settle for your first visualization but check out the situation and look for a different angle; the character of a building will reveal itself to you if you search for it. **JG**

SEASONAL LANDSCAPES

In most parts of the world the countryside looks very different in each of the four seasons, bringing a range of light, weather and landscape possibilities.

We feel that dividing our landscape projects into summer, autumn, winter and spring helps to focus the mind when we're trying to decide where to travel and what to photograph next. We may choose to go for the pretty pictures in spring, the high-contrast light and warm colours in summer, the spectacular leaf colours in autumn and the stark storminess in winter, for example. You will learn a lot about landscape photography by following the seasons.

This assignment is a long-term project; we want you to make four landscape pictures, each one in a different season. In each picture, it should be obvious which season you are depicting. Landscapes make great images to put on your wall and there are many online companies that will make good-quality large prints at a very reasonable price. You could also make a calendar of images from your seasonal landscape project – again something that can be done inexpensively online.

▲ **MIDDAY IN SUMMER**

I cropped this photograph to a panoramic shape, which suits the long, wide landscape. There was marvellous bright summer light at midday; it's often said that each end of the day has the best light, but it depends on the day and you will often find that while there are no interesting cast shadows from trees and so on when the sun is overhead, clouds will provide shadows on the landscape to contrast with the bright highlights. I set the camera on a tripod, composed the picture and waited for a beautiful cloud formation and for the sun to strike the yellow field. I darkened the foreground with the Burn tool to emphasize that yellow. **1/1000 second at f11, 48mm, 200 ISO. GH**

▲ **BIRDS IN WINTER**

This very simple winter landscape is a favourite of mine. It has a very melancholy mood with little saturation, unusual in these days of poster-colour pictures. The flock of birds flying across the highlight adds that special touch. It's a picture that demonstrates that you don't need striking colours and imposing features to make a successful landscape photograph. **1/350 second at f8, 85mm, 400 ISO. GH**

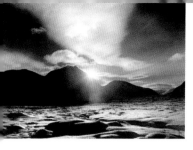

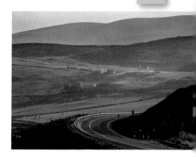

▲ WINTER IN THE HIGHLANDS

The Scottish Highlands are one of the great places for landscape photograph enthusiasts. This winter sunrise is in Glen Coe. The sun has lit the cloud spiral and backlit the foreground snow. I shot this on a Hasselblad medium format camera with a wide-angle lens, using black and white film. Putting a red filter over the lens to darken the blue sky works well in snow scenes, and I did that here. Because the colour blue is associated with cold, I scanned the negative and added the wintery blue tone in Photoshop with the Colorize button in Hue/ Saturation. **1/250 second at f8, 40mm, ISO 400 film. JG**

SPRING IN SCOTLAND ▷

All the elements that a landscape photograph is supposed to include are present in this shot of Scotland in spring. The eye enters along the road, there is a middle ground of rolling hills lit by late afternoon light and the white farmhouse provides the focal point. I used a long lens to isolate this landscape out of the huge view in front of me and also to compress the perspective, bringing the mountains and farmhouse closer to the foreground than they were in reality. It's not dramatic but it's pretty, in the classic calendar style. I used a neutral density graduated filter to darken the sky and mountains. Later I saturated the colour a bit in Photoshop and also lightened the farmhouse to make it more prominent. **1/500 second at f11, 130mm, 400 ISO. JG**

AUTUMN IN PENNSYLVANIA

In this simple autumnal picture of Pennsylvania the colours glowed in the late afternoon light. However, when we checked it out on the computer we saw a bare patch in the centre of the middle tree and the colour didn't have quite the saturation that my eye had seen – so we decided to enhance it. **JG**

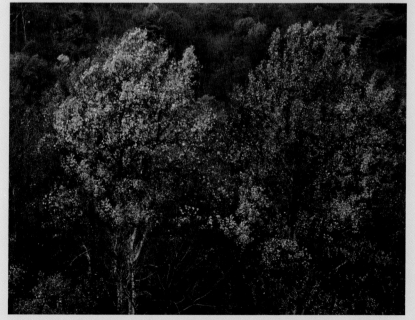

AUTUMN IN PENNSYLVANIA ENHANCED

To fill up the gap, we cloned some clumps of leaves from the tree on the right. We brightened the picture and increased the contrast, then added more saturation. We darkened some of the bright tree trunks with the Burn tool and finally, using the Dodge tool, lightened the leaves on the middle tree to make it the focal point of the picture. Sometimes the camera doesn't do the scene justice and you'll want to do some digital retouching to give the picture a final boost. **1/400 second at f8, 95mm, 400 ISO. JG**

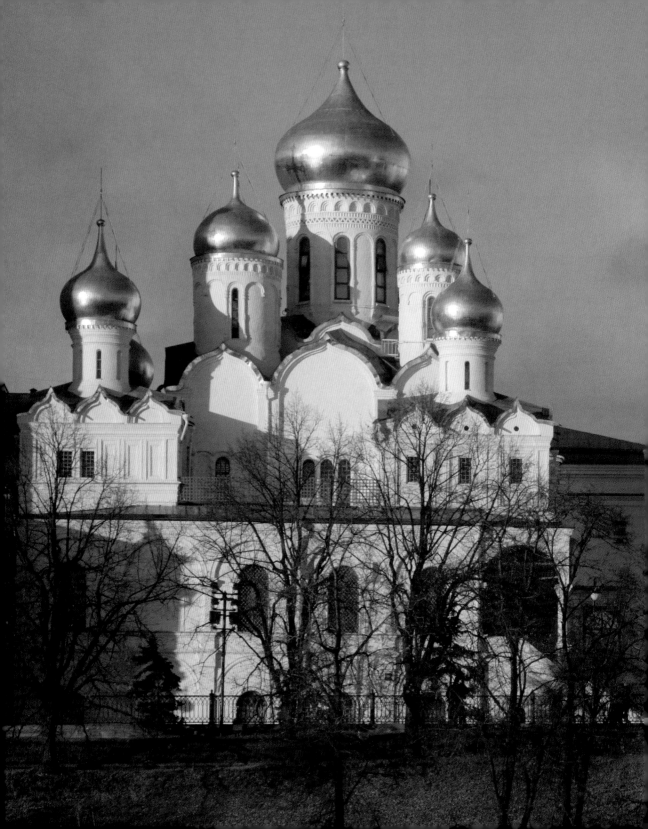

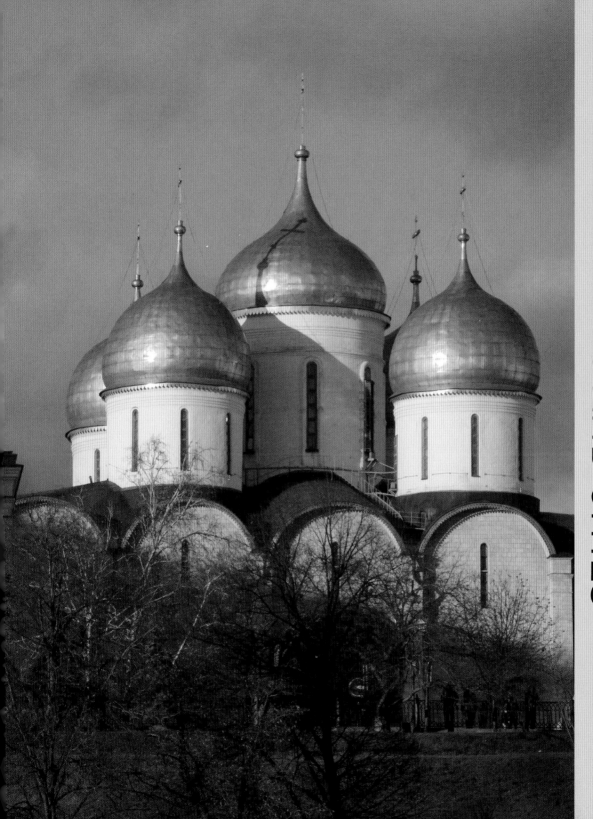

SIGHTSEEING AND CITIES

The majority of your city shots are probably taken when you are on holiday – and given that your time is limited you'll often be in the right place at the wrong time, when the weather is rainy or dull or a particular building is in shadow.

In this chapter we shall concentrate on showing you how to capture your response to a city no matter what conditions you find and take pictures that aren't just like the standard postcards you could buy from the hotel shop. Every city has its own personality and it's your job to portray that, illustrating what makes it different from any other city in the world.

Sightseeing and city photography starts at home. Good research is invaluable, and there are great guide books available to most of the world's interesting cities. With some forward planning, you will be able to make the most of a good-value city weekend break as you will be able to hit the ground running, knowing exactly where you want to go and when.

Yet even with planning and the benefit of a longer holiday, most of us have the problem of not having enough time in a city to really take full advantage of its photographic potential. There is often a travelling companion who is not really into photography or children who will become very bored and restless while you linger to get the right angle on a building – so let's not forget about our own towns and cities where we have the luxury of having plenty of time and local knowledge. Unfortunately we often become so used to what's around us that we don't see the photographic potential any more, so we would like to encourage you to take a fresh look at your 'hood' too.

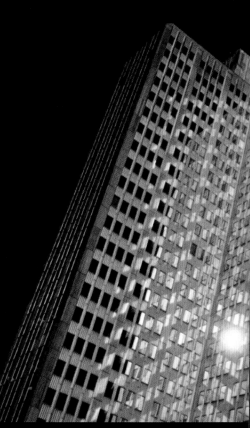

MOSCOW (previous page)
Early in the morning the low autumnal light was clean and sharp, illuminating this incredible building. The reflection off the gold was spectacular, and all I needed to do was frame the picture and shoot. There was a unavoidable post in the foreground that I removed in Photoshop.
1/1000 second at f8, 95mm, 200 ISO. JG

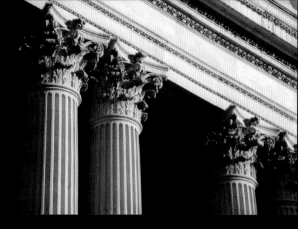

▲ COLUMNS

Architectural details can be very interesting. In this case the diagonal slant helps to give the impression of the great weight the columns are supporting – a frontal view didn't give the same effect, and zooming closer didn't work either. The picture needs the verticals to tell the story. Take a range of shots from different angles, as it is often difficult to decide which one is best on the spot. **1/160 second at f11, 75mm, 400 ISO. GH**

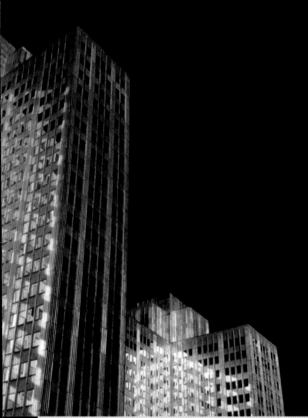

PITTSBURGH SKYSCRAPER

This was taken with the strong late morning sun hitting the glass office block front-on. The sky was a deep blue and the glass was reflecting that blue sky, perfect for a black and white picture with a red filter to darken the sky. The result was more spectacular than I had visualized; the blues have all transposed into dark grey and the steel structure is glowing, giving the effect of a night shot. I was shooting on film, but you could achieve a similar result with a digital camera, converting the image to black and white then darkening the sky (see Red Filter Effect on page 238). **1/125 second at f8, 24mm, 400 ISO film. JG**

 QUICK TIP

If you are about to make a long trip and have a new camera in mind, consider getting one with a GPS system so that you can pinpoint the location of the subjects you want to shoot.

ONE BUILDING, ONE DAY

I have photographed St Paul's Cathedral many times during the decades I have lived in London. This time I set out to capture it from dawn to dusk, watching how the light changed the appearance of the building over the course of a day.

I decided to shoot the cathedral from the south side of the Thames looking over the Millennium bridge – it's not the front of the building, but it's the view you see while walking along the river and it would allow me to get the sunrise and sunset on either side of the dome. These pictures were all shot with the white balance on the camera set to daylight.

This is an interesting project to get you thinking about the direction of light at different times of day and in varying weather conditions. Try to use an iconic building that has been much photographed for books, magazines and postcards and see if you can come up with shots that are different from the rest. You also need a large building, since one that is considerably smaller than its surrounding architecture will probably spend quite a large part of the day in deep shade.

▼ **MIDDAY CLOUD**
The weather gradually got worse as the morning progressed. When a rainstorm set in I took a couple of shots and went off to do some other things under cover. Sometimes bad weather can provide a dramatic shot, other times it is just dull and there is nothing to do but give up for a while and wait. **1/320 second at f5.6, 105mm, 400 ISO. GH**

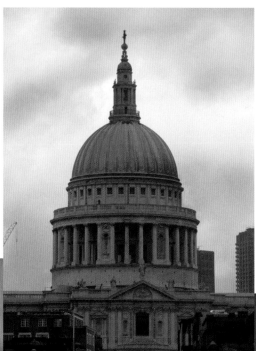

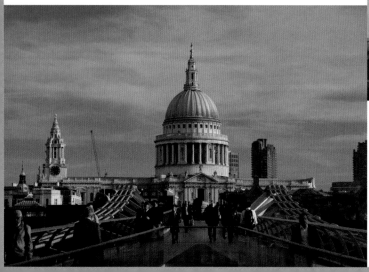

◄ **SUNRISE**
This can be tricky – getting up early isn't easy for many people. Then you have to decide if the weather is suitable and by the time you get there it may have changed anyway. It took me three visits to get this shot – perseverance usually pays off for a photographer. **1/160 second at f6.7, 65mm, 200 ISO. GH**

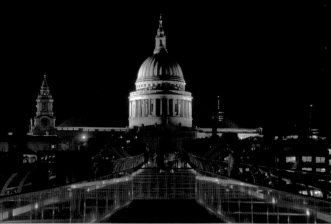

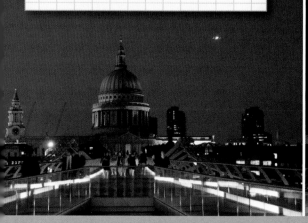

QUICK TIP

If you won't have time to spend a whole day, choose a building that is within easy reach and plan to do several return visits. Select the best view and if the light isn't very inspiring, take a few shots so that your journey isn't wasted – studying those will give you further ideas for photographs taken in better conditions next time.

◄ AFTERNOON SUN

I returned just in time to catch the sun shining through a gap in the clouds, the sidelight increasing the contrast and bringing out the detail in the building. I exposed to retain detail, causing the cloudy sky to underexpose. **1/1000 second at f8, 105mm, 200 ISO. GH**

◣ EVENING

At twilight there was still a little light on the scene and that rich blue sky you get when you shoot before complete darkness. The floodlights on the cathedral and the lights of the city have now taken over from the fading daylight. The bridge lights lead the eye to the centre of interest in the picture. **1/3 second at f4.8, 52mm, 400 ISO. GH**

▲ SUNSET

By sunset the sky was almost cloudless. I could have corrected the blue skylight on the foreground with the WB Shade setting but decided to leave it, as the blue made a good contrast with the warm sunset shining on the dome. **1/60 second at f5.6, 80mm, 400 ISO. GH**

▼ NIGHT

Nightfall created much more drama, the floodlights pushing the building forward from the black sky. The bridge lights started changing from blue to red to green; I took the shot when they were blue, giving a cool night feel and contrasting with the warmer colours behind. **1 second at f6.7, 62mm, 800 ISO. GH**

MEMORIALS AND SCULPTURES

When it comes to visiting cities, great memorials dedicated to political or military figures and public sculptures are high on the must-see list for most of us.

They are often places that we have seen many times in pictures, but as photographers we want to make our interpretation rather than reproducing a postcard. Aim for some advance planning – the local tourist office will probably be helpful enough to tell you where the sun rises and sets in relation to your subject so you can decide when you should go there for the light you want.

It is a big challenge to go after something different – your personal postcard as it were. Your project is to find a memorial or sculpture that you identify with, emotionally, politically or aesthetically, and bring that quality out in your shots. When you are visualizing your pictures, be they memorials or any other subject, be aware that the photograph may be your stage one and the computer stage two.

▽ THE LINCOLN MEMORIAL

I had seen the Lincoln Memorial hundreds of times in books and movies, so I was very familiar with it before I got there in reality. There is actually very little colour in the memorial, and it is rather mottled and stained. I was fairly sure that black and white was going to give a more emotional result than colour and that proved correct, as the black and white lent the memorial a dignity that was intended. The building is similar to the Parthenon in Athens, so I shot it from below looking up, much as one sees the Parthenon. This is a very simple picture, but that is all that I wanted. **1/500 second at f11, 38mm, 400 ISO. JG**

⬧ ABRAHAM LINCOLN

After taking shots from every angle, I chose this one because it is different from other images that I have seen and I also think it is a powerful shot. It is always important for a photographer to try to interpret a subject in his or her own way. **1/125 second at f8, 44mm, 400 ISO. JG**

PORTRAIT SHOT

The Memorial is a place of almost sacred pilgrimage to Americans, and in this portrait I tried to convey Lincoln's status with his countrymen. The camera shot was stage one of the portrait. In stage two, I took the colour image into Lightroom and darkened it with the Exposure tool, then played with tones and contrasts until I reached this interpretation. I used the Split Tone Preset in Lightroom – the colour is really a matter of personal taste, and I felt that Lincoln looks powerful and dignified like this. I vignetted the edges to bring out Lincoln's face against a darker background. **1/200 second at f5.6, 200mm, 400 ISO. JG**

THE AMERICAN FAMILY ▷

This picture is the one that sums up the Lincoln Memorial for me. I asked a Korean-American family to pose in front of Lincoln, making a symbolic image of the father of the nation looking down on his very patriotic children of different ethnicity. It was shot in colour, as were all the pictures here, but I felt that the monochrome image was more timeless. Using Antique grey in Lightroom for the final image strengthens that impression. **1/100 second at f8, 24mm, 400 ISO. JG**

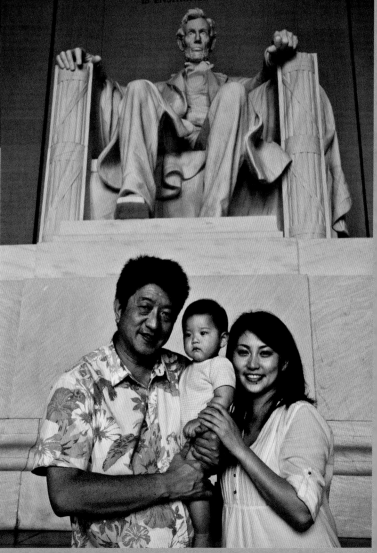

SHAPES OF THE CITY

The moment you walk into a city you are surrounded by unlimited compositional possibilities. Every element in the city has a different shape and colour, and they all change according to the light and your viewpoint.

Playing with all these shapes, colours and light is a great learning experience, and in most cases the shapes are stationary so you will have the time to perfect the composition.

You will probably walk for miles as you explore the city, so if you are using a DSLR, take just one zoom. To keep your equipment really light, the new ranges of top compacts are ideal – they produce images that are nearly as high in quality as those from a DSLR but are much lighter to carry.

Just as importantly, wear good solid walking shoes and a shirt with a collar that protects your neck from camera strap burn. If you are suffering from physical discomfort you will probably not be able to concentrate on your photographs and you will give up earlier than you had planned.

Be prepared for some disappointments – a favourite building that you have long wanted to see may be covered in scaffolding, or the weather may be rainy for the whole of your stay. Here is the big challenge – how do you still make good pictures? It's really a question of lateral thinking. Maybe that building will make a really cool picture, scaffolding and all; and if you tackle things from a different point of view, the wet, shiny city will most probably give you more interesting and atmospheric views than those to be found on postcards. Try thinking in monochrome, which can bring a moodier atmosphere to the city, where colour in rainy weather may be just dull.

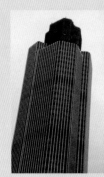

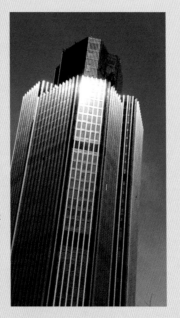

BUILDING IN SUN AND CLOUD
This is an interesting modern building in London, but the grey overcast day didn't do it justice. I took a few reference shots, rotating the camera slightly to make the most interesting shape. Later, when the cloud cleared, I returned and positioned the camera to get the reflection of the sun on the windows. If a building that should be eye-catching doesn't seem so to you, it's probably just a matter of revisiting it in a different light. **1/1500 second at f8, 55mm, 400 ISO. GH**

▲ **CATHEDRAL**
This sums up how city architecture grows and changes – St Paul's Cathedral in Melbourne is contrasted against a modern building, emphasizing the passing of time. **1/350 second at f8, 70mm, 200 ISO. GH**

VIENNESE FAÇADE

This is a small section of a stunning façade of buildings that runs down one side of the market in Vienna. It's often the case in cities that you cannot get into a position to make a really good picture of a much larger section of several buildings and here I had to settle for this section – but it turned out better than I expected. **1/500 second at f6.3, 29mm, 400 ISO. JG**

VIENNESE FAÇADE: VERTICALS CORRECTED

Partially correcting the verticals in Lightroom has greatly improved the picture (see Perspective Correction, page 236). It's usually better not to correct them wholly as the building can appear to be wider at the top. Before the days of image-editing software a heavy perspective control lens was needed; adjustment is now easier, but remember that you will lose some of the image on each side, so pull back enough to leave material at the edge of the frame that can be cropped off without spoiling your composition. **JG**

BLUE SCAFFOLD

I arrived to shoot a favourite building only to find it undergoing repair work. This was a major disappointment, but instead of walking away empty-handed I set the white balance to incandescent to add extra blue and made an abstract shot to remind me of my visit. **1/350 second at f8, 26mm, 200 ISO. GH**

SCULPTURE AT SUNDOWN: WITHOUT FLASH ▶

I turned off the flash and balanced my camera on my companion's shoulder to keep it steady. I set the ISO to 1000 and used a slow shutter speed. The floodlights were now doing a nice job, too, and the building is blue from the last of the daylight. We are often too quick to turn on the flash and in so doing kill the mysterious evening atmosphere. The latest cameras can produce great quality at 12000 ISO or higher. You can shoot in very low light at that, so avoid flash and go for atmospheric effect instead. **1/8 second at f2.8, 7.4mm compact camera, 1000 ISO. JG**

SCULPTURE AT SUNDOWN: WITH FLASH

I visited the cathedral at Palermo in Sicily when it was nearly dark. First I tried to shoot the sculpture with flash, hoping to pick up some background detail. It was not a good decision, as it is a very harsh light. **1/60 second at f2.8, 6.1mm compact camera, 400 ISO. JG**

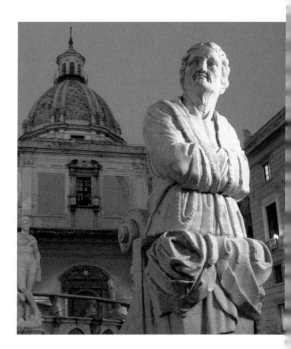

MEXICAN MONASTERY ARCH ⊿

I then retraced my steps and worked on framing the monastery in the beautiful entrance arch of the wall. Ten minutes later the light had left the monastery, and it looked rather drab and neglected – the magic had gone. It always pays to keep your camera close at hand and ready to go. **1/1000 second at f8, 10mm, 400 ISO. JG**

◁ MEXICAN MONASTERY

We arrived in this town just as the setting sun turned the monastery to gold. I rushed to capture the light and made this lovely simple image with the graphic golden shape against the blue. I didn't feel the perspective needed correcting. **1/500 second at f8, 22mm, 400 ISO. JG**

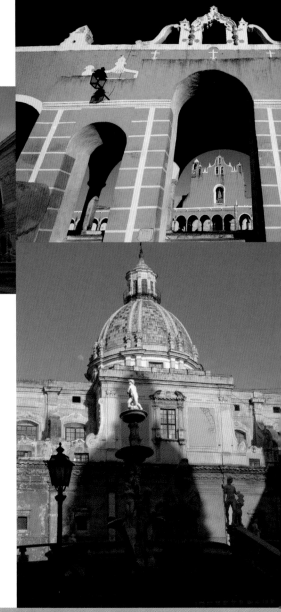

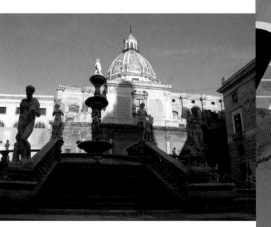

⊿ EARLY IN PALERMO

The early morning sun had not yet revealed all of the cathedral, but I liked the shadows thrown on the building. This was one of my first efforts as I walked around trying to find something special. **1/500 second at f4, 6.7mm compact camera, 400 ISO. JG**

EARLY IN PALERMO: A CLOSER LOOK ▷

I saw the little sculpture covered by the shadow, which in turn was almost a repeat shape of the dome. I zoomed from 25mm out to 120mm to make this composition and took an exposure reading off the lit part of the building with the spot meter setting. Don't just settle for your first impression – keep looking, and as you get to know the building better, so the pictures will get better. **1/1000 second at f4, 12mm compact camera, 400 ISO. JG**

MODEST SCULPTURE, VIENNA ▷

This is my first shot of a sculpture in Vienna, showing it in its setting. I noticed a yellow leaf against the dark green sculpture and went closer to investigate. **1/500 second at f5.6, 26mm, 400 ISO. JG**

QUICK TIPS

A bus tour will take you round major sights and you can make notes about where they stand in relation to the sun. A set of postcards is useful, too – you can see what the city has to offer then try to shoot more interesting pictures.

MODEST SCULPTURE: CLOSE UP ▷

A Viennese citizen with a sense of humour had added a golden maple leaf to the sculpted leaves concealing the private parts of our hero. It is the colour combination that makes the picture work so well. I used a wide-angle lens, which forces you to get close in order to fill the frame, so that I was looking down on the leaf – had I chosen a longer lens I would have been further away, seeing the edge of the leaf instead. The longer you spend walking the city streets the more things you find that make your trip a bit different from the norm – along with impressive buildings, a city will evidence wit, innovation and the character of its inhabitants. **1/500 second at f5.6, 18mm lens, 400 ISO. JG**

PROJECT

4

INTERIORS

Shooting interiors can cover everything from squeezing into the corner of a poky café or shop to trying to tackle a magnificent interior created by a great architect of the past or present.

A light travel tripod is valuable because many of the interiors you'll be photographing will be in low light and long shutter speeds will be needed so that you can stop down the aperture to increase the depth of field.

Many beautiful interiors will require a very wide-angle lens. These are inclined to distort the subject, particularly at the edges of the picture, but you can use the Correct Distortion function in Elements, Lightroom and other programs to restore a more natural look to the image.

The project here is two-fold. Photograph the interior of your favourite place – it may be a local café, for example, or simply your sitting room –

and capture the atmosphere that you like about the place. The atmosphere in interiors is mostly created by the lighting, which may be low, but as long as you have a tripod it doesn't matter if the exposure is very long.

Secondly, shoot the interior of a grand building, interpreting how you believe the architect would like it to be seen. Concentrate on the beautiful design that he or she created, finding the elegant angles and making the most of the lighting, which is often a big feature in modern architecture. In this case you are there to pay homage to someone else's art rather than trying to demonstrate your own.

▲ **SHOPPING MALL**
I was drawn to the swooping shapes of this mall in Hong Kong and took a shot that is about bold shapes and textures, making a kind of abstract image. The lens was stopped down to f11 to get all the edges sharp. I tried some shots with a wider angle, but the results just looked like a standard picture of a shopping mall. **1/30 second at f11, 18mm, 400 ISO. GH**

▲ **HOTEL ENTRANCE**
In this entrance to a hotel in Lisbon, the strict vertical and diagonal lines dictated that I had to keep them all square. This meant keeping the camera on the same plane as the verticals, looking neither up nor down. I stood on a chair to get the camera higher to avoid having to look up. The architect's design is for the stairwell to be lit by cool daylight, leading the guests up into the warm light of the foyer, and it is that contrast of colour that makes the picture work. **1/50 second at f3.5, 18mm, 400 ISO. JG**

CATHEDRAL ▶
Here I was up on some scaffolding with artists who were restoring the painted ceilings of Ely Cathedral in the UK. To get the most spectacular view possible I needed my widest-angle lens. As I had to point the camera down to include the nave as well as the ceiling, the walls appeared to be collapsing into the cathedral. Lightroom came to the rescue, and I corrected the verticals. **1/2 second on a tripod at f8, 10mm, 200 ISO. JG**

KOREAN PALACE

Here the on-camera flash got me a picture I wouldn't have otherwise managed. The palace in Seoul was very dark inside and the shutter speed was too slow even with my ISO up to maximum. I popped up the flash and it was perfect, recording the wonderful colours. I think this is a valid illustration of the room as it was so dominated by the graphics on the ceiling. **1/30 second at f5.6, 18mm, 800 ISO. GH**

DOMESTIC INTERIOR

Using available light to retain the atmosphere sometimes means the exposure range is too wide. Daylight from the window is the main light source here. I turned on the light by the far wall as I liked the warm tone from the incandescent bulb and exposed to keep some detail in the window. This meant the room is underexposed, losing detail in dark areas. **1/10 second at f8, 10mm, 400 ISO. GH**

ADDING FLASH

The answer to this was to use a flash gun to open up the shadows. I put the flash on a small light stand to the right of the camera and bounced it off the top corner of the room. I kept the exposure settings the same and let the flash in TTL mode provide the fill-in light. You can now see much more detail in the room, but the atmosphere remains the same. **1/10 second at f8, 10mm, 400 ISO. GH**

OUT AND ABOUT

This chapter is all about the genre of photography known as photojournalism or reportage, and here you will be using your photographer's eye to capture the spirit of a place and the people who live there.

While the previous chapter was concerned with portraying the iconic buildings and impressive monuments that are found in most major cities, your subject now is the essence of human life; often graffiti on a wall or a group of teenagers walking the street can say as much about a place as its architecture.

Because of the huge range of subjects within the genre of photojournalism, this chapter embraces many photographic themes. It is one of the greatest ways to develop your ability to see potential images, and just walking about finding pictures is photography at its most exciting.

Look at your shoots as photo stories – photograph the food, the shops, the small businesses and the people who live and work in that locale. In other words, get involved, and try to show that involvement in your pictures. Once you have tried a few reportage shoots you will probably find that every outing you make thereafter becomes more stimulating because you will be delving into everything you see around you, noting things of interest even when you haven't set out with the specific intention of concentrating on your photography. In other words, you will be starting to see the world with a photographer's eye.

THE SHOOTING PARTY (previous page)
This group portrait could have been taken during any shooting season in the last 60 years or more. It took about 20 minutes to assemble the sportsmen with their dogs in front of the old hut, but it was worth every minute. Sometimes you need to be very assertive to get this sort of portrait together – a great way to get people involved is to give them your email address and promise to send them a picture if they contact you. Of course, you need to keep your promise. The photograph was shot on film and scanned; I then adjusted the brightness and saturation slightly in Lightroom. **1/125 second at f8, 28mm, 64 ISO. JG**

MEXICAN LAUNDRY

This couple folding their laundry asked me to take a portrait of them. Their large friend came over and put his arms around them, making a strong composition for me. It is better to make it obvious that you are taking portraits rather than trying to hide what you are up to; often everybody will join in the fun and pose for you. Using a very wide-angle lens for this shot meant that I could include a lot of the laundry in the background. **1/125 second at f8, 12mm, 600 ISO. JG**

GENTLEMAN OF SIENA

This was one of those 'Shall I ask him or not?' portraits. He had such a great face that I did ask, and he was charming. I took several shots, he took the modelling assignment very seriously, and it worked well when he placed his hand on the wall. This is a composition based on the classic rule of thirds, with his face placed in the top left third of the frame. I lightened his face in Lightroom to lift him out of the dark surrounding tones. This was shot on film and processed in the computer. I used a telephoto setting of 180mm on the zoom and shot with the aperture wide open at f4 to throw the background out of focus. **1/250 second at f4,180mm, 400 ISO film. JG**

PROJECT

1

USING A STANDARD LENS

It's often suggested that the best way to learn how to use your camera is to work with a standard prime lens (50mm for full frame SLR or 35mm for DX format) or set your zoom lens to 50mm (or 35mm) then tape it so that it cannot change focal length.

This means that you view your subject with normal perspective as your eye sees it, and you are forced to move backwards or forwards to fill the frame and compose the picture. The standard lens also has approximately the same angle of view as normal eyesight.

Shooting at just one focal length removes the complication of making decisions as to which focal length you choose on your zoom. It's also a good thing to learn how to find and compose a strong picture without the need for optical exaggeration.

All of the pictures in this project were taken with a 35mm f1.8 prime lens on my Nikon D200

camera. The subject was a local protest about the proposed cuts to our health services. I got to the venue early and worked out where I would shoot when the procession arrived. Your project is to find an event and cover it as if you were fulfilling a magazine assignment. Imagine you have four magazine pages to fill and tell the story in six to ten pictures.

▼ **FRAMING AND CROPPING**

It's not always possible to frame just as you would like to. There was a barrier in front of me and I couldn't get closer, so I tightened this one by cropping slightly to minimize the barrier in the foreground. **1/350 second at f8, 35mm, 200 ISO. GH**

GETTING THE MESSAGE ACROSS

I couldn't resist this great character. I could have got closer for a portrait but I was more interested in including the poster to put him in context. Posters and signs can be really helpful in telling your story. **1/250 second at f8, 35mm, 200 ISO. GH**

▲ FINDING SHAPES AND COLOURS

There are strong shapes and colours here. The No Cuts placards refer to the cuts in funding that were the story I was telling. It was only later that I realized I had captured a visual pun – a clean-shaven man promoting no cuts. When you are concentrating on a particular message in a shot you don't always notice at the time that there's a bit of extra fun or poignancy to be found when you look at the photograph later. **1/750 second at f8, 35mm, 200 ISO. GH**

◀ CHANGING THE FORMAT FOR EFFECT

This man was important to the story as he probably had more immediate reasons than most to be protesting. I cropped the picture tight to increase the feeling that the health service cuts were squeezing him. **1/750 second at f6.7, 35mm, 200 ISO. GH**

FROM THE BUS

We often have limited time to explore a new place when we are travelling, but a great way to see a lot in a brief period is to get on a bus.

Double-decker buses give you a new fresh vision of a city, the high viewpoint creating space between people on the pavements and allowing you to look over the tops of walls and even into office buildings. However, you can get good shots from a single-decker as well and you will still cover more ground than you could on foot.

As bus windows are usually far from clean, a wide aperture is the best choice to keep the window out of focus. It also allows you to use a high shutter speed to minimize camera movement as the bus manoeuvres through the traffic. A technique that is very useful when shooting from a moving bus is what might be called 'the reverse pan'. Usually, a pan means that you are stationary and panning on a moving subject, but from a bus the opposite applies; you are moving and the subject is stationary. Place the subject in the middle of the frame, then as the bus moves past, pan to keep the subject in the viewfinder. Try experimenting with your shutter speeds to achieve different creative effects.

This assignment is straightforward: go for a ride in a bus, find the cleanest window and see what you can shoot. The world around you can look quite different if you look at it from a higher viewpoint. Reflections from the window can be a problem, so it is worth buying a rubber lens hood which you can press against the window to cut them out; if you don't have one, use your hand instead.

Check out both sides of the bus, as the light will be different. Try to get a seat where the sun won't be shining onto the window, as it will light up any dirt and will also flare into the camera lens.

▼ **A HIGH VIEWPOINT**

I wouldn't have seen this shot from lower down. The guy going for his bus ticket reminded me of using a banana as a gun when I was a kid. This is where a zoom lens comes into its own – you are able to frame very precisely from your own fixed position. This was taken with my compact camera. **1/45 second at f2.3, 14.1mm compact camera, 400 ISO. GH**

▲▶ GRABBING THE MOMENT

This was one of those lucky shots. As both lanes of traffic stopped, I noticed the car next to me had a reflection of a tree and the sunset on it but I was slightly too far back to make an interesting photograph. To my delight, the bus edged forward and stopped in the perfect place for me to shoot this double reflection. I increased the contrast in Lightroom and added some saturation to make it sparkle. Again, I used my compact camera. **1/30 second at f2.4, 15.6mm compact camera, 400 ISO. GH**

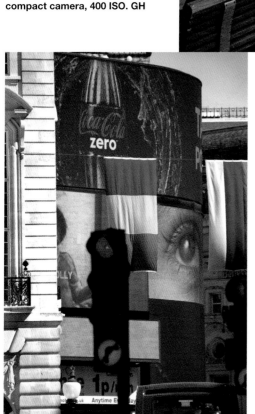

◀ JUXTAPOSING COLOURS AND SHAPES

This is an exciting juxtaposition of colours and shapes, caught from an angle I wouldn't have seen from the pavement. When you are shooting graphic patterns you will find the most successful ones include a dominant focal point within them, and here it is the red traffic light that demands attention. The top deck of a bus is the perfect place to make compositions of the posters and signs of the city, and the more pictures like this you take the better they will become. The building on the left was quite bright, so I darkened it using the Photoshop Burn tool. **1/1000 second at f5.6, 200mm, 400 ISO. GH**

◀ CHOOSING STRONG COMPOSITIONS

Here the parking-control officers are too engrossed in their work to be aware of anything else around them. The high viewpoint has allowed me to split the frame in two, using the strong diagonal line of the bench to separate them from the pedestrian. This picture is typical of multicultural modern London. From a bus, I couldn't have made a precise composition such as this without a zoom lens. As you will usually be carried swiftly past subjects you want to shoot, leave the camera on P mode. It's better to let the camera make the decisions rather than miss a great shot while you're fiddling with the exposure modes. **1/125 second at f5.6, 85mm, 400 ISO. GH**

PEOPLE ALONG THE WAY

When you're starting out, you may find it difficult to approach strangers and ask them to pose for you. However, travel portraits are an enormously rewarding area of photography, so be brave, take a deep breath and ask – once you've had a few successes it will become second nature.

It's important that you have your technique honed so that you can appear confident, since any sign of nervousness will transfer to your subject. A bit of flattery such as 'I want to photograph you because you look great' goes down well, and if there's a language problem, a bit of uninhibited sign language will break down the barriers.

It can be equally hard not to feel self-conscious when you want to take a reportage portrait of someone going about their business. You may worry that you'll upset people and they'll be watching you critically, but in fact most people will be too busy getting on with their lives to notice you. If you really feel that it's not in your nature to take candid portraits, just ask instead.

For this assignment, make a list of six people who work in your area, for example the postman, a shopkeeper and street sweeper, and make a portrait of each one. Next time you go on holiday, try to tell a story with your portraits by selecting people who are typical of their location. If their surroundings are interesting, including those too will make environmental portraits that say more about the lives of your subjects.

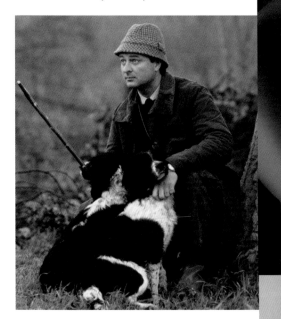

▲ PEOPLE AT WORK

This is an English country portrait of a dog handler and his springer spaniels at a pheasant shoot in Norfolk, on a misty winter's day. I like the positioning of the dogs, facing in opposite directions. The handler posed really seriously and set up the portrait for me. You will nearly always get cooperation from people at work if you ask for their help – they want to have their occupation recorded properly. **1/250 second at f4, 120mm, 600 ISO. JG**

◀ CHILDREN IN GAZA

When I was on assignment in Gaza I was followed everywhere by small children, who always love being photographed. I started shooting with the three on the left, but when the little boy peeped around the door, the composition was complete. It is one of my favourite portraits because it symbolizes the great spirit of the Palestinian people living a hard life. **1/500 second at f8, 50mm, 400 ISO. JG**

MOTHER AND BABY

A French Tahitian mother and her toddler were in the aisle next to me on a ferry in Provence. It was a very hot day, and they looked so peaceful that I was reluctant to disturb them. This is my first shot; there is a big flare from the porthole and the foreground is ugly and cluttered. **JG**

ADDING ATMOSPHERE

Afterwards I tried looking at the picture in black and white and vignetted the corners both to enclose the pair and to get rid of distracting background elements. I also softened the focus a bit in Lightroom. This final version captures how I felt about the pair at the time I saw them. **JG**

FINDING A DIFFERENT ANGLE

When I plucked up courage and asked if I could take some pictures from close quarters, the mother was happy for me to do so. The pose worked well both compositionally and in showing the relationship between the pair, but after consulting my playback I decided to underexpose by –1½ stops to darken the picture, increasing the feeling of intimacy. **1/400 second at f4.8, 62mm 400 ISO. JG**

▼ PROVENÇAL MARKET

At a market in Provence, a man was blowing bubbles for the children. I couldn't get near because of the crowds, but I shot pictures anyway, planning to crop them later. This one looked promising, but the area that I was interested in was very small in the frame. **1/500 second at f8, 100mm, 400 ISO. JG**

◄ CREATIVE CROPPING

Cropped in Lightroom and with the colour saturated further, it makes a pretty cool shot. I was really surprised at the good quality that survived after such a severe crop. Don't worry if you can't fill the frame as you would like – shoot anyway and crop later, just making sure the picture size and quality are set to maximum in your camera. You still have to visualize the final composition while shooting to get the right content.

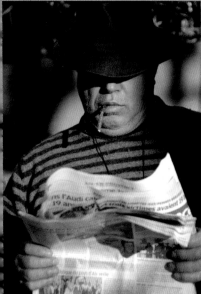

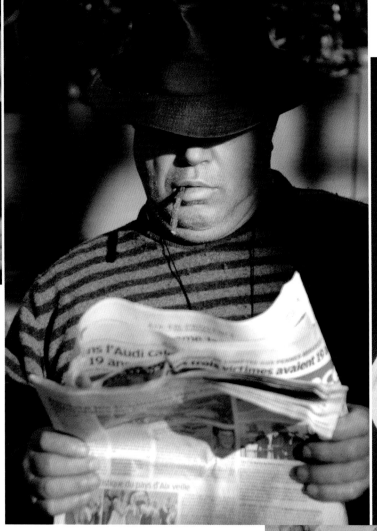

▲ FRENCHMAN IN AIX

In 2012 I spotted this Frenchman in Aix-en-Provence, looking like a still from a 1940s movie. The picture is made by the pool of light that he was sitting in. I used a telephoto setting so as not to disturb him – he was unaware I was taking his picture. I often pre-focus on an object the same distance away to minimize the time I will be pointing the camera at someone. **1/500 second at f8, 130mm, 400 ISO. JG**

ADDING SEPIA ▶

When I converted the image to black and white and added a sepia tone it looked just right for the 1940s French reportage portrait that I had visualized in Aix. It certainly is a great facility that we can now shoot colour and black and white at the same time – keep it in mind that any picture can be considered in either mode.

MEXICAN MARKET ▶

In a great little market in Mexico everybody was happy to be photographed. I could have chosen any of 20 portraits but my lovely butcher got the spot. I saw the composition with her perfectly placed in the gap and quickly zoomed to make this framing. I included the two figures at left and right of the picture as they seemed necessary to add to the environmental atmosphere of the portrait. I clowned around with the locals and bought some produce so that I was contributing, too. **1/125 second at f5.6, 50mm, 500 ISO. JG**

◀ NEW ORLEANS ENCOUNTER

This guy came bouncing up to me in New Orleans, shouting. At first it was a bit intimidating as I was in a nearly deserted street at 7.30am with expensive gear, but he turned out to be a great character – he said he was a Mohammad Ali impersonator and demonstrated that for me. Be brave, as that's how some of the best travel shots come about, and be prepared. If I hadn't been ready to shoot I wouldn't have got this picture. New Orleans is full of great characters and if you don't make contact with them, they will with you. **1/400 second at f5.6, 30mm, 600 ISO. JG**

LONDON DEMONSTRATION ▶

This shot was taken at a demonstration in London, where protestors rallied against anti-terrorist laws that caused many people taking innocent photographs to find themselves confronted by the police. When shooting in crowds, a wide-angle zoom lens is ideal to get you close up and inside the action. The articulated viewing screens on many cameras now are a great asset: you can get high-angle shots by being able to hold the camera above your head while making your compositions, or alternatively, with the camera low down, you can take pictures of people without them being aware of it. **1/45 second at f5.6, 12.3mm, 400 ISO. GH**

QUICK TIP

When you're doing street photography it's important to do your checklist at the outset as things can happen very fast and you must be prepared. Check:

- Is my ISO setting correct?
- Have I got the right lens?
- Is the WB correct?
- Have I got a spare battery and memory card?

◀ DOUBLE PORTRAIT

As I was shooting the policeman talking to the guys doing hip hop in the street, the sky was reflecting on my compact camera's screen – I didn't see the person taking a portrait of the horse on the edge of the frame until I downloaded the picture. I cropped it to a square, taking off the right side and the top, and in so doing changed the composition and made the camera and the horse's head the point of interest. **1/250 second at f4, 12.3mm, 400 ISO. GH**

ON YOUR STREET

We all spend hours out and about on our way to work or to run errands, often plugged into our iPods or talking on the phone, unaware that art is right under our feet or next to us at the bus stop.

There are dozens of interesting subjects to photograph in any street – it's just a matter of actually looking at your environment rather than walking along with your mind elsewhere.

So this project is simply to go for a walk and try to find things that you would not normally notice. Something quite ordinary can become very interesting if you isolate it from its surroundings and you may even find a subject that will start you off on a new series, like John did with his ripped-off posters (see opposite). Go for the sharpest definition and finest quality that you can get in order to achieve really sharp-edged graphic images that have the potential to make posters for your wall. A macro lens is very useful because of its sharpness and it will enable you to make close-up pictures of small, unobtrusive objects. Taking a lightweight tripod along with you is of course the ultimate way of ensuring sharp pictures with no camera shake.

ROAD ART
I started on a series I call road art many years ago, at first taking general shots like this. While they are just lines on the road that we don't even notice until we get a parking fine, they make interesting patterns. **1/90 second at f6.3, 55mm, 400 ISO. GH**

TIGHT CROPPING
When I analysed them on the computer I realized that the most interesting images were much tighter crops, using sections of the shapes. Now we are into something quite different. Here we have two back-to-back 'F' shapes; I see the picture as two duellers about to start pacing away from each other. **1/500 second at f8, 60mm, 400 ISO. GH**

AN OVERHEAD VIEW
This is one of my favourites – in fact I use it as my business logo as it looks good on an envelope label and is very memorable. Street markings usually look best if you position yourself directly above them, without any perspective distortions to spoil their shape. Make sure they are sharp, using a high shutter speed to avoid any camera shake. The colour is often brighter if you wet the road, so if you are setting out with street markings specifically in mind, take a bottle of water. **1/250 second at f6.3, 55mm, 400 ISO. GH**

◀ TORN POSTERS
This is one of a large series that I made from portions of advertising posters that had been ripped off the walls. The graphic designs are formed when the posters are partially torn off (sometimes several posters deep), making an entirely new design from the one that was intended. I used a macro lens for ultimate sharpness and also to get into very small areas if I needed to. **1/125 second at f8, 55mm macro, 400 ISO. JG**

◤ CAFÉ DOOR
As I left a café in Washington, DC, I noticed the reflection of the wall opposite in the glass door panels and liked the way it was split into four images. Stopping the aperture down to f11 held the detail in the door and the wall. **1/200 second at f11, 13.7mm compact camera, 400 ISO. JG**

▼ GRAFFITI
Very colourful walls of graffiti can look good. You could try going a lot closer than this and just get colour and texture, as in the road art shots, to make bright graphic patterns. **1/1000 second at f8, 24mm, 400 ISO. GH**

COMPOSE AND WAIT

The concept of waiting for a moving element to complete your composition is one that has been used by many photographers over the years, including Henri Cartier-Bresson.

The technique is to frame a strong composition that would be greatly enhanced by the inclusion of a focal point and then wait for the focal point to arrive. This is usually a person, vehicle or animal that moves into the space that has been left for it in the composition. You may find this quite difficult to visualize at first because we mainly see things as they are and not as they could be, but, as with everything, practice makes perfect.

For this project, search for a shot that stands as a good picture in its own right, but within it has a vacant space that is crying out for something to complete it as a special photograph. Composing your picture with the camera on a tripod is the best way, because it means that you have your composition fixed; you may have to wait some time for the subject to arrive, but when it does you will be ready to shoot without having to recompose in a hurry. The added ingredient from the photographer is patience. However, if you are not a purist, you can ask a passerby to model for you if what you need doesn't happen by chance.

STRIPED WALL ▶▶
I found this large poster on a wall under a railway bridge. It was quite dark, so I used my tripod to keep the shot composed and steady while I waited for a subject to walk into it. As the poster was high above the pavement, I needed someone tall. The presence of the man who arrived (opposite page), though he occupies just a small space at the bottom of the composition, has transformed what was just a copy of someone else's artwork into my own interpretation of it. **1/60 second at f6.7, 135mm, 400 ISO. GH**

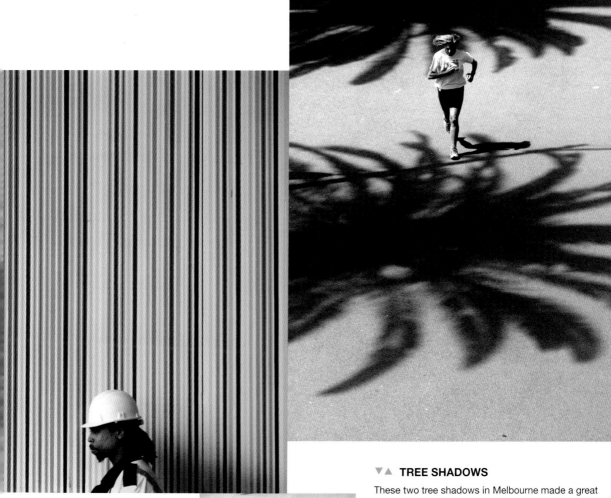

▼▲ TREE SHADOWS

These two tree shadows in Melbourne made a great pattern on the pavement. I thought that adding a figure somewhere in the composition would give it a point of interest. As it was lunchtime and the street was very busy, it took a lot of shots and a long time before I managed to get a single person in the picture, and in the right place as I had envisioned it. While the compose-and-wait technique isn't complicated, it sometimes requires a good deal of patience and maybe fast reflexes at the end – an extra person entering the frame would have spoilt this shot, and you can see that the runner was in between the two shadows for only a split second. Start pushing the shutter button before the figure gets to your allocated spot in the composition. **1/250 second at f8, 95mm, 200 ISO. GH**

THE HIGH STREET

Professional photographers may spend much of their working lives in foreign lands, but while this may sound exciting you will probably be able to find subjects in your local high street that are just as worthy of some good photographs.

We can all become so familiar with our day-to-day surroundings that we don't think of them as interesting, but it's what you make of them photographically that counts.

For this project, do a series of portraits of your local shopkeepers in front of their establishments. The advantage of working locally is that you will have plenty of opportunity to plan each picture, noting the best camera angle, the time of day when the light is right and of course checking with the shopkeepers that they won't mind putting aside a little time for you. If you have trouble stirring up some interest, you only need to find one willing shopkeeper. Make a lovely print of them, then show it to the others and they will probably all agree to pose. Remember that the shop windows will probably be very clean, so take along a polarizing filter to cut out reflections.

With a nice portfolio of local characters, you may well find that a shop or café in your high street will allow you to exhibit the pictures. If they don't want fixings such as picture hooks put into their walls, have your pictures mounted on lightweight foam-core board so that you can attach them to the wall with nothing more than small pieces of Blu-Tack, making sure you remove them carefully afterwards. Laminating your prints with plastic will prevent them from being splashed or stained by grease.

The usual arrangement is that the proprietor takes an agreed percentage of the price of any prints that are sold. Have some cards made to leave at the café in case someone wants to contact you later – and remember to get some publicity in the local press.

▲ **CAFÉ ON THE HIGH STREET**
Here is a shot of a café on my local high street. Neither the light nor the composition make for an interesting picture, so a lot more work was needed. **JG**

◀ BRINGING IN COLOUR AND LIGHT

When I returned on the next fine day, the sun was creating interesting dappled light and we put up the red awning. Owners Suzie and Diega posed with their Vespa and the window in the awning made a lovely frame-within-a-frame for them. However, the playback showed that I needed some more light in the faces and that there was a compositional imbalance. **1/250 second at f8, 30mm, 400 ISO. JG**

ADDING FILL-IN FLASH ▶

Next I used some fill-in flash, checking the camera's playback to see if I needed to increase or reduce the flash to achieve exactly what I wanted – in this case to give more light on their faces while preserving the dappled-light effect. I stood on a two-stepped ladder so that I didn't have to tilt the camera up or down, thereby distorting the verticals, and asked the couple to bring the tray forward to link them together more. I then composed very precisely, using the zoom. Sometimes we happen upon a picture that is all there just waiting for us to push the button, while at other times we have to build one using the existing elements – a satisfying thing to do. **1/250 second at f8 with fill-in flash, 35mm, 400 ISO. JG**

A project on photographing action can be a rather daunting prospect because, obviously, your subjects will be moving fast and if you are not experienced in this form of photography you may feel as if you are always playing catch up, never quite on the ball.

So, in this chapter we shall discuss how you can slow it all down in your head by means of good planning and sensible technique. You will also find out how to freeze moving figures with fast shutter speeds and discover the poetry of action on slow shutter speeds.

Don't be intimidated by the fantastic sports photographs that you see in the national press and sports magazines. These are taken by photographers who are specialists, working only in that genre. They have very expensive equipment indeed, know the sports well enough to predict what might happen and which shots will capture the spirit of the game or race, and sometimes take weeks planning just one shot.

Action photography is not only about sport itself – a small action can tell a big story too, showing the personalities behind the excitement. A hand gesture or the flash of a smile from a sportsman or woman can be worth a thousand words.

HORSES AT DAWN (previous page)
The Household Cavalry exercising their horses at dawn in London's Hyde Park is always a stirring sight. This was a very foggy morning, adding a sense of mystery. To make the scene even more impressionistic, I used a slow shutter speed and panned the camera as they moved past.
1/4 second at f8, 50mm, 400 ISO. GH

BOWLING ▶

This was taken with an old 300mm manual focus lens (equivalent to 450mm on my DSLR). I used a tripod as I didn't need to move the camera and pre-focused on the bowler when he was standing in the delivery position measuring out his run up. I had to take several shots to get him in position just behind the stumps. **1/2000 second at f5.6, 300mm, 400 ISO. GH**

MARATHON RUNNER

This man giving it his all was running in the London Marathon. I zoomed the lens to 200mm to isolate him from the others and capture his determination. A shutter speed of 1/800 second froze him enough to see all the detail. **1/800 second at f6.7, 200mm, 200 ISO. GH**

RUNNING AND RACING

While we can't all photograph the Olympics, the acme of competitive sports, most cities in the world have public sporting events such as cycle races, marathons, triathlons and so forth where you can take the same kind of pictures as are shown here.

Arrive early and check out your options so that you can judge where the best place is to take up position – if you just turn up and think yourself lucky to find a spot that is relatively uncrowded, this may be for the very good reason that there's not much crucial action to be seen from there.

The main problem at sports events is getting shots without spectators' heads blocking the camera. A lightweight two-tread folding stepladder will lift you just high enough to solve this. Ideally, find yourself a place beside a post of some kind, then wrap your arm around it when you get up on the ladder – this gives you good stability and a solid place to shoot from. You will still able to move around to another vantage point, taking your ladder with you.

For this project, go to a sports event and shoot it in two ways. First, pan the camera with the action using three different shutter speeds. Try 1/30, 1/125 and 1/500 second to get three different pan effects. Next, use the same shutter speeds again but this time keep the camera still. Analyse your photographs afterwards, noting which best convey the speed and excitement of the event and how you might take this further.

This is the perfect project for using the continuous shooting mode on your camera as it will shoot a few frames in rapid succession. Don't forget to set the autofocus to continuous as well.

◀ **TAKING EXPRESSIVE SHOTS**

My position near a corner was perfect as I could see part of the road this competitor was painfully travelling along during the London Marathon. I was close to the end of the course, which turned out to be a good place to capture the drama of the event. The frozen image shows us something that our naked eye can't see – the muscle definition and her facial expression showing the pain that she is going through. **1/200 second at f6.7, 200mm, 400 ISO. GH**

CROPPING FOR EFFECT ▶

I took many shots of the London Marathon characters in fancy dress. It's good to see the Devil struggling to get to the finish line for a change. I liked the bold colours in this shot and cropped in tight to squeeze the Devil and make it more difficult for him to finish. My telephoto zoom lens was ideal to capture the runners coming towards me; I was able to keep them in the frame by zooming back from 200 to 80mm. **1/320 second at f6.7, 200mm, 400 ISO. GH**

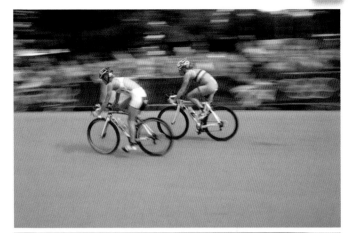

BLURRING THE BACKGROUND ▷

Taken at the woman's triathlon at the London Olympic Games, this photograph is as I shot it, with no post-production work. I panned with the bikes, using 1/30 second, as I didn't want them to be too sharp. The slight blur of the bikes gives a feeling of speed, and the panning made the background completely blurred.
1/30 second at f16, 18mm, 200 ISO. GH

CROPPING AND ROTATING ◁

When I came to crop and enlarge the action I was reminded just how creative cropping can be. By rotating the crop in either direction I could give a totally different feeling to the picture. The riders could either be struggling uphill or having a rest freewheeling downhill.

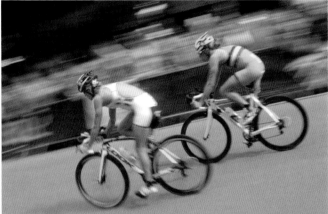

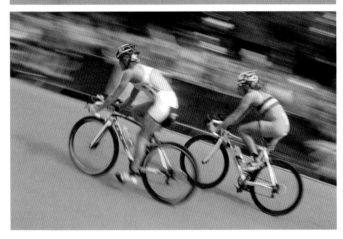

TEAM GAMES

You may never be on the sidelines of a major sporting event, but you do have the chance to shoot at local events, children's sports days and so forth.

No matter how casual and amateurish these events may be, it is most important that you first ask permission of whoever is in charge, checking whether you can shoot from the sidelines and if so from how close. A pushy photographer can be upsetting and disruptive at all times, and at children's events in particular you need to establish that you have observed the formalities.

The better you know the sport, the better you will be able to anticipate the action highlights. This is vital, as you need to be pushing the shutter release button a fraction before the peak action. If you see the action in the viewfinder, it is too late – the picture has gone by the time your finger triggers the shutter.

Your assignment here is to take some pictures at a local team-game event, such as a football match, village cricket or school sports – choose your favourite sport, then you will be starting with a big advantage. Take lots of pictures, since the only way you will ever reach the stage of taking really good sports shots is to practise, shooting at every opportunity you get. You will improve in leaps and bounds as your planning, anticipation and reflexes improve. Shooting a lot at each event also means you get into rhythm with the sport and that is when it all comes together. Get there well before time so that you can plan where the best vantage points will be – and always take an extra charged battery in case you run out.

Try to make as many different pictures in and around one sport as you can so that all together they tell a story about the team. You will probably need to get to know some of the people involved to gain access, but everybody will get a kick out of seeing the picture story – and some of the players will probably buy prints from you, which will pay some of your expenses.

◀ **CAPTURING GROUP ACTION**
This action picture, shot from the sideline, captures the concentration of the players in an American women's soccer game, one of the teams being from Gettysburg College. They are poised for a goal kick that has not reached them yet, and the front three players are preparing to contest a header. You can find fantastic compositions with group shots like this. **1/500 second at f11, 200mm, 640 ISO. JG**

◀ **ANTICIPATING THE SHOT**
The goalie is making a good save here. This isn't a difficult action shot because you can frame on the goalie, set the autofocus on continuous and wait for the ball to arrive. The recent improvement in autofocus has made action photography much easier than it was years ago. **1/400 second at f6.3, 62mm, 640 ISO. JG**

◀ THE GROUP PORTRAIT

A team portrait is often required, and it is very difficult to make a group portrait where everybody looks good. I took 12 frames of the Gettysburg College women's soccer team and even then only got one that I felt all those in the picture would be happy with. I set myself up on a table with my tripod, so that the high angle made all the girls look up at the camera. This means you get good light on the faces and you can see each one clearly; no one is hidden behind another player, as you find when shooting from ground level. Your main job is to throw yourself into the spirit of the picture to entertain the team so that you keep their attention on you and they keep smiling. Once you lose the attention of a group it's very difficult to get it back. **1/80 second at f8, 22mm, 400 ISO. JG**

◀ THE INSIDER SHOT

My son Matt is the coach for this team, and here he is working in the rain. The insider sports pictures can be as interesting as the action shots. In a situation like this, remember that it is your hobby but the coach's profession, so take a couple of pictures quickly and then get out of the way so that everybody can concentrate. **1/50 second at f5.6, 25 mm, 800 ISO. JG**

◀ CROPPING AND ENLARGING

I took this picture a long way from the action and the players leaping for the header were small in the frame. This crop represents only about one-third of the picture area so it is a bit grainy, but I like it because it has a really competitive edge to it. These girls are great athletes, and I wanted to make that point. I also like the big G for Gettysburg in the background. If you see a good piece of action grab it, no matter how small it is in the viewfinder. The grain often adds some gritty atmosphere to an action picture. **1/250 second at f5.6, 180mm, 1000 ISO. JG**

▲ INTERPRETING THE GAME

Here the player has the ball well placed to the outside of her foot and is looking up to find the perfect pass, the sort of picture a coach loves. The better you know a sport the better interpretation you will make of the subtle technical aspects of the game, and that is very satisfying. **1/500 second at f8, 120mm, 650 ISO. JG**

▲ FREEZING THE ACTION

You don't need to capture the ball in all the shots. The striker had just kicked the ball and that doesn't appear in the picture, but what you do see is just how balletic football can be. It may be only when you freeze a sporting action that you appreciate how athletic the players are. **1/1500 second at f8, 112mm, 400 ISO. GH**

USING MANUAL FOCUS ▶

Behind the net is a great place to find some action. You have to be quick because you are so close to the players, but reaction time is not the only thing of importance here; if you shoot on autofocus you will find the net rather than the players is sharp. The solution is to set the lens to manual focus, choose a spot on the ground where the action will happen and pre-focus on it. If you want to keep both the net and the players in focus, stop down to a small aperture for a greater depth of field, upping the ISO if necessary to keep your shutter speed fast. **1/350 second at f13, 32mm, 400 ISO. GH**

▼ SHOWING THE SPIRIT OF THE GAME

This picture captures the intense competitiveness of the players, both determined to get to the ball first. This was shot with the autofocus on continuous. From a compositional point of view, the parallel legs and arms make a great shape. **1/1000 second at f5.6, 200mm, 400 ISO. GH**

 QUICK TIPS

- Before you shoot an event, look through the sports pages in newspapers to discover the best vantage point. Note the most interesting shots, which may not always be of the action – they could be of the expressions on the players' faces.

- You will probably be using fast shutter speeds. If you have insufficient light, try increasing your ISO speed from, say, 200 to 800 – that will allow you to increase shutter speed by 2 stops.

FROZEN ACTION

When you freeze fast action, the resulting photographs show you things that the human eye cannot register because they occur too fast.

It is a fascinating area to work in, discovering a world you have not seen before. A classic early example is the study of a galloping horse by Eadweard Muybridge (1830–1904), which showed its true gait and brought an end to the rocking-horse style of motion that artists had always depicted.

To explore this world of frozen action, you will obviously have to work with fast shutter speeds – but just how fast depends upon the speed at which the subject is moving, and whether it's coming towards or across the camera. If you're having trouble getting a high enough shutter speed even with your aperture wide open, increase the ISO speed until you reach the required result.

For this project we want you to shoot an athlete or an animal in action with shutter speeds sufficiently high that you freeze the action to enable you to see every sinew and muscle. Then try a nature shot, freezing moving water such as a waterfall or even a large splash, and find the shapes that the frozen water drops make that are impossible to see with the naked eye.

◀ **TOWARDS THE CAMERA**
Because my dogs were running towards the camera I needed a shutter speed of only 1/250 second to hold the front one pretty sharp; if they had been running across the camera 1/500 or even 1/1000 second would have been required. I didn't trust the autofocus to keep up with the action so I pre-focused on a spot, locked the focus and shot when they ran into the area.
1/250 second at f11, 200mm, 400 ISO film. JG

▲ **DIRECTING THE SHOT**
I asked the swimmers to leap up from underwater and used a 1/4000 second shutter speed to freeze the water. The shape of the splash and the individual drops of water could never be seen with the naked eye.
1/4000 second at f11, 70mm, 200 ISO. JG

ANTICIPATING CONFRONTATION ▶
Calcio Storico is an ancient football game, played in Florence since the Renaissance. It's very violent; I shot this picture as the green player was about to be punched in the guts. This action needed to be anticipated and frozen to show the explosive moment.
1/1000 second at f5.6, 160mm, 400 ISO. JG

When you use a slow shutter speed on an action shot the blurred movement that you capture also shows you action that is invisible to the naked eye, but this time it is in the form of the shape that the blur describes.

4

BLURRED ACTION

There are two ways of photographing action using a slow shutter speed: keeping the camera still, focused on a moving subject, or following a moving subject with the camera and so blurring any object that is stationary (see page 22).

This project is about the first method, using subject movement. Find a swing – or something similar in that it moves past you at a fairly constant speed – and photograph it with a variety of shutter speeds, starting at 1 second and progressing to 1/1000 second. You will learn from this what shutter speed is required for blur to show. It is important to note that the expression 'slow shutter speed' is a relative term, as the shutter speed's ability to freeze a movement is largely dependent on the speed of the moving object – for example 1/125 second would be a slow shutter speed if the object were a racing car, but for a baby crawling past the camera it would be a fast shutter speed that would freeze the action.

◄ SLOW SHUTTER SPEED

This boat caught me by surprise and I had time for only one shot. The camera was set to aperture priority mode at f6.7 and the corresponding shutter speed was 1/10 second, since the light levels were low. The blur gives a feeling of movement without obscuring the subject. **1/10 second at f6.7, 120mm, 400 ISO. GH**

▼ KEEPING THE BACKGROUND SHARP

Here, I wanted to feature the crowd, flags and Olympic logo while still giving an interpretation of the cycling event. I set the lens to manual focus on the background as the autofocus would have shifted to the bikes as they came past. I chose 1/100 second so that the background would be sharp but the speed would be slow enough for the bikes to blur in the foreground. **1/100 second at f13, 32mm, 400 ISO. GH**

BLUR FOR CONTRAST ◢

Seen from my window, the snow had isolated the hedge and gate into a great graphic shape. This was a classic 'compose and wait' shot. I put the camera on a tripod, opened the window and waited. A shutter speed of 1/15 second recorded just enough movement to contrast with the sharpness of the foreground. The image is blue-toned in Lightroom to give a wintery look. **1/15 second at f4.2, 38mm, 400 ISO. GH**

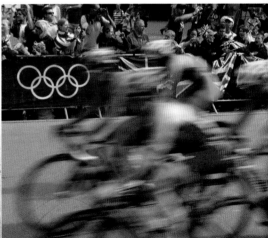

PANNED ACTION

Panning is the classic alternative method of capturing action used by sports photographers for many years. By following a moving object with the camera – panning – you can keep the subject sharp and blur anything that is stationary.

Your choice of shutter speed will depend on the speed of the subject you are panning with and whether you want the subject sharp or with some blur. This panning technique does take practice, as you will find it difficult at first to get your pan at the same relative speed as the subject – it's easy to either get ahead of it or find it disappearing out of the frame as you try to catch up with it.

The important technique that you need to practise is to achieve a smooth sweeping movement rather than a jerky one, and that will come as you get into rhythm with the subject. Stand at the side of a busy road and try some panning on the cars going past, using a variety of shutter speeds. When you download the pictures you will be able to see how different shutter speeds affect the background blur and sharpness of the moving cars.

▲ **SLOW SHUTTER SPEED**
Using a slow shutter speed and panning the camera when the chicken ran past has given a great feeling of speed. A higher shutter setting would have made the chicken more sharp, but the background wouldn't have been as blurred. In a shot like this it usually makes compositional sense to leave room in front so that the subject has a space to run into. **1/15 second at f8, 50mm, 200 ISO. GH**

◀ **PANNING FAST ACTION**
This shot was taken at a motorbike hill climb. It was a very wet day, and even though I covered the camera with a clear plastic bag, I had to wipe the camera and lens frequently to keep them reasonably dry. I set the camera on continuous autofocus, framed the bike in the viewfinder halfway up the hill, then panned the camera with the bike as it came past me. A shutter speed of 1/180 second held detail in the bike but still gave enough blur to add the feeling of speed. **1/180 second at f4.8, 80mm, 400 ISO. GH**

Action photography is often assumed to be all about sports and other high-speed activities full of excitement, but this is far from the truth; some of the greatest pictures are about capturing a minimal action that might be missed altogether by many viewers.

Two pairs of eyes meeting, a handshake and so on can transform an ordinary picture into something special. The great reportage photographers captured these small actions, resulting in pictures that were often of historical significance. It was the ability to pull this off that made photographers such as Henri Cartier-Bresson, Eugene Smith and Robert Capa such major figures.

While it may seem easy in comparison to tackling cars and people at speed, you may in fact find this the trickiest project in the action chapter. Look for a situation in which two or more people are in conversation or relating to each other in other ways and try to make a picture in which you capture a small gesture that will create a story. As with other action photography, anticipation will help you here.

MINIMAL ACTION

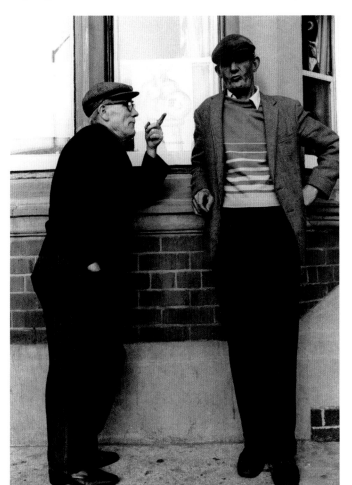

 THE ARGUMENT
Two old pals are shown here having a heated discussion outside a pub. It is that small action of the pointing finger that makes the picture. If you are aware that a picture needs that little something to happen, you can stay on your toes and wait for it. I got just the one frame and then they wanted to pose for portraits. **1/250 second at f8, 30mm, 400 ISO film. JG**

Most of us are familiar with the still life genre from paintings. Photography is not disparate from other forms of visual art, and when you are learning how to handle a subject such as this it's well worth looking at how artists over the centuries have approached it.

These days, you don't have to travel further than your computer to view the collections of the world's art galleries, so spend some time looking analytically at great works in the genre. The Google Art Project is a particularly rich source.

One of the great pleasures of still life photography is that you can take your time and be very relaxed about it. In the professional world, it tends to be regarded as a specialist subject that photographers devote their whole careers to; spending long periods of time rearranging inanimate objects is not everyone's cup of tea, but those who do like the quiet, contemplative discovery of the perfect composition of their chosen objects find it an endlessly rewarding genre.

Of course, still life is not confined to shooting objects in the studio – wherever we go we have a huge choice of subjects to shoot *au naturel* or to arrange to our heart's content. In this chapter we shall be discussing the selection of subject matter and composition and finding surprises by going very close up. The great thing about still life is that if you are not happy with the first shots you have got, you can rephotograph the same composition or change it as many times as you like.

PRESSED FLOWERS (previous page)
This picture of flowers photographed on a light box is from a series I have been working on for several years. The flowers are pressed between blotting paper under a heavy weight and once dry they are ready to shoot. I laid a piece of tissue paper between the flowers and the light box to add some texture to the background. This photograph reminds me of the paintings of Joan Miró. **1/10 second at f8, 55mm macro, 200 ISO, GH**

▲ CUTLERY

This photograph was taken at an auction of kitchenware – I was lucky with the composition and just shot it as I found it. I like the way the eye is drawn along the handle to the void of the ladle bowl. It was shot on black and white film then scanned into the computer, where I burned around the top and sides to remove the detail of the cutlery box. It could equally well have been shot digitally, converted to black and white and then given some film grain effect. **1/125 second at f8, 28mm, 400 ISO film. GH**

FISH ON DISPLAY

I found this fish picture in a market in Vienna. It was just a matter of selecting a composition that pleased me and shooting away. Most found still life comes down to the 'seek and you will find' philosophy rather than technique, and markets are a rewarding place to do your seeking. **1/50 second at f8, 105mm, 500 ISO. JG**

JEWELLERY

Shooting jewellery, whether it is for a jeweller, for your own insurance inventory or just for aesthetic pleasure, can be a very satisfying still life project.

Dust is the still life photographer's worst enemy, particularly in the case of jewellery. Make sure the item is carefully cleaned and brushed before you shoot it; if it has polished surfaces you will need to wear gloves or use a cloth to move it around to avoid your fingerprints appearing on it.

Backgrounds are vitally important. Keep them simple, just black, grey or white, unless you have a colour that especially complements the piece you are shooting. Be careful of textured and patterned backgrounds, since once the photograph is enlarged they will be very dominant in the picture.

The lighting can be quite simple, but you will need to use a studio flash – your camera flash can only supply direct front light, which will not flatter the jewellery at all. For best results use a macro lens that will focus very close, or add a close-up supplementary filter to the front of your camera lens. You will need to close the aperture down to about f16 if you wish the whole item to be sharp and set a low ISO of 200–400 to produce the best noise-free quality. Even with all your care there will probably be a little retouching to do to make the image perfect.

ACCESSORIES

You need a few accessories for shooting jewellery or similar items. They are: a brush, or better still a blower brush, and a lint-free polishing cloth (a microfibre lens cloth is great); a magnifying glass to check that you have cleaned the jewellery sufficiently; and Blu-Tack to hold objects in place. A ring standing up is the hardest thing in this respect – a tiny piece under the ring will usually hold it, though you may have to retouch any visible bits later.

Because you are backlighting the subject, in most cases you will need some small reflectors to fill in shade and add some highlights. I use pieces of white and silver card, or small mirrors to add a sparkle to gemstones. Tilt them back and fasten them to small blocks of wood with Blu Tack, then move them around until they reflect the light back onto the subject.

▼ **FLASH SET-UP**

This is my standard set-up, using one studio flash and a soft box to spread and diffuse the light around the jewellery. The light is positioned over the top and to the back of the item being photographed. This backlights the subject and gives great highlights over the surfaces. The studio flash head has an incandescent light bulb incorporated so that you can see exactly how the light falls to set up the shot. Alternatively, you could use a flash gun or desk lamp behind a diffuser or sheet of tracing paper. Place it far enough from the diffuser to light its whole surface. You can hand-hold the camera when you are using flash as it fires at a very high speed. **GH**

LIGHTING FROM THE SIDE ▶

Occasionally a backlight over the top of the jewellery will not bring out the best in a piece. The light reflecting off these stones washed out the colour, so I turned the brooch and the camera 90 degrees clockwise. The bright highlights show that the light is now on the left, and the colour of the stones is stronger. I added a white reflector to the left and bottom to highlight the gold edge. All the jewellery pieces shown here are by the renowned London jeweller Barbara Christie. **1/125 second with flash at f11, 55mm macro, 200 ISO. GH**

▲ USING A WHITE BACKGROUND

These earrings were shot on a white paper background; I secured the posts to it with Blu-Tack to stop them falling over. The grey at the top is produced by throwing a shadow on the background. A piece of black card on the background at the back of the jewellery does this job. Give it some form of support (I use a chemistry retort stand) and move it around until the shadow looks right. Brush off any dust that has fallen on the background before you shoot. **1/125 second with flash at f13.5, 55mm macro, 200 ISO. GH**

◀ EQUIPMENT

This is my own accessory kit. None of the items is expensive, and you will be hard pushed to get satisfactory shots without them. **GH**

◀ WINDOW SET-UP

This is an alternative way to create a light similar to the flash set-up. Cover a window (the bottom half of a large window would be sufficient) with diffusing material. I have used white plain voile net curtain fabric here, but you could also tape white tissue or tracing paper into place. With window light, and also with a desk lamp, you will definitely need to use a tripod. With the aperture closed down to around f16 you will have a slow shutter speed, and any camera movement will blur the jewellery. **GH**

▲ SELECTING THE SURFACE

This necklace was shot on a sheet of smooth matt black plastic. If you want a reflective surface, use glossy card or plastic – or you can cover any surface with a sheet of clear acetate, but adding more surfaces risks more dust. Depending on your camera angle you may get the top light reflected on the surface, which can be either good or bad, depending on the subject. I used two pieces of A5 white card, one each side of the lens and about 20cm (8in) from the necklace, to reflect some light back into the front of it. If you want brighter reflections, cover the card with silver foil. **1/125 second with flash at f16, 55mm macro, 200 ISO. GH**

WOODEN FIGURES

The photographs shown here are from an assignment I did for an exhibition catalogue of sculptures dating from 1890 to 1920. They are carvings made by Africans, many of them showing their colonial masters, and my client wanted something different from the usual catalogue illustrations.

I found these figures fascinating. I began by trying to shoot them as still life artefacts, using classic lighting, but as I got to know them I decided to take portraits. Just as with human portraits, the longer I spent with these little folk, just 6–35 cm (2½–14in) high, the better I got to know their personalities. It was an unusual assignment for me, but I learnt a lot as I went along – and so will you, as your experience with still life grows.

You may not have African sculptures like these in your home but the assignment is mainly about lighting, so you could use any small objects, figurines, vases or other items borrowed from family or friends. As in these pictures, try different light sources and varying angles to make the object important. You will find this project very useful if you are in the habit of photographing objects for sale online, since the better you can make them look the better your sales are likely to be.

FRONT VIEW ▶

This carving of two figures on the same base was an obvious front-on double shot, but they look rather boring and the detailed carving in the clothing is not evident. It was shot in window light, with a spotlight on the lower area of the background. **1/2 second at f8, 35mm, 200 ISO. JG**

PROFILE VIEW ▶

I turned them into a profile view and instead of being two sculptures they became one, with the detail in the costumes showing to good effect. I added a small floodlight to front-light them (a desk lamp would have done the job, too). **1/2 second at f8, 130mm, 200 ISO. JG**

▲ NATURAL LIGHT

In search of a more dramatic interpretation I turned off the light and used just window light. I played with the colour in Lightroom until I was pleased with the results – sometimes it's just a matter of experimenting until you find a look you like. This image works well for me: it is a unified portrait, it is strong and it shows off the work of the sculptor. **1/2 second at f9, 130mm, 200 ISO. JG**

◄ FINDING DIFFERENT ANGLES

This little character had the look of an officious minor district officer. I shot looking down on him – it's very interesting to see the difference the camera angle makes to the conferred status of the person. I sprayed colour on the background and used a strong little spotlight. I tried shooting from other angles but this one works for me. **1/3 second at f8, 29mm, 200 ISO. JG**

◄ COMBINED LIGHTING

This needed to be a profile portrait to show the chair and desk. The figure is lit by the window light; I threw a spotlight onto the background and later increased the spot effect using the vignetting tool in Lightroom. I manipulated the colour in Lightroom using the Antique Grey preset. **1/10 second at f5.6, 120mm, 200 ISO. JG**

▼ SINGLE SPOTLIGHT

Here I used a spotlight and a black background. It is a simple portrait, but it breathes some life into his wooden face. You can also get this effect with a desk lamp or a strong focusable torch. **1/25 second at f5.6, 200mm, 200 ISO. JG**

◄ SILHOUETTED PROFILE VIEW

This one has a face with the same distinctive appearance as the seated figure and I decided to emphasize the great shape of his profile. I lit him with window light but held a black card just out of shot in front of his face to make sure that no light bounced back and spoiled his beautiful profile. I shone a torch onto the background to silhouette the dark part of his face. There was no need for any post-production work; this shot shows what successful effects you can get with minimal equipment and very simple lighting. **1/20 second at f5.6, 200mm, 200 ISO. JG**

COPY OF AN OLD MASTER

The Silver Goblet, painted in 1768, is by Jean-Baptiste-Siméon Chardin, one of my favourite painters of still lifes. Here I have set up my own version of his arrangement and photographed it, giving it a similar treatment. The composition is quite simple, so not very difficult to reproduce.

This project is invaluable because it will teach you to really study and analyse a picture, which you will then carry over to your own still lifes. You need to work out the viewpoint for the camera, what and where the light source is, and the colours and textures in the subjects and background.

First find a picture that you like, keeping it simple for your first attempt. Make a list of the props you will need – in my case, a goblet, three apples, a bowl, a spoon and two chestnuts. Work out how you will represent the background and analyse where the light falls, noting whether the lighting is contrasty or soft. If the artist's viewpoint is close to the subject you will need to use a wide-angle lens; if it is further back, a telephoto of appropriate length. Have fun doing this project and don't rush it.

▲ **THE BACKGROUND AND SURFACE**
As with most still lifes, the background here is as important as the subject itself. In the original, the table top and foreground are a warm colour and the background cooler. I bought two sheets of art paper and tried to match the colours to the painting, using pastels and smudging them with cotton wool to mimic the texture. I applied white pastel, smudged, to produce the highlights around the fruit and goblet. **GH**

◄ **THE ORIGINAL PAINTING**
My inspiration was *The Silver Goblet* by the French artist Jean-Baptiste-Siméon Chardin (1699–1779). **GH**

THE FINISHED SHOT

I had a bowl and spoon of similar shapes and borrowed the goblet, which is actually a pewter tankard – I turned the handle to the back to hide it. A trip to the market gave me the apples and chestnuts, then it was a matter of moving things around until they matched the painting. Blu-Tack is great to hold things where you want them, and I used it to stop the apples from rolling out of place. You will need to do a number of shots of your own still life and check them carefully against your original to get the look just right. After the shoot I worked on the image in Photoshop, using the Dodge and Burn tools to get the highlights and shadows looking like the original. The picture looked too sharp, so I softened it a little with the Smudge Stick filter and added some texture with the Craquelure filter.
1/4 second at f5.6, 55mm, 200 ISO. GH

STUDIO SET-UP

I hung some net curtain over the window to diffuse the light, as the original is fairly soft, with no strong shadows. The background is a sheet of card propped up, and I added another sheet to the left that blocks the light to produce the shade on the left of the background. The piece of natural-coloured card on the right acted as a reflector to soften the shadows a little. I set the camera on a tripod, just above the height of the table, with a short telephoto setting to match the look of the original. **GH**

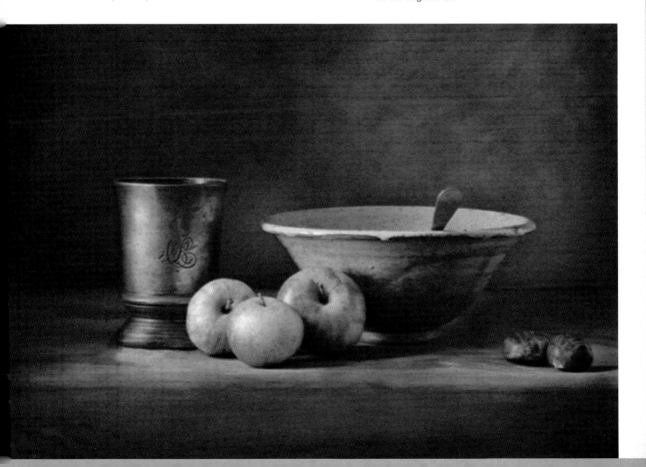

FOUND OBJECTS

Photographing found objects is one of the most pleasing forms of photography; there is something very satisfying in taking an everyday item and transforming it into a piece of art.

It is a matter of finding the right object, which can be anything that amuses or inspires you, working out the background and lighting that complement it, then allowing plenty of time to play around and create something new.

So, for this project, look for objects that you like and make a picture of them in the location where you found them. Then take them back home and shoot them singly or grouped together without the clutter that probably surrounded them on location, concentrating on their pure shape and essence. Switch on your light source, but don't worry too much about its position at this stage – just sit there and play around with the objects until you have a pleasing shape. This may take a while, but it is worth spending time on as composition is a big part of a successful still life. Then put the camera on a tripod, set your zoom to 50mm to begin with, and fine tune your composition in the viewfinder.

If you enjoy your found object shoot, start making a collection of items that strike you as interesting, even if you cannot think what to do with them for the time being. I am always on the look out for likely objects, some of which lie around for years until I come up with a way to shoot them. Putting things aside until an idea of how to treat them floats into your mind is part of the creative process for a visual artist in any medium.

 SHELLS SET-UP
There is no need to worry that lack of equipment will prevent you from producing first-class results. This set-up is simple – a desk lamp for the light source, a small corner set made from three pieces of card taped together and a camera; that's it. I smudged a little pastel on the walls and floor of the set to give a bit of soft texture. Then it was time to organize my subjects. **GH**

 SHELLS COMPOSITION AND LIGHTING
It's helpful to have a starting point for the composition. I often base a nature still life on family groups; only one 'child' in this shot, or maybe two. Here I pushed the two rear shells together to close the gap between them then added the small one, pulling it forward a bit to fill in the space between the others. Next I moved the light around and decided that light coming from the right suited the shape of the shells. I positioned it so that the right wall had a slight shadow on it while the left wall acted as a reflector, bouncing some light back to soften the shadow. I wanted the background soft, so I focused on the front of the shells and used a wide aperture. **1/60 second at f5.6, 50mm, 400 ISO. GH**

BARK SIMPSON

I'm always on the lookout for unusual and amusing things to photograph. I found 'Bark Simpson' in the park, just lying on the path. When I got home I photographed him on a piece of smudged paper, using just window light. **1/2 second at f11, 55mm macro, 400 ISO. GH**

BARK SIMPSON ENHANCED

I couldn't resist playing with this shot and taking it a bit further. I changed the colour of the bark to yellow, using the Hue tool in Hue/ Saturation, and added the eye and teeth. While still lifes have been the subject for many of the greatest names in photography there is no need to treat the whole genre with reverence – have fun, too. **GH**

FOUND OBJECT ▶

The shot of the can as I found it is good but ordinary – it is a piece of rubbish you would not even notice as you walked past. **1/250 second at f8, 70mm, 400 ISO. GH**

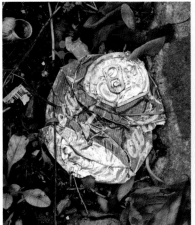

◀ USING STRONG SHADOW

This shot is unusual because of the way the background is arranged. It was shot in direct sunlight shining through a window. At first I placed the leaf on a piece of white paper, but the shadow was not big enough so I lifted the leaf higher. That was better but a bit ordinary, so I played around with it and found a better way: I folded the piece of paper in half then opened it and laid it on the floor with the crease uppermost. I then balanced the leaf on the apex of the fold. The sun lit one side and threw the other side into shadow. **1/125 second at f11, 55mm macro, 200 ISO. GH**

▲ NATURAL LIGHT ON WHITE

I took the can home and shot it very simply, on a piece of white paper with the window light from the side to cast a shadow. This has transformed a piece of rubbish into an item of beauty, a piece of Pop Art for the wall. **1/2 second at f8, 55mm macro, 400 ISO. GH**

STUDIO FOOD

Food is the new art form and chefs are the new superstars. Most of us have at least a few beautifully photographed cookbooks, and some of us have shelves of them.

Consequently, food photography has become a genre in its own right. You might like to have a go at this area of still life; it is an interesting one because you have lovely shapes and colours to work with.

As with every other theme, food photography has changed style as food fashion has moved on. Historically, food was shot on large format cameras producing 10 x 8in transparencies, using studio flash; now, most of the beautiful illustrations we see are shot on digital and a great many of them use daylight.

The professional photographer has the great advantage of having a food stylist to prepare and arrange the food, but you can do it yourself. Find a picture that you like and have a go at making a version of it. Take care over it and find some props to complement the food. Alternatively, we have provided a couple of simple food shoots you could try. Remember that the food must look so delicious you want to eat it off the page. That's down to lighting, the freshness of the food and the colour and arrangement of the various elements of the dish.

▲ **BASIC SET-UP**

This is a good basic set-up for food photography, using a large window with a voile curtain in front of it to act as a diffuser. There are many ways to light food, of course, but this gives good backlight to provide a three-dimensional look with highlights on the top and shadows at the front. A small LED video light has also been used to add extra highlights and give it a sparkle. You may need to use a reflector at the front to lighten any dark shadows. **GH**

◄ **MACKEREL PÂTÉ**

This mackerel pâté is a simple shot using daylight. Make sure the food is freshly prepared and any garnish, such as the celery leaves here, are added just before you shoot so they don't wilt and look tired. Set your camera on a tripod and get all your props arranged and the picture composed before bringing on the food.
1/30 second at f6.7, 55mm, 400 ISO. GH

TANGERINE SORBET ▷

The tangerine sorbet has been lit with daylight from a window at the back, with a silver reflector in front to lighten the shadows. The background is four paper fans. I chose the colours of the cups, plate and background to contrast with the sorbet and make it stand out. **1/15 second at f11, 55mm, 400 ISO. GH**

▽ LOBSTER

A single spotlight was used for this lobster, but you could use a desk light or an LED light instead. A gold foil reflector at the front has lightened the shadows and added warmth. The green chives tied around the claws give some contrasting colour and the lobster has been sprayed with water to make it look fresh and glistening. **1/8 second at f1, 55mm, 400 ISO. GH**

FOUND FOOD

For many people on holiday, the enjoyment of encountering different types of food is as important as seeing the landscapes and architecture.

Much of this food can be found in local markets and street cafés. We have taken countless market pictures over the years and still cannot resist shooting away at a beautiful display of exotic fruit or vegetables.

This project is designed to make sure that you come back from your next holiday with lovely food shots. They may be of a table setting or a market display – anything that has that feelgood thing going on to remind you of the holiday.

In a restaurant, don't just snap away at the food when it arrives in front of you and leave it at that; look carefully at what is on the plate and turn it around to see if the arrangement of the food looks better from another side. Try to find a place on the table where the light makes the food look delicious and use some of the table props, such as cutlery or a wine glass, to make it more of a still life than just a plate of food. If you have a smartphone, that will be ideal for capturing a memory of a great meal that you had along the way.

▲ COMPOSING A STILL LIFE
I added the butter dish and wine bottle for some colour. This shot is not really about food, of course – it's about the juxtaposition of shapes and the backlight coming through the window. **1/500 second at f11, 42mm, 500 ISO. JG**

THE RECORD SHOT ▷
I really do have a thing about taking still life pictures of my food in restaurants – they remind me of the meals that I have enjoyed. This first shot shows all the elements exactly as they were when I looked down in front of me – quite nice, but I thought some additions were needed. **JG**

▲ THE FIRST SHOT

These baby pumpkins were on display at a farm in Pennsylvania. This picture was my first reaction to them. It is decent enough, but there is no contribution from the photographer. **1/90 second at f8, 60mm, 400 ISO. JG**

ARRANGING A PATTERN ▶

With the permission of the farmer, I played around with the pumpkins, placing them with the stalks pointing inwards to make a pattern. I then added the white one. This was an improvement. I changed to a wide-angle lens, which was an important final decision as the exaggerated perspective, making the pumpkins large at the front and small at the back, adds to the interest of the picture. **1/90 second at f8, 25mm, 400 ISO. JG**

PORTRAITS

According to research, 80 per cent of our digital pictures in the 21st century are of each other. In the very early days of photography the Victorians too were portrait mad, though they were limited to formal photographs from professional photographers or amateurs who had the leisure and affluence needed for expensive pastimes.

Until film arrived in the late 19th century, paper, copper and glass plate negatives coated with light-sensitive material required long exposures of up to three minutes – a long time for the subjects to keep absolutely still. Because of that, their studied, often beautiful portraits give the impression of a very serious-minded era.

Now we can snap away endlessly and although snaps are fun, in this chapter we discuss the art of beautiful portraits, both informal and formal. While it's great to have shots of friends and family caught in action in their daily life, using our lightweight modern cameras and smartphones, the tradition of formal portraits, carefully thought out and posed, shows no sign of waning. What both have in common is that communication between subject and photographer is vital to success.

The face that we see, however briefly, is evidence of the subject's journey through life. The lines in the face of an old person have largely been earned by their habitual expressions; tension in the hands and body language betrays what is going on beneath the surface. Great portraitists have learned observational skills to a very high level to enable them to capture the essence of the people they photograph. Observation and communication skills are the areas to work hardest on in portraiture – expert technique alone won't be enough here.

▲ **TRAIN DRIVER**

When this perfect little steam train came to a halt at the station the engineer stood up, making a charming portrait towering above it. The light was that very sympathetic portrait light – bright overcast. Black and white felt appropriate for the atmosphere of bygone days. I cropped the photograph almost square later and gave it a slight sepia tone in Lightroom. **1/250 second at f11, 100mm, 400 ISO. JG**

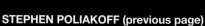

PERCY

This portrait of legendary athletics coach Percy Cerutty came from one of my first commercial sessions and remains one of my favourites. The profile view is often neglected in portraiture, which is a mistake as it can be just as revealing about the person as a full-face shot. I was very lucky with the daylight, and I was wearing a white T-shirt that has reflected the light back into the side of his face, giving a perfect balance with the light on his profile. The low camera angle gives the image great power. **1/500 second at f11, 80mm lens Rolleiflex medium format camera, 125 ISO film. JG**

STEPHEN POLIAKOFF (previous page)

One of the great British writer-directors of our generation, Stephen is a very private and intense man. The session went well enough but not wonderfully until Stephen's two Burmese cats decided to join him on the kitchen bench, making this beautiful composition. I could not have placed them better. You sometimes get lucky, but that only works if you recognize the lovely picture you have been given and grab it. The portrait is in daylight and shot on film with the zoom on 120mm, which compressed the perspective to make sure that Stephen and his cats all appeared to be on the same plane. **1/200 second at f6.3, 120mm, 3200 ISO film. JG**

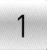
CELEBRATING AGE

Most magazines and books giving tips on portraiture use young models, and good-looking ones at that. Obviously, the fewer unflattering angles there are the easier it is to get a shot that the subject will be happy with, but there is a beauty too in the character that shows in older faces.

Even so, not many people love their lines and everyone wants to look their best, so the photographer needs to find a sympathetic approach that brings out the subject's personality.

For this project, shoot portraits of people of middle age or older, making them look great but not characterless. The over-use of soft focus is very tempting as you can remove nearly all age lines and achieve the skin of a 30-year-old on a 65-year-old, but it looks artificial and removes so much of the personality from the face. Those lines that have come from the life well lived are gone and you no longer have a true representation of the person at that stage of their life.

How much retouching you do depends largely on what the portrait is for. If you're aiming to flatter a friend, use soft front lighting plus some extra softening in Lightroom or Photoshop. However, if you're taking a magazine-style portrait of a famous poet or artist, for example, you will probably want to show every line as a statement about their life.

To bring out the best in your subject you need to study them to understand what their best actually is. The facial structure is very important, because that dictates the camera angle. If your subject has a double chin you need to shoot from a higher angle, about 30cm (12in) above head height. For a long nose, shoot from just below chin height and use a telephoto lens such as 80mm. Generally speaking, a wide-angle lens is not suitable for close-up portraits as it will exaggerate the nose and be generally unflattering to any face. Keep checking as you go and

remember your options for altering the angle of the camera and the perspective given by the lens.

Deciding upon the clothing the day before is a good idea, so that you can choose an outfit that goes well with the surroundings. The light is the magic ingredient, of course, so choose and plan with care – a reflector is a great assistant to have with you. Most important of all, remember that the mood of the session, which creates the subject's mood, is up to you. Having all the technical skill and equipment in the world won't help you to take a good portrait if the subject is feeling uncomfortable and anxious to get the whole thing over with.

ANNA (opposite page)

My friend Anna has a great face and I wanted to take a portrait that showed her as a mature woman in her second bloom. Working in her garden, I got this first photograph all wrong; I shot from her eye level and the overcast light has made her eyes look rather sunken, with shadows beneath – not flattering at all. **JG**

◄ CHANGING THE ANGLE AND LIGHT

Placing a gold reflector on a tripod next to the camera and raising the camera above head height has done the trick. The new camera angle has made her look up, which has had the effect of stretching her neck to show off her strong jawline, and the reflector has done a great job of filling in the eyes. The sun came out, too, giving some pretty backlight on her silver hair, and we joked about a bit, which brought on a lovely smile. I slightly softened the sharpness using Clarity in Lightroom, which also adds a glow to skin tones; a problem with digital portraiture is that the images are often too sharp, and can look very harsh. Putting a soft focus filter on the lens is an alternative to Lightroom. **1/250 second at f6.3, 65mm, 400 ISO. JG**

A POP PORTRAIT

Australian singer-songwriter Gabriella Cilmi asked me to take some pictures during the rehearsal stages of a new album. After the session I tried for some portraits of her.

At the back wall of the studio there was a light that I thought might make for some images that could be the starting point for some quite cool portraits, and with a lot of Lightroom work I ended up being very pleased with the final results.

For this project, make a rock-and-roll kind of portrait by marrying your camera and computer to produce something really different and striking. Remember, though, that retouching software should not be used to fix up bad technique, so work hard to get the image as right as possible in the first place. Keep the cover of a CD in mind as something to aim for, and of course if you really intend it for that purpose, your shot must be suitable for cropping successfully into a square format.

You don't need to know a pop star – just ask a friend to act as one for a few hours. The shoot will need some careful preplanning in discussion with your model. What will the makeup and clothes look like? Do you need props, and if so what should they be saying about your 'pop star'? If you're going for just a plain backdrop, what colour should you be looking for in relation to the clothes?

Lighting is very important in this sort of cool portrait. Depending on the clothes, make-up and general ambience of your model, will window light or outside back light with a reflector be best, or should you use flash or studio floodlights? If you want to go retro, it's a good idea to research some old pictures and try to work out the lighting so that you can copy it.

◄◄ GABRIELLA

This is the original file that I started work on. It's too sharp and her complexion does not look as good as it is in reality, but I like the angle of her face and she is looking intensely at the camera, which is great. **JG**

◄ LIGHTENING AND TONING

I made several versions in Lightroom. In this one I lightened the face considerably to reduce the sharpness using Clarity and then decided to look at it in black and white. I experimented with the preset toning tools and decided that this pink combination looked quite funky. **JG**

USING THE SPLIT TONE TOOL ▶

After listening to her album again, I decided to try a cooler look to try to match the feel of it. In Lightroom I used the Split Tone tool and made the highlights yellow and the shadows blue, mixing them until I got the blend that worked. **1/250 second at f5.6, 24mm, 400 ISO. JG**

A ROMANTIC PORTRAIT

The great Russian opera baritone Dmitri Hvorostovsky and his wife Florence agreed to sit for a portrait, and as we are neighbours it was easy to start off in their garden.

I asked them both to dress in white, as my plan was to create a black and white portrait based on the combination of Florence's long dark curls and Dmitri's contrasting silver hair. The garden light was overcast and that was giving them dark shadows around the eyes, which was not flattering. They didn't look relaxed and although we made some pleasant portraits, I was not at all satisfied so we decided to have a break and came inside.

I asked Florence to change into a sleeveless top as the all-white effect was too strong in the portraits so far. Dmitri sat down at his piano and started to play, immediately looking relaxed; Florence came back in the new top and

spontaneously put her arms around him. It was just the picture that I wanted. The light from the French windows was perfect, Florence was looking beautifully feminine and they looked very happy together.

That picture took only about five minutes to make, because everything was just right. When you feel that a portrait is not working it's good to take a break and try something else; if you begin to struggle for a shot your sitters will only become less and less relaxed, so you will be on a downhill path. Portrait assignments are tricky, because we can easily become self-conscious ourselves and then we aren't capable of putting our subject at ease. Taking portraits of people you already know

DMITRI AND FLORENCE
Here the eyes are pitted because the couple are looking down into the camera. I tried a silver reflector to throw some light into the eyes but it made Dmitri squint a little. I also wanted to see both heads a more similar size. **JG**

A SECOND TRY (far left)
The light on Florence is not doing her justice in this photograph. The couple are not looking relaxed, and their heads are too far apart to look really intimate. **JG**

THE WINNING SHOT
Now indoors, Florence is obviously more at ease. The light is lovely and they look really happy. Their heads are together and Florence's bare arms and hands are framing Dmitri's face, which makes them look like a couple who are very much together. I zoomed to a longer focal length to compress the perspective, which makes their bodies closer and their heads the same size. They look warm and sexy, which is how they really are. **1/250 second at f8, 80mm, 400 ISO. JG**

is the best way to learn because you will be familiar with their personality and you can work on showing the attributes that you like about them in your photograph.

For this project, take a portrait of a couple you really like and try to make them as good-looking as possible. Give them some guidance in advance about clothes and jewellery, since strong patterns and sparkly shapes distract from the face – ideally things should be kept simple. In black and white portraits, very light colours or white look soft and romantic. If the couple wear the same colours it implies the unity of their relationship as well as again keeping all the concentration on their faces – though in black and white, of course, the colours need not be the same as long as the tone is uniform, something that you can check by taking a black and white shot. Posing your subjects with their heads touching also helps to make two separate people into a couple.

Finally, a little softening of the environment helps the mood. Some romantic music really does contribute here and you should make sure the temperature is warm, whether outside or in – and that all the mobile phones are turned off.

CONVERTING AND RETOUCHING ▶

The colour picture looks nice, but I much prefer this black and white version, converted in Photoshop. Black and white smooths out skin blemishes, and the fact that it is not the way we see people in real life makes it into more of an art form. We are also influenced by the fact that so many portraits from our past are in black and white, making it feel like a portrait medium. I used the Dodge tool to slightly lighten the area around their eyes and mouths. However, you need to be very careful not to retouch portraits too much as that produces the rather plastic effect that makes real people look like shop-window mannequins. **JG**

A BEAUTY PORTRAIT

The term 'beauty portrait' covers the portraits used in advertisements for beauty products, publicity shots of celebrities and so forth.

However, these are more like still life photographs, since no attempt is made to show character; the purpose is to create a glamorous image that is an idealization of the woman or man concerned. It can be fun to try to produce this idealized image of your friends, and you'll find that most people can look the part when photographed in the beauty portrait style.

The portraits of Sophia and Claire shown here were shot on black and white film using a red filter. The lighting came from a window, with an added key light from a small spotlight. The red filter and spotlight combination is wonderful for smoothing out skin blemishes, and the effect is a retro Sixties high-key look. The use of a 100mm lens compressed the perspective, which has the effect of giving less prominence to the nose and is generally more flattering to most faces.

Much of the high-key style is finished off in the darkroom, where I printed light, on contrasty paper, to remove most of the midtones from the faces. I smoothed out the skin tones with a very slight soft focus filter over the enlarger lens. You can achieve this effect on some digital cameras using the red filter setting or in the computer using Lightroom, though it's difficult to get the wonderful glow that film gives.

Have a go at this beauty portrait technique. Make sure your subject is strongly front lit – use a flash gun or desk lamp if you haven't got a spotlight. If you have shot digitally, convert to black and white, increase Brightness and slightly increase the orange in the Black & White mix to lighten the face. Most importantly, to give a glow, set Clarity to –100 in Lightroom. The Clarity tool is also available in Photoshop Elements 11. If you have an earlier version, try the Blur filter instead.

◀ **CLAIRE**

The spotlight is directed from a 45-degree angle, right of camera, to create a 1940s Hollywood look. Claire's hair is deliberately a little untidy to contrast with the very cleanly lit look of the rest of the portrait. **1/250 second at f8, 60mm with red filter on lens, 400 ISO film. JG**

◀ **SOPHIA**

Here the spotlight is directed straight onto Sophia's face, illuminating her beautiful features. Her face is framed with dark clothes to emphasize the high-key light on her face. The background is just a white wall that has a lot less light on it than her face, making it go mid-grey. **1/250 second at f8, 60mm with red filter on lens, 400 ISO film. JG**

PROJECT

5

RECOMPOSING

Although it's important to compose your shots very carefully in the viewfinder, it is also worth while looking at the possibilities that you can discover later on the computer by cropping your original composition and also altering the angle of the head in the frame.

While you can do this the traditional way with a film negative in the enlarger, the greater ease with which it can be carried out in Lightroom or Photoshop, with the ability to keep experimenting and see instant results, is a real luxury. By reframing you may find you can make a more compositionally dynamic image than you had originally visualized.

It may also be the case that when you review the pictures from the session you feel that you haven't captured the full force of your subject's personality. By making a tighter crop and thinking about the possibility of what a different angle may imply you will be able to make a more characteristic picture for your subject and a more satisfying image for yourself.

◀ **MAURICE**

This how we started out, with strong window light from a three-quarter angle over Maurice's right shoulder and the main light created by a gold reflector next to the camera. The window has given a beautiful back light, and via the reflector the main light as well. Reflectors are wonderful lighting tools for portraits but greatly under-used. **1/60 second at f5.3, 60mm, 400 ISO. JG**

FINDING A STRONGER IMAGE ▶
Before we started shooting I noticed Maurice sitting with his head in his hands, looking intensely at the camera, and I asked him to return to that position as it made a strong image. **1/60 second at f5.3, 105mm, 400 ISO. JG**

◄ CROPPING AND CONVERTING

As we looked at the photographs on the laptop I started to do some cropping, and as soon as I tried this rather extreme composition we both really liked it. We decided to convert it to black and white, making it even more dramatic compared to the uncropped colour version. I added the vignetting in Lightroom so his spiky hair would stand out from the background, since it is part of his personality. **JG**

INTERPRETATION

A good portrait is a well-lit likeness of the subject – but a really good portraitist takes that next huge step and makes his or her personal interpretation of the subject's character.

This involves risk-taking, since the subject may strongly disagree with the interpretation and in the case of a professional photographer the subject is most probably the client who may not want to pay the bill. However, if you really want to progress and be one of those portraitists, you have to go for it. Even so, it's a good idea to start off playing safe first with a good flattering portrait so that your subjects are not too dismayed by interpretations that they don't like. You will be relying on friends and family to model for you while you explore portraiture, so it's in your interests to make sure they will co-operate again.

For this project, have some fun taking a friend out and making an interesting composition matching a background to their personality. You could also use lighting effects, clothing and props. A series of pictures of your friends with their favourite possessions, which could be anything from a vase to a motor car, would be interesting to do and would also give you a portfolio of images that would act later as a reminder of your own life at the time, intertwined as it is with theirs.

◤ BILL BAILEY

Commissioned to take publicity portraits of the comedian Bill Bailey, I did a series of friendly portraits that could be used for press releases and so forth. The light was perfect – bright but overcast, which is very flattering for portraits. However, they were too conventional for my liking. **1/200 second at f6.3, 70mm, 400 ISO. JG**

▼ FINDING A LOCATION

We went for a walk and found ourselves under a flyover. Bill really liked the atmosphere and we ended up with this portrait. I organized the composition to make Bill part of the crazy Batman-like swirls that the structure makes and used a wide-angle lens to exaggerate the perspective of the structure.**1/50 second at f6.3, 18mm, 400 ISO. JG**

▲ CONVERTING TO BLACK AND WHITE

As a final touch I decided to change the image to black and white, which gave it a more authentic Batman comic-book look. It is my interpretation of Bill and he liked it too. **JG**

EXPERIMENTAL PORTRAITS

Portraits don't always have to be of the traditional kind; it's an area that has the potential for a great deal of experimentation.

A photographer we associate with innovative portraiture is Man Ray, who in the 1920s made what were then pioneering portraits for their time, using revolutionary techniques such as solarization. When we consider his portraits today we find that very few of them are really sharp by modern standards, but a lot of their emotional impact is in fact due to the lack of that pin-sharpness.

As this is experimental portraiture, the aim is that you loosen up on your technique and forget about sharp focus. By trying different things you may come up with unusual results, many of which may be unsuccessful, but when you strike gold by virtue of your own ideas you'll find it very rewarding.

As a starting point, hand-hold the camera on slower shutter speeds, for instance; use a torch and a slow shutter speed, perhaps with a piece of tracing paper to soften the light as torchlight can be quite harsh; and you'll find that candle light makes a beautiful alternative, or indeed low natural light from a window. Even a make-up mirror can be put to use to bounce light onto the subject's face.

As you progress there are numerous interesting techniques that you can experiment with, such as double exposures and hand-colouring the prints – and of course the chance to do post-production work on the computer opens up vast possibilities. In this genre, the shot is often just the starting point.

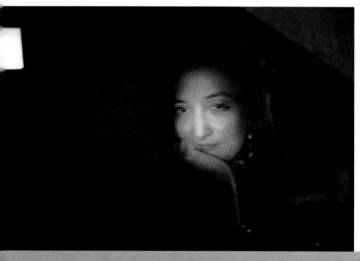

◣ LAURENCE

One evening at a beach bar in Mexico, I wanted to make a portrait of my friend Laurence. The light was almost gone, so I tried lighting her face with a little torch, holding it in my left hand and the camera in my right, hence the camera movement. However, I decided that movement had created a softness that looked romantic. The picture is an interesting image but requires some work in Lightroom. The colour needs improving and the lamp at the left top corner is distracting. **1/4 second at f4, 18mm, 800 ISO. JG**

▼ POST-PRODUCTION WORK

Those improvements took 15 minutes in Lightroom. I softened the image a little using the Clarity tool, which took away the hardness of the torch spotlight effect on Laurence's skin. I then removed the lamp by cloning the surrounding area, lowered the contrast and improved the colour using the Saturation tool. **JG**

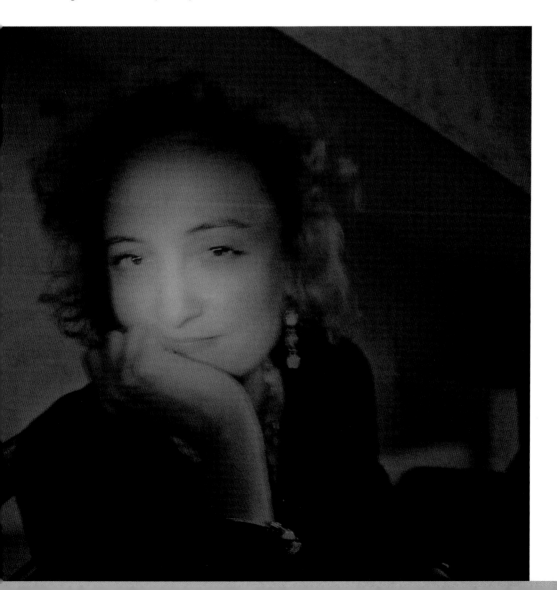

GROUP PORTRAITS

If doing a single portrait can be challenging, each extra person included in the shot represents double the problems. Keeping your attention on the light, the camera, the grouping and the expression on all the faces, checking that everyone looks good, is tricky indeed.

As the camera tends to emphasize the gaps between people in a group, one of your primary tasks is to arrange everyone close together. This is not as easy as it sounds as we all have an innate need to have our own space, but if you explain the reason why it will encourage everyone to be relaxed about it. Even with only two or three people in the shot you may have to place one slightly behind another to make an interesting composition, stopping down the aperture to give a greater depth of field if necessary. Use a long lens of 80–100mm to compress the perspective if heads in the foreground look bigger than those in the rear.

Larger groups of people, at a party or family gathering for instance, will need careful managing. Place the tallest at the back and ask them to squash together with their shoulders overlapping, one in front of the other. You can also raise the camera higher by standing on a chair or ladder so you can see the people at the back. If need be, ask people to shift position until everyone is clearly visible.

It's best to start by getting everyone to be serious and taking the picture on a count of three, as this usually ensures their attention and gets a couple of safe shots. Then, change the atmosphere by being the entertainer and making them smile and laugh. Make sure you take at least 20 pictures, because it is so difficult to have everybody looking good in the same picture.

For this assignment, make four double portraits with the same two people. Place their heads in different juxtapositions to each other in each portrait – next to each other, one head above the other and so on. Once you feel you've developed some skill at posing more than one person at a time, try larger numbers. For an easy way into this, if you are involved with a group of any kind, such as a sports team, a choir or further education class, suggest that you take a group shot and share the picture with everyone to thank them for co-operating. You will feel more confident with people you already know, and they are more likely to be patient if it takes you a while to establish the best arrangement.

◄ BARBARA AND GEORGE

This picture of Barbara and George is what is termed an environmental portrait – meaning that the subjects are shown in their surroundings, which could be home, work or anywhere that says something about their lifestyle. I shot this in their sitting room, with my camera on a tripod low down so that I was looking directly at them. I included the two pictures above them to show their love of art and only noticed later that a book of Matisse is showing on the right, a lucky accident. The use of available light is common in environmental portraits, and here it came from French doors behind the camera. It was shot on film, then scanned and post-processed in the computer. **1/30 second at f8, 40mm, 400 ISO film. GH**

▼ FATHER AND DAUGHTER

I made this portrait in my studio, using a plain white background and lighting the pair with a flash in a soft box from the top left. When I started they were too far apart, so I gradually moved them closer. Giving people something to lean on often helps them to relax, so I pulled up a small table, they fell into this pose and that was my picture. It needed a lot of manipulation – I cropped it tight, darkened it all over then lightened the girl's face with the Dodge tool. Using the Burn tool, I darkened the top right as the background was too light. **1/125 second at f11, 100mm, ISO 200. GH**

◄ WINSOME AND HER GRANDCHILDREN

The portrait of Winsome with her grandchildren was shot with the standard lighting set-up I use for groups and children (see Children's studio portrait, page 168). The closeness of their heads makes a nice triangular composition and also emphasizes their relationship. **1/125 second at f11, 50mm, 100 ISO. GH**

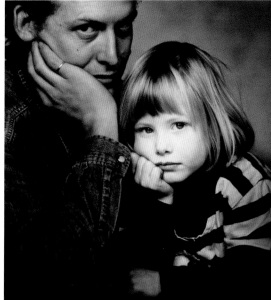

FAMILY GROUP (top)

When photographing a group it is usually best if you can get above eye level and look down, allowing you to see the people behind the front rows. This large group was enjoying a birthday celebration and I took up position at a window above the conservatory roof. After setting up the camera on my tripod, I realized I couldn't get everyone back far enough to clear the roof in the foreground, so that would have to be cropped off later in the computer. I wanted to be in the shot myself, but was too far away to use the self-timer. The solution was to start by photographing the group with space left for me (circled in red). **1/180 second at f6.7, 38mm, 400 ISO. GH**

PUTTING THE PHOTOGRAPHER IN THE SCENE (left)

Next I went down and stood in my place while one of the other guests photographed me so that I could be cut out and placed in the main picture. **GH**

AFTER POST-PRODUCTION (above)

After some work on the computer, this is the final picture with me included. It obviously takes more work than using the self-timer, but if it's a matter of making a dash to get into the shot you may find this approach preferable so that you look as relaxed as the rest of the group. **GH**

BODY BEAUTIFUL

In this chapter, the projects are on nude, semi-nude and glamour photography. When friends hear that you are shooting nudes you will probably get some jokey comments about your motives, but the truth is that the qualities that you require to shoot good nudes are the same as those of a still life photographer.

The body beautiful is actually a difficult object to find, and most of your work will go into showing off the beautiful bits and hiding the not-so-beautiful bits, dispassionately judging how to arrange angles and lighting just as you would with any other subject.

This area can be a difficult one for the amateur. The pro photographer can hire pro models who in the main have good bodies and also usually know how to pose effectively. However, the best nudes and glamour shots are often of girls and guys who have never modelled before as they bring with them a freshness and enthusiasm – in fact all the models in this chapter are first-timers.

Our pictures in this chapter are of people with few or no clothes on, on location and in our home studio. They are of people we know and respect too much to take a picture of them that will embarrass them later. Nude and glamour photography is based on trust. Your photographs must never appear on social media such as Facebook, nor even be shown to your friends, without the very clear permission of the subjects.

▲ **TORSO**
This torso was lit with window light from behind the camera. I dramatically increased the contrast and darkened it to accentuate the muscles and give a feeling of strength and power. **1/4 second at f8, 60mm, 400 ISO. GH**

CORSET

Here is a woman who is prepared to suffer for art, an example of street glamour spotted at a rock festival. The exaggerated hourglass shape that she has created is a parody of the body beautiful. I took the exposure reading off the centre of the corset to make sure that detail was held in the blacks. This meant that the background is totally overexposed but in this case it separates the figure from the surround. **1/250 second at f8, 100mm, 400 ISO. JG**

NUDE IN THE AFTERNOON (previous page)

This picture was not shot in a professional studio – the model was lying on a bed with white sheets and a white duvet placed against an off-white wall, bathed in soft late afternoon light coming through a dormer window. All that whiteness created very soft, sympathetic lighting. I took about 50 shots, but as usual a very simple composition worked the best. I lightened the exposure by about ⅓ stop in Lightroom and slightly softened the picture using the Clarity tool. **1/200 second at f6.3, 60mm, 400 ISO. JG**

MALE NUDES

The growing market in male beauty products and designer underwear has led to a big increase in the number of male nude and semi-nude pictures that appear in the media today. Consequently, there is now plenty of reference from which you can find ideas for your own shots.

In order to give a masculine look the lighting on male nudes is generally more low key and shadowy than that used for female nudes, but the principle of concentrating on composition, pattern and light applies equally to both.

The classical male body is a very athletic and toned ideal that few of us can aspire to. One of its most famous representations is the Discus Thrower, a Greek sculpture from about 460–450 BCE. I thought it would be a great image to copy, so I asked Brian, a friend who works out in the gym, to pose for me.

The photograph of the sculpture in a book I used for reference had a black background and I decided to follow that. After buying a discus I realized that it was far too heavy for Brian to hold for the length of time it would take to set up and shoot – so I photographed the discus, made an inkjet print of the same size and glued it to a piece of card. This looked the same as the original but was a fraction of the weight. This proves the point that it's important to be well prepared so that a shoot can run smoothly.

Finding a classical reference to make your own interpretation of is a good idea for this project. Having an image as a starting point for a nude shoot is a big plus as it takes away any uncertainty about what to do, and your model, unless very body-confident, will find a classical figure less daunting than trying to match up to a superhoned modern icon. Once you have started you will naturally find other poses to shoot.

THE DISC THROWER
The Discobolus, or Discus Thrower, is one of the most famous sculptures from the ancient world. This was my starting point for the picture of Brian. **GH**

THE SET-UP
Here is the set-up, demonstrating that you don't need a large studio with multiple lights – this was done in my living room. I used the window with some net curtain to diffuse and spread the light. The background is a large sheet of black felt supported by two stands, with folds left in the fabric to add a bit of texture. I hung a white sheet on the opposite wall to add a bit of fill light to the shadow side. **GH**

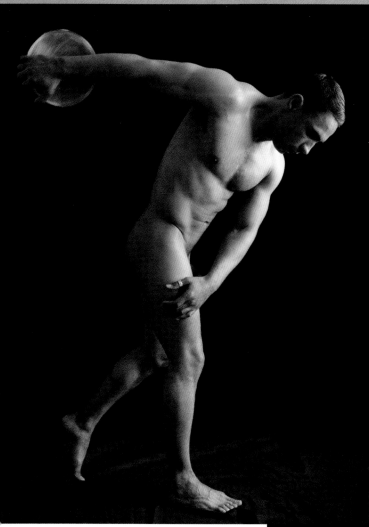

▲ **THE SECOND SET-UP**

For the next shot I used the same black background as the discus shot but this time lit by two inexpensive LED video lights, one each side and closer to the background than Brian. This produces strong sidelight with dark shadows to the front – the classic low-key look, giving a strong sculptural image. **GH**

▼◢ **HIGH-CONTRAST LIGHTING**

In these poses, the side lighting has given a strong, solid look. Take care that you don't get lens flare from the backlights. If it's a problem, two pieces of black card taped on light stands placed each side of the lens will eliminate it. **1/4 second at f6.7, 30mm, 400 ISO. GH**

WINDOW LIGHT ▲

Sidelight from the window has brought out the shapes of Brian's musculature. With the camera on a tripod, I took a few test shots to get the angle and pose worked out. The exposure needed to be adjusted as the camera meter wanted to overexpose because of all the black background. I set the exposure compensation to −1½ stops, a low-key exposure that would keep detail in the highlights and underexpose the background to make it black. We did many shots, varying the angle and pose. **1/15 second at f6.7, 24mm, 400 ISO. GH**

LOCATION NUDES

While studio photography sounds formal and professional, you may in fact find it more difficult to shoot nudes on location. Those extra elements of what should be in the background and the suitability of the environment in general add considerably to the necessary decision-making.

It's also not easy to keep that discipline of the still life photographer as your principal aim. Added to that, the lighting is still a big issue, as well as the question of whether the pose accentuates the best features and hides the less beautiful bits, as it should.

Finding a lovely location and putting the model in as an afterthought probably won't work well. Instead, choose a location that is really sympathetic to his or her body as that adds to the sensuality of your nude picture. Look for one that has good light, too, so that you don't have to introduce artificial lighting and make the shoot more complicated than it need be.

Many of the most beautiful location nudes of the past have been made by photographers using their partners as their model. If you have a partner who is willing to take part, that is ideal as you will be comfortable and confident together.

◀ **NATURAL LIGHT**
It was a warm, overcast day, and the light in the little garden was perfect for nudes – soft and providing lovely moulding. Yamilla adopted various relaxed positions, and this languid pose works well for me. I shot in colour, but converting to black and white gave the picture a slightly surreal effect which I liked. I added a film grain effect in Photoshop to give the texture. **1/200 second at f8, 40mm, 400 ISO. JG**

▲ **CONTRASTING SHAPES**
For this shot I asked the model to stand in a window alcove against the Venetian blinds. The window frame has given me picture frames to play with and the horizontal lines of the blinds add contrast to the soft curves of the body. The model is standing on her toes, which stretches the body and lengthens the legs, while keeping the arms up lifts the breasts. I shot in colour, then reduced the colour in Saturation setting in Lightroom until I was left with just a hint, like a toned black and white darkroom print. **1/650 second at f8, 80mm, 400 ISO. JG**

TUNGSTEN LIGHT ▶

I switched off the spotlight and turned on the room light and table lamp next to the window. The tungsten light has changed the picture from blue to pink. With Yamilla facing the camera, there is some subtle light on her arm, legs and breast which comes from the window and the table lamps. The light was low, but with the camera on a tripod and a stationary subject that doesn't matter. The temptation is to add lots of light when we are faced with low lighting, but the difference between a dark picture and a light one is only a matter of exposure. **1/8 second at f6.3, 45mm, 400 ISO. JG**

▲ DIFFUSED DAYLIGHT

Some of the pictures were made in a room with a feminine feel that I felt Yamilla would be comfortable in. There was nothing that fought for attention with the nude – everything added atmosphere. I started with daylight from the window as the main source, then added a small spotlight to light her face and top half, placed to the right of the camera, and a table lamp to the right and slightly behind her. I set the WB on Incandescent to balance for the addition of artificial light. The diffused daylight has made a blue cast over the picture. I was careful not to use a wide-angle zoom setting because that would have made the foreground leg too big in proportion to the rest of the body. **1/30 second at f6.3, 45mm, 400 ISO. JG**

◀ STRETCHED POSES

Here the light is coming entirely from the French windows. The wall has enabled the model to lean and stretch – the arch of the back and the high arm position result in about the most flattering position possible. While I shot in colour, there is very little colour in the picture, which was not manipulated later. Stretched poses are the best way to start posing nudes and simple locations such as this that subtly contrast with the round body shapes are good backgrounds to look for. **1/250 second at f5.6, 25mm, 400 ISO. JG**

STUDIO NUDES

You don't need to have any form of studio for this project, where the body is isolated against a simple background with no distracting elements. Your living room or bedroom will suffice, as long as you keep it very warm so that the model feels relaxed and his or her body looks its best.

The nude is the ultimate challenge to a photographer wanting to interpret shape and form. The body is comprised of tubular and round shapes and to reveal these shapes you need to light from the side, top or back. Front lighting flattens the curves, giving a two-dimensional effect, so avoid using front flash or direct floodlights. Take great care to watch what your lights are showing – while painters are able to narrow a waist or ignore cellulite and so forth, photographers must do that with a combination of lighting, posing and choice of camera angle. It is really important that you study the mechanics of the body, such as what happens to the breast when the arm is raised or how a change of leg position alters the shape of a hip.

It's a good idea to ask your model to wear loose clothes and no underwear for an hour or so before you shoot, because underwear marks take a long time to fade and can spoil an otherwise lovely picture. The model will also be more comfortable with a dressing gown to wear between shots rather than standing around in the nude while you rearrange your set-ups. The best nudes are usually a collaboration between model and photographer, so include him or her in the creative process. Your model will be more enthusiastic if treated as a partner in the shoot rather than as an object.

It may take a few sessions before you start making really good nude pictures, but just keep experimenting with lights and poses until you have developed your technique. You need to be patient for this type of photography, spending a long time adjusting the model's position and fine-tuning every angle. For very precise pictures, it's a good idea to connect up your camera and laptop so that you can see what you're doing on a large screen.

◀ **LIGHTING FROM ABOVE**
This model has a figure of the traditionally desirable hourglass shape. I wanted to concentrate on her beautifully rounded hips. I placed a floodlight on a boom arm, which enabled me to light from the top right, 1.5m (5ft) higher and about 50cm (20in) behind her head. She has very little light hitting her body, yet you can see the classic feminine shape; her raised arms have lifted her breasts and continued the curves of her silhouette. The light has spilled onto a dark grey background.
1/125 second with flash at f11, 100mm, 200 ISO. JG

◀ STUDIO SET-UP

Here I used the full studio set-up, but you could obtain the same effect in a large room. The brief was to produce a symbolic interpretation of sun-worship trends. I sprayed a grey background with gold pressure-pack paint made for motor cars – if you want to replicate this, do it outside as it makes a terrible mess. The light is from a studio flash from the side, which is also lighting the left side of the background. The light was bounced into a white umbrella and then through a sheet of diffuser material that was hung in front of the light. The right side of the background is lit by another flash. The pose stretches the body into a flattering shape. I had the lights turned down to their lowest setting so that I could use a large aperture on a long lens and by so doing keep the background out of focus and cloudy. **1/125 second with flash at f4, 150mm, 200 ISO. JG**

▼ LIGHTING WITHOUT SHADOWS

This pose was the model's idea – she wanted to look like a sculpture in a museum. I started with a large white background (a sheet would work as well), then covered a table with white paper. This enabled me to get the camera angle sufficiently low to make a profile of her without my having to lie on the floor. The light all comes from two flash guns, one on each side, directed at the background. I placed two 1.5 × 2m (5 × 6½ft) white polystyrene boards 1m (3¼ft) in front of the table, with a gap between them to take the picture through. The light bounced off the background onto the boards, which then bounced it onto the model, giving this soft, shadowless effect. **1/125 second with flash at f9, 80 mm, 200 ISO. JG**

▲ DIFFUSED LIGHTING

This picture came out of a session where the model and I were working on making beautiful compositions from portions of her body. She was lying on the floor so I had to as well in order to get this angle, with the camera on a low tripod. The light is from a floodlight shining through diffusing material, positioned about head-high and 45 degrees to the right of camera. I converted to black and white and softened the focus a touch in Lightroom, which adds a glow to the skin. **1/60 second at f8, 55mm, 400 ISO. JG**

PROJECT

4

GLAMOUR

The glamour photograph really became a genre in the 1940s and '50s, when photographers who shot the young Hollywood starlets described themselves as 'glamour photographers'.

Today the magazines are full of glamour photographs, with actors and actresses seductively posed in various stages of undress and the majority of perfume and underwear advertisements following the same style. For many young people, these are iconic images that they would like to emulate, so you shouldn't have problems finding models, both male and female.

If you don't have access to models with beautiful bodies, glamour photographs are easier to shoot than nudes because you can expose the best features of the body and clothe the rest. Study the lighting, make-up, clothes and poses

of the magazine photographs in the pages that you really like. They will of course have been mainly done in studios with a wide choice of lights and backgrounds, as well as stylists to handle the clothes, hair and make-up, but don't let that deter you – the indoor photographs on this page were taken with only daylight and a flash gun. The lighting principles that work well with nudes will work for glamour, too.

How raunchy you want to make your glamour pictures is up to you but, as with nude photography, always take care that you are not making your model feel uneasy.

SHADOWS AND LIGHT
The black bra is a cliché when it comes to erotica. I wanted to make a picture featuring the bra but making a cool erotic image rather than a tacky one. The bra is contrasted with a white shirt and the light coming through the Venetian blinds casts shadows to add a bit of mystery. **1/350 second at f8, 100 mm, 400 ISO. JG**

REINTERPRETING THE IMAGE
When playing around in Lightroom I came up with a second visualization. I kept some colour but made it softer, then lightened the image and softened it using the Clarity control. The softening has added a glow to the whites. Finally, I added a vignette. It's always worth reinterpreting your images – even if you decide you prefer the original, you will have gained more experience in evaluating your photographs. **JG**

◀ USING WINDOW LIGHT

This is a glamour picture of the kind used for selling lingerie or perfume. While a nude can be coolly sculptural, once you drape the body in flimsy clothes, leaving parts exposed, the picture becomes sexy. Pola is seated on a windowsill, three-quarter backlit with daylight, which is very sympathetic to the curves of the body. A white reflector opposite added some fill to the shadows. This is a Lightroom conversion to black and white with the edge taken off the sharpness with the Clarity setting, which has added a glow to her skin. **1/250 second at f8, 55mm, 400 ISO. JG**

▼ COLOUR AND BLUR

I went to take a snap of a friend just after a swim and she hid behind her scarf. The backlight made a silhouette of her body behind the colourful fabric that fluttered in the wind, giving a painterly look to the image. I dialled up the colour using Saturation in Lightroom and added sparkle using Brightness settings. Apart from the movement of the scarf, the blur was an accident; I had left the aperture stopped down to f22 from the previous pictures and that made the shutter setting 1/20 second. Errors sometimes work out well. **1/20 second at f22, 55mm, 400 ISO. JG**

CELEBRATIONS

Our celebrations are those events that occur yearly, such as birthdays and anniversaries, along with weddings, reunions and public festivities – parades, carnivals and so on.

Millions of pictures are shot during these times, and the challenge is to progress from taking snaps to creating really memorable images that will hold the attention of viewers who weren't even there. It's all about using your imagination to look at the events from a different place, not necessarily physically but by trying to capture the spirit of the celebration. That might mean an interesting camera angle or lens setting or a multiple exposure – something to make the pictures different and more arresting.

The majority of those millions of pictures will have a camera flash straight in the faces of those celebrating, which usually makes everybody look unattractive. This chapter will help you to do much better. Of course the temptation is to throw yourself wholeheartedly into the celebrations too, but to make a memorable photo story of the event you need to take a step back and concentrate. It is a bit like being voted designated driver for a night out: someone has to stay cool and sober.

JUMPING GROOMSMEN (previous page)
This picture of the jumping groomsmen at a wedding was a spur of the moment idea and I had to make quick technical decisions. To freeze the action I used flash, but I needed a slow shutter speed of 1/15 second to record the available room light. This combination produced the effect of motion. I removed the carpet using the Clone tool in Photoshop

▲ THE KISS
The 'you may now kiss the bride' picture is a must in a wedding photo story, though I set this up after the official kiss because the couple were hiding each other's faces in the first pictures. I cropped the image and then softened it in Lightroom after converting it to black and white. **1/30 second at f5.6, 112 mm, 800 ISO. JG**

THE BIRTHDAY CAKE
Simple pictures such as this take more planning than you might imagine; you need to get into position first and direct the whole set-up for the camera. Success is rare if you just try to grab the action as it happens. I placed the family close together and used a wide-angle lens to pull the cake forward in the picture. We had to do the shot a few times, as the candles were repeatedly blown out before I could get the compact camera to focus. **1/30 second at f4, 5.2mm compact camera, 400 ISO. GH**

GUEST AT THE WEDDING

Most of the guests at today's weddings will be clicking away, so there will be plenty of pictures recording the event. However, most of them will be pretty haphazard, so if you can add some intelligent shots from the sidelines they will be valuable.

The professional photographer present will be taking the essential shots such as the couple at crucial moments and the family groups, which means you can have fun shooting informal pictures with no pressure to produce something for the wedding album.

As the professional photographer may be too concerned with his or her own problems to consider any pictures not on the pre-arranged list, that gives you great scope to look for all those pictures that make great memories, such as the little incidentals that are usually overlooked in the razzmatazz of the day. Don't avoid the bride and groom entirely – try to get some traditional shots as well, since there have been many weddings

where, for one reason or another, the main photographer has let the couple down. Your pictures could save the day. However, make sure you don't get in the main photographer's way, as he or she is there to do a very stressful job and you need to respect that.

So, your project at the next wedding you go to is to produce at least five pictures that are different from, and more exciting than, those from the official photographer. It's important to get some practice in beforehand, shooting portraits, groups, and low-light and high-contrast situations as these are what you will find at weddings. Get as much experience with your flash as possible, too, as you will be using it a lot of the time.

▲ THE DANCE
Try to find an elevated position from which to get some unusual views. Concentrate on capturing a really romantic picture, as that is probably the most important image of the whole wedding. **1/45 second at f4.8, 200mm, 1000 ISO. JG**

▼ THE INFORMAL VIEW
To capture the happiness of the occasion I had James and Nanda run to the camera several times. It was inevitable that they would be laughing. The low camera angle has made them more dynamic in the picture. **1/250 second at f8, 48mm, 400 ISO. JG**

CINEMATIC MOMENT

All the guests were waiting for transport to the reception. I turned around and saw the bride looking intensely concentrated. The light from the overhead lamp was dramatic, isolating her from the guests – it looked like a still from a 1960s Italian movie. I burned in the background and lightened her face just a little after conversion to black and white. **1/125 second at f4, 25mm, 400 ISO. JG**

THE LOOK

This was shot during the ceremony, between the heads of other guests. The loving look from bride to groom is what every wedding photographer wants to capture. I was waiting for that look and knew that I had a lovely picture as I was pushing the button. **1/125 second at f4, 110 mm, 400 ISO. JG**

◀ THE RINGS

The most important symbols of the marriage are the rings, so don't forget them. Fill-in flash was used here, as the light was very dark and flat. The advantage of fill-in flash over straight flash is that it includes available light as well, giving a softer effect. **1/45 second at f4.8, 32mm, 400 ISO. GH**

◀ THE COMEDY

A serial wedding-goer, this dog was wearing the best tie of the day. Look out for the funny pictures that can add lightness and give everybody a laugh later. **1/20 second at f4.8, 52mm, 400 ISO. GH**

 QUICK TIP

Even as the unofficial photographer, you need to research the wedding shoot.

- Are you allowed to shoot in the church?

- When will the couple arrive?

- How many bridesmaids and groomsmen will there be?

- Will there be speakers, or other people performing a special function?

PROJECT

2

OFFICIAL PHOTOGRAPHER AT THE WEDDING

If friends ask you to be the official photographer at their wedding you will be in a position of great responsibility, since this isn't a shoot you can have another go at if you don't get it right.

Your first task is to consult them on the must-have shots, which not only include their special moments such as the signing of the register but also family groups and who they want included in them.

While professional photographers may work single-handed, they have probably shot hundreds of weddings and their experience means that they know exactly what they are after and how to achieve it. Lacking that experience, you must arrange a project manager – a friend or a family member – to handle the organization of the groups, since the people you need to include may be busy chatting in various parts of the venue. The ideal is to have two people, one from each family, as they will know exactly who should be in the shots. If you try to tackle this yourself, you may become flustered and anxious when you should be concentrating calmly on your photography.

The other essential is a checklist, which you must consult before leaving home. Itemize everything you need down to the smallest detail and carry spares – batteries, chargers, memory cards, and a camera, too. If you don't have a spare camera of your own, borrow or hire one for the event and familiarize yourself with it thoroughly so that if you do have to swap over there's no hold-up while you wonder where the various controls are. Your thoughts should all be on the image, with your camera-handling as second nature.

Other practical considerations are to fill the petrol tank – you can't stop to refuel if you are following the bride and father – and to allow much more time to get to the venue than you think you will need, since you cannot be late.

Finally, when your friends ask you to be their main photographer, think very carefully about it and unless you feel confident about your skills, say no. This is a very important day for the couple and that brings with it a lot of tension. Photographing a wedding is a long and tiring job and if you are in any doubt as to whether you can produce a series of shots that will make your friends happy, offer to be an active photographer at their wedding rather than the official one and build up your experience for the future.

THE COUPLE

For my portrait of Richard and Sal, I used the stairs so that I could have them looking up to camera and the light. I recruited another guest to hold the reflector to fill in the eyes. Using Lightroom, I converted the image to black and white, applied the cream tone preset and then added a vignette – I was looking for a film-star romantic look. To get the most out of your retouching tools you need to know what you are planning before you take the picture. **1/25 second at f5.6, 150mm, 400 ISO. JG**

▲ THE RINGS

The exchange of rings is one of the wedding cliché pictures except that this is a picture of the hands of two men. I was waiting to catch this moment, so I got a really strong composition. It looked more cool and timeless converted to black and white. **1/60 second at f7.1, 75mm, 400 ISO. JG**

◀ THE GROUP SHOT

Richard and Sal's wedding in Barcelona took the form of a weekend party. I approached the shoot as I would a magazine current affairs story and tried to capture all the little details as well as those musts such as the family groups. This is the group shot of all the guests. The big tips for large group shots are to get up high and to be the performer so that everyone is looking up at you and laughing – that will ensure that the camera will see every face. **1/250 second at f7.1, 24mm, 400 ISO. JG**

PROJECT

3

CARNIVALS AND PARADES

Colourful public events such as carnivals and parades are a real gift for the photographer, offering a visual stimulus way beyond that encountered in everyday life.

The participants will have put many hours of creative thought and work into the planning and making of the costumes and floats, and to get the photographic best out of the day you need to do a bit of planning and thinking, too, rather than just wildly snapping everything that's in front of you.

Such events usually mean tightly packed crowds, and for convenience and safety, as well as considerations of weight during a long day, it's best not to take a bag loaded with equipment. One DSLR and an 18–200mm zoom lens will cover most eventualities, and if it's a particularly notable event it's a good idea to slip a compact camera into your pocket as a back-up – along with spare batteries for both cameras, of course.

Try to do some advance research into where the best vantage points will be, and where the crowds will be so thick that you stand little chance of getting a good view and also risk missing a lot of the action while you try to struggle your way out. Unfortunately, those two considerations will probably coincide, and you may have to be more creative than most in finding a good spot.

Depending on the nature of the event, it may be possible to negotiate a ride on a float, from which you'll get excellent views of the spectators. For photographic purposes, you won't want to stay on it for long as your view of the parade will be limited to your float and the ones immediately in front and behind, so if you contact organizers beforehand to explain your aims and offer them something of interest in return for a brief visit, such as photographs, food, drink or transport for equipment on the day, you may be lucky.

So your project is to photograph both the parade and the revellers at the next pageant, festival or carnival you go to. Rather than standing on the sidelines taking shots of everyone going by, get in close and capture the colours, enthusiasm and interaction of the participants. The images on these pages are all from the famous Notting Hill Carnival in London, the largest carnival in Europe.

◀ **SCENE-SETTING**
It can be difficult to get a good general shot at a really big carnival, as there is so much detail that an image can just look a bit of a mess with no particular distinguishing features. It's a good idea to look at it from a distance, using your long lens to get you into the thick of it. I used my maximum telephoto setting and that has compressed the foreground people, the colourful flags and the crowds in the background. The result works as the establishing shot of the carnival. **1/250 second at f8, 200mm, 400 ISO. GH**

THE CENTRE OF THE ACTION

By getting to the carnival route very early I managed to find a foothold on a traffic island in the middle of the road. It was raised one step high and with the carnival flowing around me I had a vantage point in the middle of the action from which to photograph the upturned faces of these girls. **1/640 second at f5.6, 52mm, 400 ISO. GH**

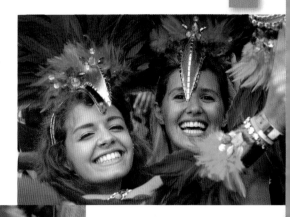

▲ USING A LONG LENS

I used a telephoto zoom for this golden face. The combination of the long lens and a wide aperture separated the masquerader from the foreground and background, placing the emphasis on his expression. **1/640 second at f5.6, 150mm, 400 ISO. GH**

◀ CREATIVE BLUR

These guys were really going for it. I tried some shots using a slow shutter speed to get some blur that would suggest the dancing and general noise. This one was just right for what I wanted – any more blur than this tends to give an image that is too abstracted, hiding the subject matter. **1/8 second at f32, 95mm, 400 ISO. GH**

◀ DYNAMIC COMPOSITION

Here are a couple of high-octane revellers. The yellow and white clothing is pushed forward by the red background. The joyous expression on the girl's face is the point of interest, placed in the classic rule of thirds position. **1/500 second at f6.7, 170mm, 400 ISO. GH**

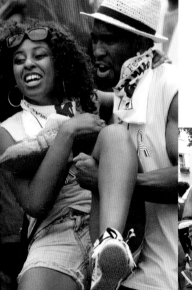

◀ WIDE-ANGLE LENS

Trying to capture the excitement of carnival means getting close to isolate some protagonists from the mayhem in the background. This shot is a puzzle of shapes joined at the hip. I used the wide angle on my zoom and got in close, which has the effect of pulling the dancers towards the camera. **1/200 second at f8, 18mm, 400 ISO. GH**

PARTIES

Most party photographs that are not taken by professional photographers show evidence of the built-in flash on auto. Of course, there are occasions when the flash captures images that we can get no other way, but direct flash can really kill the atmosphere.

Fortunately, the new DSLR cameras have the capability of very high ISOs, which means they can produce excellent-quality images in very low light conditions.

However, even without dialling up to 25000 ISO, the possibilities are exciting when you just turn off the flash and grab the mood, regardless of what the lighting may be. This project is about taking alternative party pictures – don't worry about blur, just go for it and try to catch the excitement. To avoid the jaundiced facial tones that you often get from incandescent lighting, make a colour test shot before the party gets

underway and find the best WB setting, keeping in mind that a slightly warm colour balance can be in keeping with the party feel. Conversely, for quieter parties, such as those to celebrate an elderly relative's birthday, the softness of available light provides a gentle, calm and timeless feel.

Check your pictures as you go – if they don't look as if you're part of the party, you may be too far away from the action. Set your zoom to wide angle and walk forward until the action fills the frame. That way the photographs will look as if they're taken right in the centre of the party, rather than from the point of view of an observer.

ROBERT'S PARTY
This is a boring but sadly typical party picture. The flash has killed the whole spirit of the celebration. **1/60 second at f4.5, 38mm, 400 ISO. JG**

SHOOTING WITH CANDLELIGHT
This looks more like a party. The flash is off and Robert is lit by the candles on the cake. There is movement and the colour is too red, but the shot has captured the fun of the night. **1/4 second at f4.5, 45mm, 800 ISO. JG**

DIRECT FLASH

The party time after the wedding dinner, taken as the usual direct flash party picture. The flash has all but killed the disco lighting and you can sympathize with the person making for the exit. **1/60 second at f6.3, 18mm, 400 ISO. JG**

A DIFFERENT VIEW

When I looked up I saw the whole thing reflected in a mirror-effect ceiling. Now that really seems like a fun party. The colours kept changing – I chose this image with lots of vibrant blue. There's always another way of viewing everything if you take a look around. **1/13 second at f4.8, 55mm, 800 ISO. JG**

A HIGH ANGLE

Here is the arrival of an amazing birthday cake. I anticipated that I would have trouble seeing the cake between the guests standing around me, so before it arrived I stood on a chair to get above head level. I had to angle the camera to fit Judy and the cake in the frame as I was at my widest zoom setting. **1/30 second at f6.7, 24mm, 400 ISO. GH**

AVAILABLE LIGHT

This was my mother's ninetieth birthday party, with a young helper to blow out her candles. I used available light, overexposing with +1½ stops compensation to cope with the strong backlight. **1/15 second at f5.6, 65mm, 400 ISO. GH**

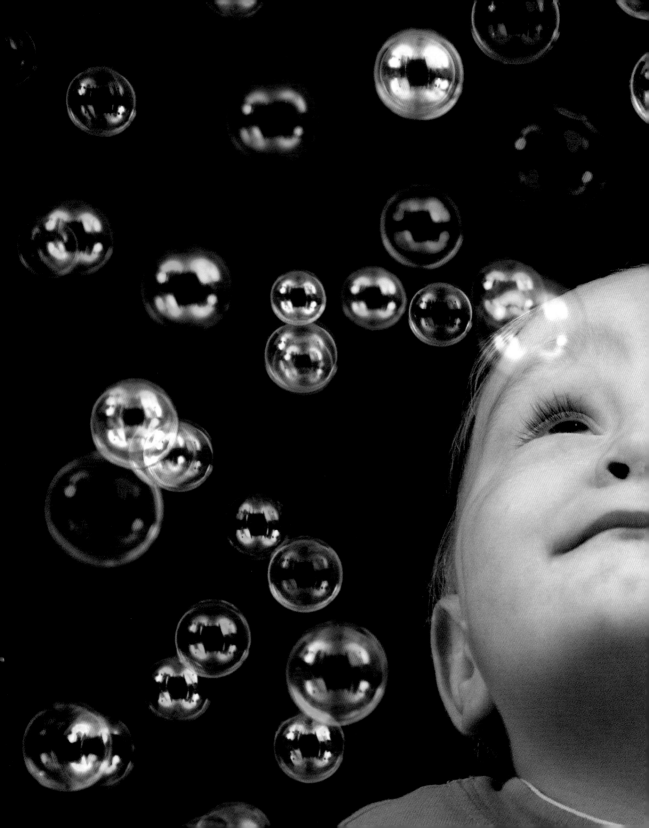

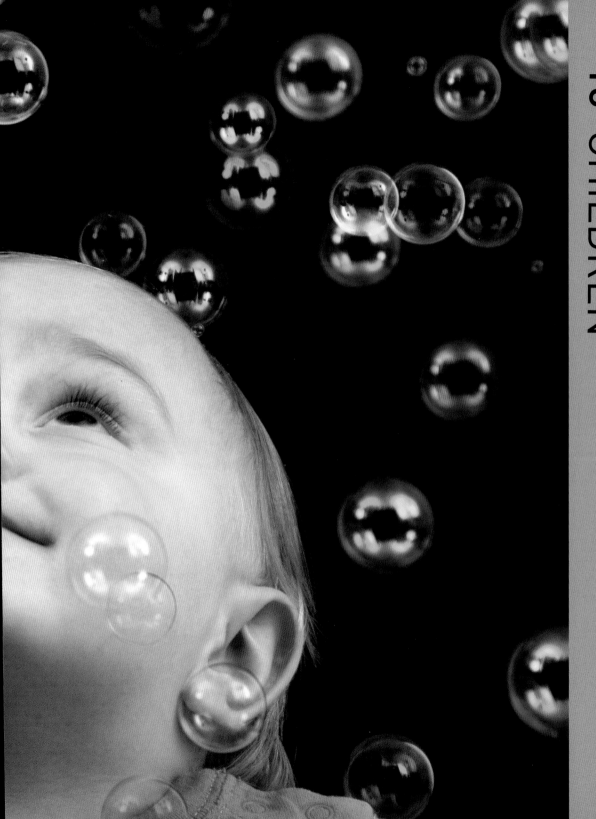

CHILDREN

Of the many millions of portrait photographs that are taken, the majority are of children. Even in the days before inexpensive snaps were available and when people were photographed few times during their lives, formal portraits of the new members of a family were considered important.

Today, babies are often photographed practically at the moment of birth, and those pictures can be immediately sent to relatives eagerly waiting with a laptop on the other side of the world.

However, just because we can do things at such speed these days doesn't mean we should leave it at that. Taking a considered approach will result in more meaningful photographs that are not only striking at the present time but will bring extra interest to future generations who want to see how their parents and grandparents looked when they were little. This doesn't necessarily mean formal shots – taking things slowly can also mean spending the afternoon in a park, shooting when the light is right and the mood is mellow.

We both took hundreds of pictures of our family life as our kids were growing up and we are now in phase two, shooting pictures of our grandchildren. Our children were used to us nearly always having a camera at hand and so acted as if it were not there. That's the best way to photograph children – aim to keep things casual and fun, and if they're disinclined to join in that day, don't make a big deal of it or you'll spoil your chances for the next time you try.

SEEING THE BIG PICTURE
(previous page)
This looks like a complicated shot, but it was quite simple to set up. I hung up a sheet of black felt for the background so that the bubbles would stand out. Using two flash guns, I bounced light off the white walls and ceiling to create a general light which put reflections on the bubbles and lit Luke's face. **1/125 second at f9.5, 105mm, 100 ISO. GH**

SHOULDER RIDE
Here is my son Matt with his daughter Isabella on a cold winter's walk in Pennsylvania. Photographing children is usually about evoking memories down the generations, and this was a flashback to when I carried Matt around on my shoulders. I decided to change it to monochrome and add a blue tone to make it feel colder. **1/80 second at f8, 32mm, 400 ISO. JG**

NEWBORNS

Photographs of newborn babies provide a touching record of their vulnerability, and capturing the first bonding between mother and child will provide something special for the family and future generations.

Whether the birth takes place at home or in hospital, light levels will probably be low, but don't consider using your flash; direct flash will kill the atmosphere, and you will get more natural pictures if you don't dazzle the tired mother and baby. Instead, increase the ISO to a higher setting, such as 1600, and use the available light. It doesn't matter that the pictures may have more grain or noise than at a lower ISO, as it gives the film-like look of documentary photography and in this situation that is preferable to camera movement.

To get some good pictures you may need to be there for a while, taking lots of shots, so keep everything minimal and calm. Unloading a lot of equipment may spoil the mood, but a mini tripod is a good idea; if you don't have one, there may be a surface such as a table that you can use for support. Take care not to crowd the family by getting in too close – this first meeting is a time that can never be repeated for them, and if you are being too intrusive you will probably be asked to leave them in peace.

Remember to include other family members in the shoot, too – older siblings are usually very much involved in the arrival of a new baby, and relatives far away may be there in the form of a Skype call on a laptop. Photographs of everyone involved will sum up the excitement of a whole family when a new arrival comes on the scene.

FIRST MEETING ▶
Capturing the first meeting of Isabella and Charlotte was about anticipation, just as in sports photography. You can't follow the action – you need to be in place and have everything ready so that all you need to do is push the button. When great memory pictures are missed, it's usually through lack of planning. **1/30 second at f5.6, 62mm, 800 ISO. JG**

◀ **BONDING**
Their mother, Kerry, sat Isabella securely on the bed and placed Charlotte in her arms. This picture captures her immediate protective instincts. The light was low and rather warm, but if need be I could alter the colour balance in Lightroom later. **1/40 second at f5.6, 56mm, 800 ISO. JG**

◀ MOTHER AND DAUGHTERS

The composition formed by the arms tells of the family bonding that is taking place. I put the camera on a mini tripod for some of the pictures; for others I used a table or simply rested the camera on my knee while I sat in a chair. **1/50 second at f7.1, 48mm, 800 ISO. JG**

 QUICK TIP

When shooting the baby from above, make sure that you use the camera strap, whether it's for the wrist or the neck. Never take the risk of dropping the camera.

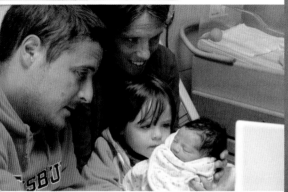

▲ THE MODERN FAMILY

Once the family had all met the new member and done some bonding, Matt got out the laptop and Skyped his family and friends all over the world – technology that is all part of the occasion in modern life. **1/30 second at f5.6, 32mm, 800 ISO. JG**

FATHER AND DAUGHTER ▶

I went really close up for this portrait of father and daughter to make the most of the beautiful juxtaposition of the two heads. I changed the image from colour to sepia in Lightroom as I felt it added to the warm atmosphere of the image. **1/50 second at f5.6, 70mm, 800 ISO. JG**

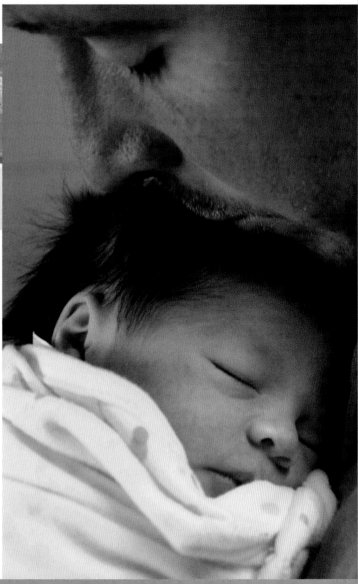

BABIES

Babyhood is one of the easiest periods in which to make photographs of a child, since babies can't run off when they get bored as older children are apt to do.

Nonetheless, it's a great benefit to have some help from their mother or a helper of your own to keep them amused, wipe their face and so on – a large-aperture lens is a very useful piece of kit, but equally so is a dribble cloth.

It's much better to use available light rather than firing a flash repeatedly into babies' eyes – they will soon become unhappy with that and your shoot will be over. Using an ISO of 2000+ makes flash-free photography possible in most light conditions without sacrificing much quality. As many of your pictures will use a window light, keep a white reflector handy and ask your helper to hold it opposite the window for some shadow fill. Alternatively, shoot outdoors on fine days –

light overcast is best, but if the sun is out, choose a spot in light shade to avoid harsh shadows and screwed-up eyes. If you do need to use artificial light, plan and prepare carefully to get what you want in as few shots as possible.

For those blotchy-skin days, converting to black and white and adding some retouching in Lightroom or Photoshop will work wonders. However, if a baby is tired and fretful, don't waste your time trying to change that, unless it's something that can be fixed by a snack. If the shoot didn't work today there's always tomorrow, and it's much better to give up quickly rather than become associated in the family's mind with the sound of crying.

NATURAL LIGHT
The softness of natural light is ideal for the curves of a baby's face. This was taken when Luke was asleep with his head partly shaded by the pram hood, the light making a feature of his ear. Overcast daylight gave it a sculptured look, so I decided to carry that further by converting the image to black and white, making it look almost like marble. His striped jacket was in the way when I took the shot, but I cropped in tightly at the bottom to lose it. **1/180 second at f5.6, 70mm, 400 ISO. GH**

▲ **STUDIO PORTRAIT**

This is the classic baby portrait. Getting everything set up and ready to go before you place the baby on the background is the most important part. I used white photographic background paper here, but a white sheet ironed and stretched flat will work as an alternative. It was lit with two flash lights, one in a soft box to the left and one on the background, and a reflector on the right to soften the shadows. **1/125 second with flash at f11, 60mm, 400 ISO. GH**

▲ **THE END OF THE DAY**

The time of day when the baby is finally asleep is something tired parents give thanks for, and it's great for a photographer too. This portrait was shot in low light. The colour has come out with a bluish cast that I could have corrected in the camera with WB setting or in the computer, but I decided that I liked the night-time look of the image as it was. The colour balance affects the mood of the picture, and baby pictures are all about feeling – they don't have to be technically correct. **1/8 second at f4.5, 30mm, 800 ISO. JG**

▼ **INDIVIDUAL FEATURES**

The hands, feet and ears of babies are really beautiful and make lovely close-up pictures. This baby was apparently fascinated by her own hands. With her face in the background they formed a strong composition. In colour the skin tones were a bit blotchy, so I converted to black and white and softened the focus a touch in Lightroom. The result is a baby picture that is a bit different. **1/160 second at f4.5, 35mm, 600 ISO. JG**

▲ **THE PLAYFUL PICTURE**

I lined up the cars, but my grandson was moving around so quickly I didn't have time to get all the other details right, such as removing the armchair in the background – I figured that if I didn't grab a snap immediately I would lose the shot altogether. I cropped it tight to a panoramic shape to emphasize the line of cars and burned in the chair to make it less obtrusive. This is one of my favourite shots of him. **1/90 second at f4, 24mm, 400 ISO. GH**

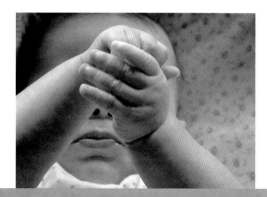

CHILDREN'S STUDIO PORTRAIT

Most parents take dozens of photographs of their children in everyday situations, but for formal portraits they tend to go to a professional studio. This project will show you how to get photographs of similar quality in your own home.

You need a room with some clear space; I used my living room for the photographs here and hung a smooth white sheet against the wall for the background, but your wall alone will suffice if it's white. The simple lighting set-up is one that I use often for groups and children. It consists of two flash guns, the front light fired by the camera and then firing the other one. There are cables available to get the flash gun off the camera while still providing all the electrical connections for the camera and flash to talk to each other. More recent flash guns can operate remotely, the camera firing the flash gun or guns from a distance without needing a cable.

If you're using on-camera flash, rotate it so that it bounces on the ceiling and wall behind you as this will give you soft, shadowless lighting on the faces, avoiding the problem of one head throwing a shadow over another when the children move around. This assumes that the ceiling and wall are painted white, or a pale neutral colour. If not, you can produce a similar effect by bouncing the light off a white umbrella. These are cheaper to buy from a department store than from a photography shop – you shouldn't have difficulty finding one as they're used for weddings on rainy days.

Put your backlight on a light stand at the children's head height, directed at the centre of the background. You can buy inexpensive light stands on the internet, but if you haven't got one, try placing the flash on a chair seat. The background light needs to be 1½ stops brighter than the front light, otherwise your white backdrop will photograph grey.

Especially in the case of children, you should do some test set-ups with a stand-in before your real subject arrives. Children will rapidly get bored if they have to wait while you fiddle about trying to get things right.

◤◥ GETTING THE SHOOT GOING

I made a start with Mia and Darcy standing together and smiling for some good safe head and shoulders shots, then to liven things up and try for a more interesting picture I asked them to shout out loud. This loosened them up a bit and they started to play around. I then asked them to rub noses, which they thought was funny. It looked great, so, asking them to stay in that position, I quickly moved Mia's hair clear of her shoulder and continued shooting. **1/80 second at f11, 80mm lens, 100 ISO. GH**

▼ **THE FINAL PICTURE**

I didn't want to move the camera closer to the children as I was more concerned with catching the moment, and I knew I could crop in later to concentrate on their expressions. I also used the Photoshop Dodge tool to lighten Mia's face a little. **GH**

QUICK TIPS

• Don't be afraid of making a fool of yourself when working with children, especially small ones – you have to do what it takes to capture some animated pictures. It's a good idea to have a few toys to shake around above the lens.

• Ask parents to help by standing close behind you and waving toys, pulling faces and so on while you concentrate on catching the expressions. They may feel they're intruding on your personal space and start moving to one side, but encourage them to stay in place or the child's gaze will be directed away from your lens.

• Studio flash kits have come down a lot in price and are very versatile. They have built-in guide lights that enable you to see what the lighting will look like and they give you the ability to reproduce the look of window light with the advantage of freezing movement. LED video lights are cheap, cool and provide a soft light source, but to get a fast enough shutter speed you need to provide a lot of light or set your ISO very high.

THE WORLD OF THE CHILD

This project is about following children and trying to capture them absorbed in their own world rather than asking them to pose for you. The more that they see you around with camera in hand the easier these pictures become.

Encourage children to become involved in a favourite activity and then back off to photograph them unobtrusively. Trying to take a great picture of children at play a few minutes before you have to dash off rarely works, but if you delay taking any pictures until they're engrossed in something they will hardly notice your presence.

What you need here is a telephoto zoom, a motor drive and plenty of patience. Don't worry about how many misses you have – you will get some beauties if you spend some time at it.

Alternatively, the smartphone cameras are so good now that you could get some of your best 'kids world' pictures with one of those, since what you're doing will be even less noticeable.

Before you tackle this project, practise over and over again the technique of composing and shooting very fast. You can do it in spare moments – autofocus, turn, compose, shoot almost in one movement. Check first that your autofocus is on central and the shutter speed is fast enough to freeze any action.

ANTICIPATING THE MOMENT
You can often predict what will happen in certain circumstances. I had seen Luke watering the garden before and had a rough idea what would happen. I took the 'watering the garden shot' and waited; sure enough he put his hand over the water jet and my wait was rewarded. The high shutter speed has frozen the water drops. **1/500 second at f5.6, 65mm, 400 ISO. GH**

▼ **CHILDREN INTERACTING**
This was taken a long time ago but has become a family classic; John's son and my daughter. They were talking together and were unaware of me and the camera. I took a number of shots until the right action happened; Matt decided to end the conversation.
1/125 second at f8, 50mm, 400 ISO film. GH

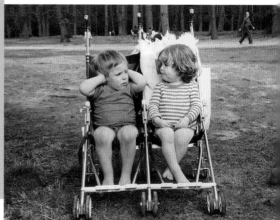

◀ ROMANTIC SHOTS

This was shot with a diffusing filter on the lens to make the highlights glow, giving it a dreamy Alice in Wonderland look. If you haven't got a filter, try breathing on the lens for a similar effect. The Clarity tool in Lightroom is the best I have found to replicate the effect in post-production. I cropped the picture tightly to make the most of the reds and to remove the background to the left, which was not contributing to the quality of the picture. **1/60 second at f4, 120mm, 400 ISO. GH**

◀ INCIDENTALS

The favourite red shoes. Don't forget the little incidental pictures – they may not have much value now, but they will provide great memories in years to come. **1/90 second at f9.5, 75mm, 400 ISO. GH**

▼ IMPROMPTU SHOTS

Luke had almost emptied the shelf to make a little cubbyhole in which to play with Lego. This was taken with my compact camera that I have with me most of the time so as not to miss these gems. It is lit with daylight from a window on the right, the white wall bouncing the light and softening the shadows. **1/45 second at f3.4, 5.2mm compact camera, 400 ISO. GH**

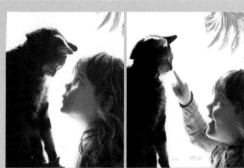

KATHERINE AND ZOE

I found Katherine playing with Zoe in front of a large window. There was just enough bounce light from the white walls to fill in the foreground. Because of the very bright backlight, I set the exposure compensation to +1½ stops to get enough exposure into their faces. The simplicity of these almost silhouetted figures makes them stand out – had there been a confusion of background detail, they would have been lost. **1/30 second at f4.5, 50mm, 800 ISO. GH**

◀ ACTION SHOTS

Photographing children in action can be tricky, but the combination of the autofocus on continuous, the motor drive and a zoom to keep the action in the frame makes things easier and the pictures will be great memories. Encourage the child to get involved in something and then you can set to work. You need to shoot a lot of pictures as this gets you into the rhythm of the action. Set the ISO high enough to allow you a shutter speed of 1/500 second or faster. **1/500 second at f5.6, 120mm, 400 ISO. JG**

▼ ISABELLA COWGIRL

This is the sort of thing most children can't resist. It's a cliché, but the spot of light coming through the trees makes the picture interesting. **1/300 second at f5.6, 120mm, 400 ISO. JG**

▲ THE FAVOURITE TOY

The Pink Panther was Matt's favourite toy. It was actually bigger than him but he carried it everywhere with him anyway. It is one of those glimpses into a child's world that are so rewarding years later. **1/500 second at f4, 150mm, 200 ISO film. JG**

▲ MEALTIMES

This is classic Rembrandt-style lighting, with daylight coming in through a doorway and just enough fill-in from the white walls in the room. It is of course the expression on his face, eyeing the food that he didn't finish, that makes the picture. I managed to do two shots on my compact camera, this one and a blurred one as he raced off. **1/180 second at f4.3, 15.6 compact camera, 400 ISO. GH**

UNDERWATER SHOTS ▶

Nick had just learned to swim underwater and was really enjoying the new experience. I made several attempts to sit on the bottom of the pool and shoot with my underwater Nikonos camera as he swam down towards me. It took about half an hour to make the picture, which is one of my favourite family shots. Underwater photography is great fun; the pictures are best taken around noon when the sun is right overhead, providing the highest level of underwater light of the day. **1/300 second at f5.6, 28mm, 400 ISO film. JG**

◀ ICONIC MOMENTS
This is an iconic little-boy shot of the sort that you generally get only of your own children. I only noticed later that he is wearing odd boots, a big one and a small one. I shot just two frames and left him to get on with his own shoot-out. **1/250 second at f6.3, 40mm, 400 ISO film. JG**

BATHTIME ▶
The high viewpoint makes this picture a bit different, with my daughter surrounded by all the bathtime symbols. Her face looking up, slightly brighter than everything else, is the point of interest. **1/60 second at f4, 45mm, 400 ISO film. GH**

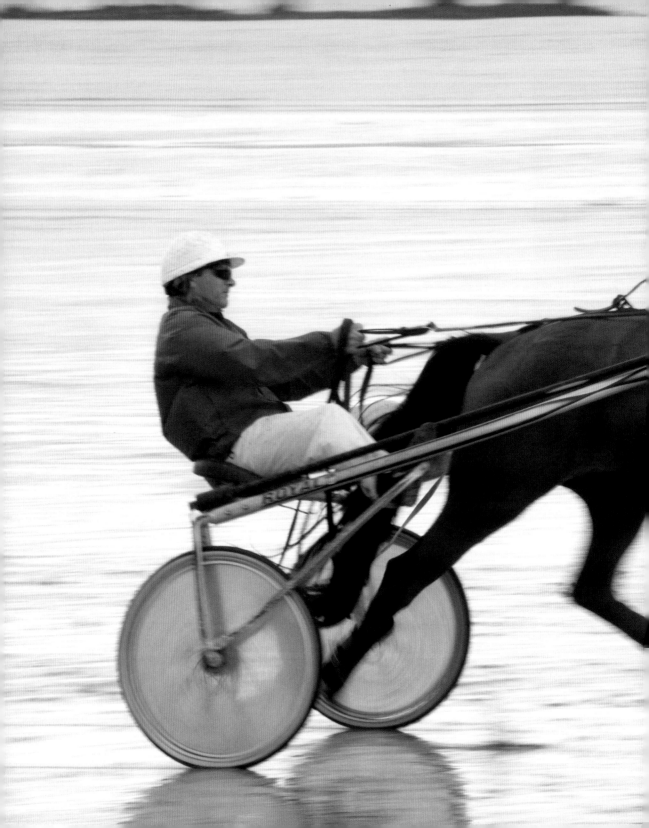

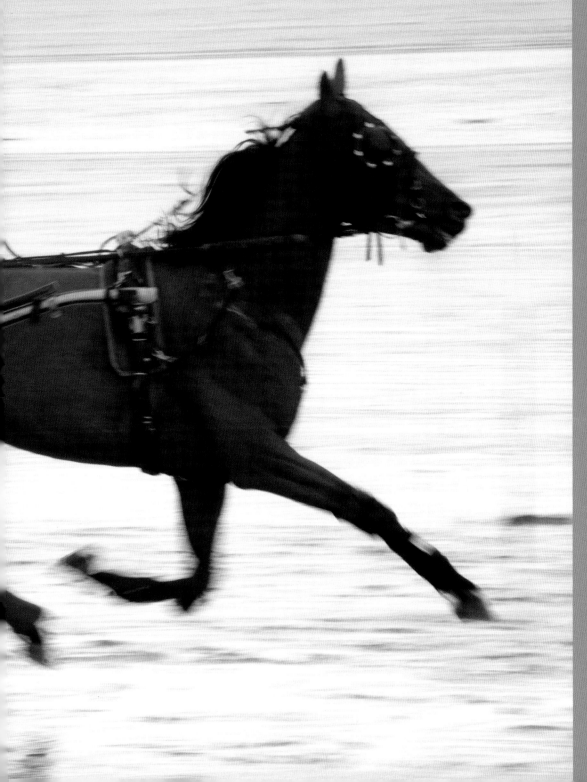

This category of photography is such a wide one that there's something for nearly everyone. Maybe you want to go on nature holidays abroad, seeking the iconic animals of Africa or the Galapagos Islands, or you love a particular type of domestic animal such as the horse – equine photography is in itself a wide-ranging genre.

Alternatively, you might just want to take cracking photographs of pets. What all these topics have in common is that animals aren't going to pose for you and you'll have to work out the best way to get your shots by thinking about their natural behaviour and then being very patient while you wait for the right moment.

The great wildlife pictures that we see in books and magazines are taken by specialist photographers who devote their lives to photographing animals. Although we can't compete without possessing their dedication and skill, we can take satisfying wildlife pictures by means of getting out there and practising. Going on safari equipped with high-quality telephoto lenses and accompanied by a guide is expensive, but there are lots of good wildlife pictures to be made close to home. Even in towns there are urban foxes, deer in local parks, garden birds and zoos. Knowledge of wildlife is just as important as skill with your equipment, and both will increase as you go along.

If you have pets, starting your animal photography at home is ideal, since knowing their behaviour patterns will enable you to anticipate the action. From there, you can branch out, visiting stables, farms, zoos, agricultural shows and gymkhanas. The more time you devote to this genre, the faster you'll see your work improve.

TROTTER (previous page)
At the beach-trotting races in Brittany the weather was poor, but the drizzle provided me with the attractively washed-out colours. I panned with the horse, which at 1/90 second slightly blurred the background and enhanced the feeling of speed. The driver's red jacket really helps the picture. I used a camera raincoat. Extreme conditions are a gift for the photographer, since that's when we get the kind of shots that rise above pretty postcards. **1/90 second at f16, 120mm, ISO 800. JG**

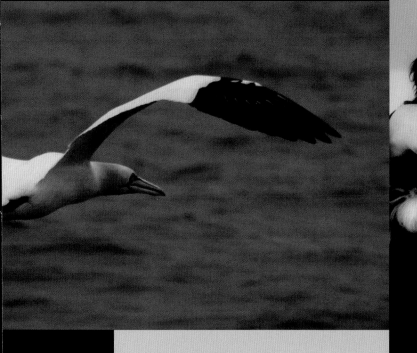

GANNET IN FLIGHT

Continuous autofocus enabled me to follow the flight of this gannet as it soared high and swooped low along the surface. Birds in flight are not easy; try to lock on to one bird and follow its flight pattern, keeping it in the centre of the viewfinder with the centre focus brackets selected. I underexposed this by −1½ stops to increase the drama of the picture. Back home on the computer, I cropped the picture to make the bird bigger and lightened the beak and head slightly. **1/5000 second at f5.6, 200mm, 400 ISO. JG**

▲ LAURENCE AND COCO

It's often easier to take a portrait of a dog when the owner is present. Laurence was giving Coco a cuddle, I moved them closer to the window and turned them both around to face the window so they were front-lit. A bright overcast day ensured beautiful soft light. I checked the camera controls before I put the camera to my eye – you have to be prepared to get the shot in one exposure in case the animal loses patience. The background is a white wall. **1/100 second at f5.6, 65mm, 400 ISO. JG**

PROJECT

1

WILDLIFE

While you can take fine pictures at the zoo, in the park or in the countryside, the ultimate animal experience is out there in the wild, such as a safari in Africa. Unfortunately safaris and other nature holidays tend to be expensive, but if animal photography is your passion that's what you should aim for.

For this you will need a telephoto zoom such as 200–400mm. The new digital cameras that produce excellent quality at very high ISO ratings are a big help, because most wildlife species are active early and late in the day when the light is low. Now it's possible to shoot at that time of day without the professional skills and equipment that were once required.

On most safari holidays you will be provided with a suitable vehicle driven by a knowledgeable guide who will find the animals for you. You can buy a tripod head that clamps to the door of a vehicle, but an easy alternative is to fill a plastic bag with dried beans and lay it over the door with the window wound down. The lens sits in it and is very stable. You can also pack up quickly if your guide feels that the situation is getting a bit dangerous.

Often a good safari shot comes at the end of a long and patient wait. Keep checking that there's plenty of life left in your battery and that you have plenty of space left on your card – it would be a tragedy to miss a great shot because the battery ran out or your card was full. Always have a newly charged battery and a fresh card with you, and don't wait until the last minute before putting them in the camera.

While you're on safari, concentrate on photographs that you can only get in the wild; the easy option is to shoot a whole series of animal portraits, but you can do that at a zoo back home. Your assignment is to shoot a series of pictures that illustrates the behaviour of a species in its natural habitat. This could be a pride of lions and their kill, animal behaviour at a waterhole, or predators in the act of stalking, for example.

Of course, not everyone can go on safari abroad, but shooting wildlife at home is not much different. The animals may be less dangerous and the weather may be cooler, but the principles remain the same: be prepared for a long wait and have everything ready to go when the action happens. Most species in more urbanized countries tend to be frightened of human beings, so give some thought to how you can minimize sound – which includes not putting your equipment in bags that rustle or in pockets with Velcro fastenings.

▼ WORKING WITH LOW LIGHT

In the dim early morning light the shutter speed was 1/60 second, too slow to handhold a 300mm lens. I supported the lens on my bean bag. Shot on film, the colour turned out too cold so I warmed it up in Photoshop. **1/60 second at f5.6, 300mm, 400 ISO film. JG**

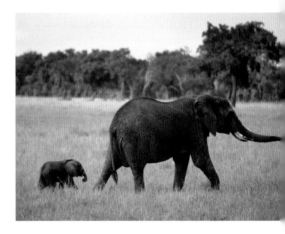

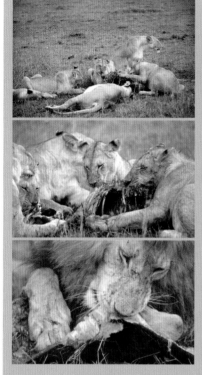

THE ESTABLISHING SHOT

Photographed at 7am, this pride of lions was breakfasting on a recent kill in the Masai Mara. The 100mm zoom setting was ideal to give me an establishing shot. **1/125 second at f5.6, 100mm, 800 ISO. JG**

ZOOMING CLOSER

To get closer to the lions' heads I zoomed to 200mm. This can be considered more or less the normal lens setting for safari pictures, from the point of view of safety. **1/125 second at f5.6, 200mm, 800 ISO. JG**

CLOSE UP WITH AN EXTENDER

It wasn't until I placed a 300mm lens with a 1.5x extender on the camera that I was able to see the evidence that this male has had to fight hard to keep his pride together. Sometimes only a very long lens can expose the harsh realities of life in the wild. **1/125 second at f5.6, 300mm plus 1.5x extender, 800 ISO. JG**

QUICK TIP

The right clothing is as important as camera equipment on safari, since you can get very sunburnt. Wear a shirt with a collar to put up and sleeves to roll down, plus a proper sun hat that shades the face and, of course, sun block. You cannot take good pictures if you are sizzling.

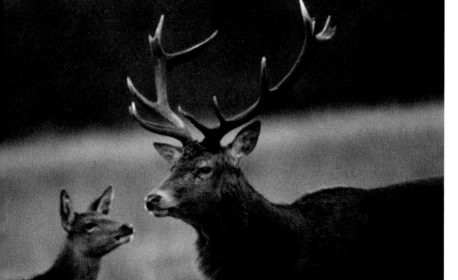

◄ USING SHORT FOCUS

While there's nothing in this photograph to indicate that it wasn't shot in the wild, it was in fact taken in Richmond Park on the edge of London. It was almost dark when I spotted this stag with a young fawn in the background. I had a 400mm lens on the camera and the camera was on a tripod. Shooting at maximum aperture turned the background into a nice soft tone. I took a number of photographs and in this one the attractive shape of the negative space between the stag and the fawn makes the composition strong. **1/60 second at f3.5, 400mm, 800 ISO film. JG**

GOING TO THE ZOO

Seeing exotic animals in the wild is the ultimate privilege, but if you can't achieve that, all is not lost – with a bit of planning you can have a great day out capturing some beautiful animal portraits at a zoo.

This is also great practice if you are planning to go on safari, since you can familiarize yourself with some of the animal traits, get your eye in and master your technique.

Obviously, one of the main problems to overcome is how to exclude the cages and any background that hints at captive animals. Modern zoos have made this much easier, with large open enclosures and clear plastic viewing windows in some areas. Even so, you will need a lens with a long focal length and a wide aperture. For an animal in a cage, provided it is not close to the wire mesh, such a lens allows you to throw the mesh out of focus while you focus on the subject. This is also necessary for viewing windows, as they will have smudgy nose and paw prints on the inside and fingerprints on the outside. While you can carry wipes to clean the outside of the window in the area you want to shoot through, there's obviously nothing to be done about the inside.

This project is exciting yet requires a lot of patience – be prepared to spend all day and maybe pay more than one visit. Arrive early, as soon as the zoo opens, and on a mid-week day if possible so there are fewer people. The animals will move about and the light will change, so you will probably have to visit them more than once to get the shot you are after. Make a portrait of one of the animals that is behind wire mesh or bars, using the technique shown here to remove those and show the animal in all its glory. Then, as feeding time usually offers the chance for some good shots, ask the attendants when this occurs for the animals in which you are most interested and take a series of pictures there, too.

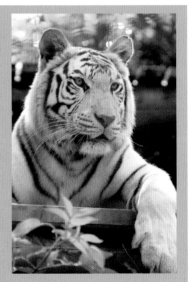

THE DISTANT SHOT (left)
This is a straightforward shot of a snow tiger as I found it, luckily a good distance from the wire mesh of its cage. **1/320 second at f4.8, 48mm, 400 ISO. GH**

USING A SMALL APERTURE (below left)
I got as close to the mesh as possible and focused on the tiger using a longer lens. As you can see, with a small aperture of f16 the cage mesh is visible, though not in focus. **1/60 second at f16, 170mm, 400 ISO. GH**

USING A WIDE APERTURE (right)
With a wide aperture, the mesh disappears completely and the wooden structure behind the tiger is also thrown out of focus. While the vegetation remains unlike the habitat of this animal, the constraints of the zoo have been minimized. **1/500 second at f5.6, 170mm, 400 ISO. GH**

EYE-LEVEL SHOOTING ▶

Meerkats are a joy for the photographer as their natural behaviour makes them appear to be posing. As the viewing window stretched to the ground I was able to lie down and get the camera at meerkat eye level. Using a wide aperture threw the background out of focus, isolating the meerkat from its surroundings. **1/750 second at f6.7, 135mm, 400 ISO. GH**

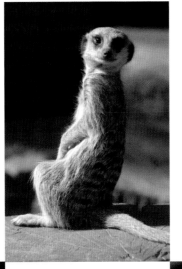

▼ LOOKING FOR THE RIGHT LIGHT

When I first saw the flamingos the light was uninspiring, so I gave up after a few shots. Later the sun came out, backlighting the birds, and eventually I got this great configuration. If you have only one chance at a subject go ahead no matter what, but if you can return later when conditions are better, that extra effort will pay off. **1/500 second at f6.3 200mm, ISO 400. GH**

◥ FINDING SHAPES AND PATTERNS

I photographed these two sisters for some while, returning a few times during the day. They finally moved into this position and I was just able to get this double profile shot at an angle through the window. I cropped it tightly later to remove some foliage in the foreground. **1/180 second at f5.6, 105mm, 400 ISO. GH**

◀ WAITING FOR A SHOT

The tiger snoozed, I waited. Finally he went for a stroll and as he emerged from a bush the sun came out, rewarding me with a few colourful, brightly lit shots – a combination of perseverance and luck. **1/800 second at f6.8, 200mm, 400 ISO. GH**

PHOTOGRAPHING A GYMKHANA

If you're interested in equine sports, there's probably no shortage of showjumping, dressage and cross-country events up to the highest levels you can visit. However, you're likely to get more interaction with the participants, both four-legged and two, at a local gymkhana.

While they don't have much in the way of star names and advanced skills, gymkhanas are great events for photographers as well as horse-lovers because they provide us with the opportunity to capture that special relationship between children and their ponies.

As with most animals, anticipation is key to getting photographs that show horses at their most interesting and beautiful – there's less than a second between getting a fantastic photograph or one where there's a leg at an unattractive angle. Even if you are very familiar with horses, you can learn a lot about how to photograph them by just watching them for a while, relating their movements to the moment when you would need to take your shot.

Stationary shots and portraits of heads are of course much easier and at a local gymkhana the participants will probably be relaxed enough to pose for you, especially if you offer to provide a print by way of thanks. At many events there will be an accredited photographer in the ring taking shots of the competitors in action and printing them out on site at a low cost, but most horse lovers will happily encourage their beloved steed to look alert, ears pricked, for a photograph that's a bit more personal. If you want to include a child you don't know in the picture, it's wise to ask permission from the parents first.

The pictures here are an extract from a photo story about children and parents at gymkhanas. Trying to provide a narrative of an event is a good way to focus your mind and shoot with a purpose, so you could choose to follow the course of the day from the arrival of the horses through saddling up to competing and then resting afterwards. Look for small details and amusing angles – where there's a horsebox there's often a dog peering out of the window, for example, and a rear view of a small child on a fat pony is always irresistible.

You can find many walks of horsey life at a gymkhana, from sturdy pets and their doting owners just having a fun day out to ponies with thoroughbred genes and immaculate riders using this as practice on the first foot of a ladder to much grander events. Capturing the scene as a whole will give you the strongest story.

◀ **DRAMATIZING A JUMP**
I didn't want to spook the pony and cause a fall, so I decided to back off a little and use the fence in my composition. I sat on the ground and set the zoom to its widest setting. The low camera angle has isolated horse and rider against the sky, and the wide-angle lens gives the feeling that the jump is more formidable.
1/500 second at f8, 20mm, 200 ISO film. JG

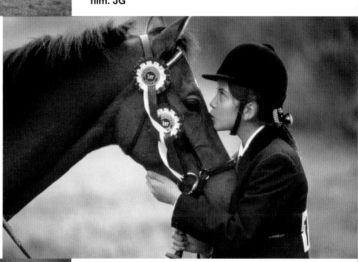

◀ SHOOTING FROM INSIDE THE RING

Here, a proud mum is escorting her even prouder child on a winner's tour of the ring. The judges gave me permission to stand in the centre while the horses paraded around in a circle. This was a perfect situation for a long zoom lens as it enabled me to keep any one of them in full frame as they moved along. I made about a dozen pictures trying to get what I wanted, and in this one everything has gone right; the legs are well balanced, and the position of the trophy and faces is about perfect. **1/350 second at f5.6, 120mm, 200 ISO film. JG**

FOCUSING ON A PARTNERSHIP ▶

I spotted this young rider planting a victorious kiss on her horse and asked her to repeat it for me, repositioning them in profile to make a strong, simple composition. I used a 300mm lens, the longest in my bag, at its maximum aperture. This has turned the field into a soft background of greens, giving a watercolour effect. **1/800 second at f4, 300mm, 200 ISO film. JG**

◀ CAPTURING THE COMEDY

Sweet, funny pictures such as this are all around you at a gymkhana. Using a long lens at its widest aperture again, I was able to take pictures of this little boy without him seeing me – though he probably couldn't have done so anyway. The long lens and wide aperture combination has done its job again by converting distracting trees into a soft green background. **1/500 second at f4, 300mm, 200 ISO film. JG**

A PET PORTRAIT

Taking a good portrait of someone's beloved pet is a really satisfying thing to do, but it's potentially tricky. You may find it takes some while to get the right setting, the right pose and the right expression to come together, so you need to have endless reserves of patience.

Our friends Richard and Sal have two Boston terriers, and in an over-confident mood one day I offered to make a portrait of them, thinking that it would take about 20 minutes, no problem. Two and a half hours later I reckoned that I finally had a few nice dog portraits. We went to a park and I started by following them around while we tried to make them sit – no joy! Next I lay on the ground and we sat them together, but they were distracted by all the other park activity so they wouldn't both look at the camera; then Richard and Sal picked them up, but it was a hot day and by now their tongues were hanging out unattractively.

In desperation I sat them up on a plinth that carried an Egyptian-style sculpture, and Richard and Sal placed them into several nice positions. They were too high off the ground to attempt an escapist leap, and in the shade they pulled their tongues in. I had them captured at last, and the sculpture added a theatrical quality. I now had their full attention and they made all the cute doggy kind of expressions that I would have appreciated some time earlier.

Your assignment is to make a portrait of someone's pet, or indeed your own. Choose a pose where you are not looking down on a small animal from a standing position – it's not flattering and the pet won't look dignified. And remember to leave plenty of time!

THE UNPOSED SHOT

I thought a park would be an easy location for a dog shot, but hadn't bargained on the distraction caused by all the other park activity. As this pair ran around in the heat they began to look hot and bothered, with lolling tongues. Here, they sat together and I lay down to shoot them at eye level, but they wouldn't look at the camera – there was too much going on elsewhere. **1/200 second at f9, 90mm, 400 ISO. JG**

FILL-IN FLASH IN SHADE

Up on the plinth of a sculpture the dogs were captive, and cooler in the shade, too. I used my flash set on fill-in as flash really brings out the gloss on an animal's coat. But there was still a problem – the dogs had recently been clipped and their pink skin was showing through their short coats on the chest area. **1/500 second at f6.3, 70mm, 400 ISO. JG**

POST-PRODUCTION ▶

Lightroom came to the rescue; when I reduced the red using the Saturation tool the pink all but disappeared and the dogs had white chests as they should. The colour has almost disappeared from the picture and it looks quite like a 1950s hand-tinted portrait. I could have done the same adjustment with Photoshop or any other retouching software. **JG**

PHOTOGRAPHING FISH

Photographing fish in a tank might seem straightforward, but in fact it can be quite time-consuming and taxing on the patience. However, some basic knowledge of how to go about it will take you a long way.

First, make sure that the glass of the tank is very clean, as this will save you a huge amount of retouching time later. If the tank is in bright light you can shoot in that, as long as there are no reflections on the glass from a window, for example. If not, you will need to use a flash gun off-camera at 45 degrees to the glass to avoid reflections. A tripod is no help here as the fish keep moving across the tank, so the camera needs to be more mobile; depending on the height of the tank, sitting on a chair will allow you to shift your position easily to follow the fish as they swim around.

If you are too close to the tank the fish will swim to the back of it to get away from you, so you will need a lens of at least 60mm. I used a macro lens, but your zoom, as long as it will focus close enough, will be fine. Once you have set up, just sit there for a while and let the fish become accustomed to you. You may find you need to use manual focus as the auto may focus on reflections on the glass at the front of the tank.

Depending on the existing background, it may be a good idea to provide one by using a sheet of card – white has been used in most of the photographs shown here, since black, while good for isolating the fish, shows up dirty glass more.

This is a good project for honing your camera skills as it requires you to think about a lot of details in order to get it right. Be prepared to take many shots, as you will probably find that if you are using manual focus many of them will be slightly out of focus. Make notes as you go, so that if you realize your photographs are not as good as you would like and you make a second attempt you will know where you went wrong.

For this project, get in close to make some fish portraits, both profiles and front-on shots. Having the fish large in the frame makes it less likely that there will be messy details of the weed and other tank accessories in the picture.

◀ **ON-CAMERA FLASH**
This is what happens if you use your flash on the camera – the light bounces straight back into the lens. The other problem with this picture is that the fish is too close to the glass, which means all the dirt and smears on it are also in focus. Wait until the fish is further back and use a wide aperture to throw the glass out of focus. **GH**

◀ THE SET-UP

Take the flash off the camera and use remote control or an off-camera cable to fire it. Setting the flash at 45 degrees to the glass avoids flash reflection. If you are using available light, you will need a high shutter speed since fish are constantly in motion. **GH**

▼ FRONT VIEW

I used the black background for this one. It looks great, but I spent a long time with the Photoshop clone tool getting rid of spots on the glass that I hadn't been able to clean off. Good preparation before you start shooting is essential. **Flash off-camera, 1/125 second at f8, 55mm macro, 200 ISO. GH**

▼ PROFILE VIEW

Close-ups are better than the longer shots as they isolate the fish and avoid all the clutter of weed in the background. They also show minute detail of the fish to give a fine portrait. Be prepared to shoot plenty of pictures – I had a high failure rate when taking these photographs. **Flash off-camera, 1/125 second at f8, 55mm macro, 200 ISO. GH**

PATTERNS

The world that we inhabit is a mass of interwoven patterns, some large and some tiny. We photographers just have to find them, and it is one of the most exciting adventures and the greatest way of learning to see images.

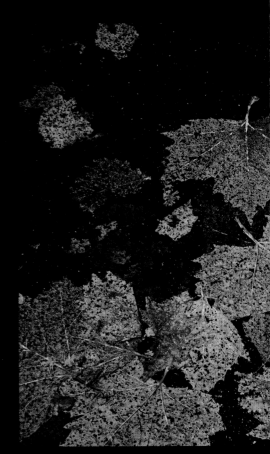

While you may not have realized it, you walk past many wonderful photographs every few minutes and once you teach yourself to really look at everything around you, your world will change forever. Everything will be more interesting to your eye, and thus to your mind too.

In this chapter you will find patterns photographed around the home, at the seaside, in the city and in the country, along with some step-by-step pictures that describe the paths that we took to find our chosen patterns. The eventual aim is that you will see patterns in everything that you shoot. You will compose your portraits differently, for example, and you will be unable to push the button on a still life until the patterns are working harmoniously for you. In fact, we are aiming to spark up your compositional awareness for all your photography by helping you to see with a more disciplined and creative eye.

DUCK ON THE POND (previous page)
This shot was taken in Regent's Park in London. I was fascinated by the straight-line reflections of the fence being distorted by the ripples the duck made. I took a few shots, but the problem was that the duck had its head turned away from me. The silhouette wasn't right as no beak was showing, but I didn't have time to wait – so I put in the beak with Photoshop, using the clone tool. **1/30 second at f4, 24mm, 400 ISO. GH**

▲ PEOPLE AT THE WINDOW

Waiting around at an airport, I noticed this unusual double reflection coming off two windows. The only colour was the reflection of the sky. This was just a matter of seeing what was around me. I exposed for the highlights so that the shadows would go black and hold their shapes. **1/200 second at f4.5, 30mm, 200 ISO. JG**

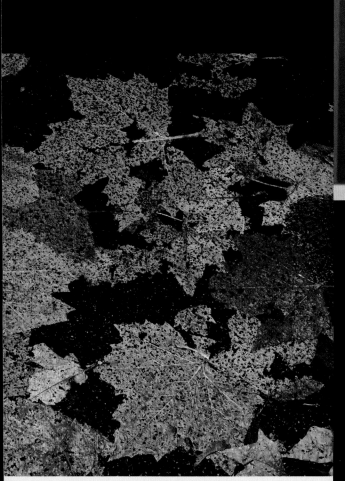

AUTUMN LEAVES

It was autumn and the leaves had been crushed into the wet road by the traffic. I had tried previously to shoot these leaf patterns in daylight, but the texture of the road was ugly. Crossing the road on a wet night, I fired off a couple of shots with the built-in flash. The leaves have reflected the flash, leaving the wet road dark and unobtrusive. **1/250 second at f11, 48mm, 400 ISO. JG**

COLOUR-DOMINATED PATTERNS

There's a big difference between shooting colours that just happen – the colours that your picture has presented to you – and deliberately searching out multi-coloured images.

Looking for pictures where the colour is really the subject is a great exercise, though not as easy as it sounds. However, once you get your colour eye in, you will start to find really exciting images that are full of energy. You will also discover how, for example, a red next to a green will have a different impact from that of a red next to an orange, for adjacent colours affect how each one is seen.

As you probably know, green is a colour that has a calming effect, while red encourages excitement that can be happy, passionate or angry. Blue is considered a cold colour. It is easy to remember which is which, because we draw these associations from the natural world –

respectively, trees, grass and restful landscape; the heat of fire and the sun; and the chill of ice and snow. Look for colour-dominant images and see if the colour does indeed dictate the mood of your picture. Take them into your image-editing software and radically change the colour. Does that new colour change the whole mood of your picture?

The assignment here is to take a set of photographs that are dominated by one colour and a second set where strong, contrasting colours vibrate to provide the excitement. For this project, don't worry too much about the content of your shots – the subject matter is the colour itself.

▼ **STRONG CONTRASTS**
The ambient temperature was –20°C (–4°F) at this roadside stall in Siberia, though the vibrant orange might tell a different story. The young woman was selling frozen smoked fish, the light was crystal clear and sharp, and the combination of colours and her glowingly healthy face had to be photographed. The orange and blue have been brought forward in the picture by the contrast of the bright green background.
1/500 second at f3.8, 24mm, 400 ISO. JG

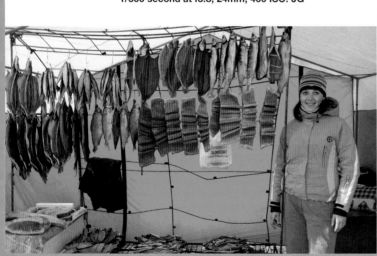

COMPOSING WITH COLOUR

The pink interior of a Mexican monastery gave a soft, gentle feel, so I made a symmetrical composition that doesn't jar with the mood. I used a wide-angle lens to exaggerate the perspective and made sure my camera was vertical, avoiding distortion of the perpendiculars. Pattern comes from the repeating doorways, the tiled floor and the verticals and horizontals of the chair, echoed in shadow on the wall. **1/13 second at f9, 15mm, 400 ISO. JG**

SHOWING A SUMMER MOOD

As soon as I saw the girl swimming underwater I was reminded of a David Hockney painting. It is the rippled blue pattern that creates a refreshing summer image. I used a wide-angle lens so I could get the camera over the water to capture this pattern of blues. **1/1600 second at f14, 20mm, 400 ISO. JG**

ISOLATING PATTERNS

The folk festival was a mass of coloured shapes on the move, and it was a matter of isolating patterns out of the confusing wall of bright hues. I was attracted to the unusual mixture of strong bright stripes leading up to a softer floral pattern at the top. **1/320 second at f6.7, 170mm, 400 ISO. GH**

YELLOW BUILDING (top)

I have shot this building a number of times. This day the sun was high, shining from directly behind the camera. It simplified the shapes and the bright primary colours of yellow contrasted against blue sky were dazzling. **1/640 second at f8, 80mm, 200 ISO. GH**

RED BUILDING

In Photoshop, I used the Hue tool to change the yellow building to red, this time with a green sky. Here two complementary colours are opposing each other, creating a visual energy so intense that it almost vibrates. **GH**

SATURATED COLOUR

It was the kaleidoscope of colour that attracted me to this seaside shop. I started with the whole interior, but then decided that a closer view told the story better. The contrasting colours make the spades almost jump out of the picture, while the darker edges hold the shapes together. Increasing the colour saturation gave it more zing. **1/125 second at f8, 85mm, 200 ISO. GH**

SILHOUETTES

Creating silhouetted images is another of those photographic genres that gets under your skin, making you increasingly fascinated as you explore further.

Here story-telling is all done by patterns made up of shapes – there are no facial expressions or other such clues, but many very emotive and complex images have been made just by using silhouettes. This is another good subject to look at in your search to see images in greater depth.

Any kind of strong backlight will create a silhouette if a solid object is placed in front of it. You will probably need to underexpose, since you don't want detail in your silhouette. With digital photography, you have the advantage that you can check the best exposure in any situation using playback on the camera.

The first part of the project is to use just one figure or object in your composition, making sure that the shape of the silhouette is elegant or interesting and not just a shapeless blob.

Secondly, use two or three figures or objects, choosing a composition that makes a more complex pattern – the silhouetted shapes must all complement each other to form a beautiful picture. They could be workers backlit early in the morning on their way to work, trees at sunset or anything else that inspires you. Silhouettes are usually quite sharply defined, so make sure you have focused correctly.

▼ **BIRDS**
Here the large black shape of the building emphasizes the delicate silhouetted shape of the birds. This image has been partly created in-camera and partly on the computer. Using Photoshop Elements, I increased the contrast to achieve a solid black then darkened the top left corner of the sky with the Burn tool to deepen the blue sky. **1/350 second at f8, 100mm, 400 ISO. GH**

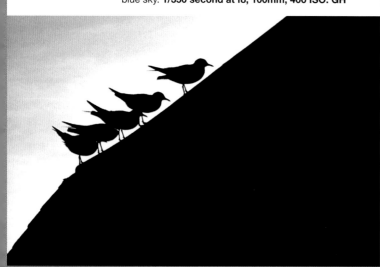

▲ AQUARIUM

To the untrained eye this would not have looked like obvious potential for a silhouette because there was considerable detail in the children. I could see that the brightness range would allow me to expose for the water and let the foreground go dark. Even so, I could not eliminate the detail in the children completely but I was able to darken the foreground later by increasing the black with the Blacks Slider in the Lightroom Develop module. **1/125 second at f8, 42mm, 400 ISO. GH**

▲ CONSTRUCTION

Shot directly into the morning sun, this image looks like a line drawing and is a traditional photographic silhouette. The difficulty of silhouettes is that the shapes must be perfect, both to tell the story and to create a pleasing graphic composition. I saw the workmen in exactly the right position as I arrived, but as they were moving around I had to wait for another half hour before they assumed these perfect profiles. **1/500 second at f16, 80mm, 125 ISO film. GH**

◀ BRIGHTON PAVILION

Silhouettes don't have to be black and white; the sunset behind the Brighton Pavilion has added an exotic flavour sympathetic to the spectacular design. When you shoot any kind of silhouette, ignore all the detail – in this case in the surfaces of the building – and concentrate purely on the shapes against the light background. **1/80 second at f6.7, 150mm, 400 ISO. GH**

◀ ISABELLA

Engrossed in her favourite TV programme, Isabella took no notice as I photographed her in silhouette, her face backlit by a large French window. The effect is like one of the Victorian silhouette portraits that became popular in the mid-19th century. Wherever there is a face and a big window you have the potential for a shot like this; make sure that you underexpose so that there is no detail in the face. I also used a large aperture to throw the background out of focus. **1/1000 second at f4, 40mm, ISO 600. JG**

REFLECTIONS

Like silhouettes and shadows, reflections require a different way of looking at the world around us – they are the alternative world, as it were.

You'll often find that amazing graphic designs pop up in your viewfinder once you start training your lens on reflections, and they also allow you to capture ambiguities, giving two contradistinctive views of the same subject in one photograph. The most likely places to find what you are looking for are glass office buildings, lakes and rivers.

The project here is first to take a picture of a person and their reflection in one shot; you may need to use a small aperture to keep both in focus. Secondly, photograph a reflection in water, aiming for an effect like a watercolour painting. You can use fast shutter speeds (1/125 second upwards) to get crisp shapes or slow speeds to get a soft, more impressionistic look. Wind is the enemy of water reflections, but rainy days that look so unpromising for most other photography are great for reflections on hard surfaces, especially at night.

MOTOR SCOOTERS
I found this line of motor scooters parked in the road, making an interesting diagonal pattern. I looked a bit closer and noticed the reflections in the mirrors. **1/250 second at f8, 50mm, 400 ISO. GH**

FOCUSING ON THE MIRRORS
After lining up the mirrors so that the buildings were reflected in them, I selected a wide-angle setting on the zoom lens and moved the camera to make the mirrors form a diagonal line. I used a small aperture because I needed a deep depth of field to get both the buildings and the scooters sharp. **1/90 second at f16, 20mm, 400 ISO. GH**

SEEN IN A WINDOW

Estelle was sitting opposite me on a tram in Vienna. As I looked out of the window I noticed her reflection showing quite strongly against the dark background of a day with low light levels. I took this first picture looking directly at Estelle, with the rigid structures of the train repeated in the reflection. **1/250 second at f7.1, 40mm, 500 ISO. JG**

FRAMING FOR CINEMATIC EFFECT

This is one of the many reflections shots that I made. Estelle has a rather dramatic expression that gives the feeling of a clip from a movie. The colour was very muddy, so I restored it to how it would have looked in the movies. I placed her face right on the edge of the frame to give her a trapped look and used a wide aperture to let the foreground go out of focus. Here the patterns are in soft-focus colour. **1/125 second at f4, 170mm, 500 ISO. JG**

FRENCH HOLIDAY

Visiting friends in the south of France, I took this picture for them as a memory of the holiday. It's a straightforward shot of a house with a pool. **1/200 second at f11, 18mm, 200 ISO. JG**

REFLECTIONS IN THE POOL

The reflection of the house in the pool becomes much more interesting. A photographer wants to do more than just record people and places as memories. That may be what you used to do; now you are hopefully looking for an interesting photograph in every situation that you find yourself in. The very brightly lit house and the pool in shadow have created the strong reflection. **1/125 second at f11, 38mm, 200 ISO. JG**

SHADOWS

Once you become conscious of the possibilities that shadows offer a photographer you will see them with a fresh eye everywhere you go. They are a great opportunity for patterns and for atmosphere, too, as we normally associate them with drama and mystery.

Your local high street can be a bright and cheerful place at noon, for example, but by the late afternoon the shadows may have changed it into a more dramatic place, perhaps becoming even dangerous later when inky shadows lie beyond the light from the street lamps. It's a good idea to expose to find detail in your shadows when you shoot them. You can then take the image into the computer and decide whether to keep some detail or alternatively increase the contrast and make them black.

On a bright sunny morning or afternoon when the shadows are long, shoot some pictures of a subject and its shadow, plus some of the shadow

only. Look for a shadow composition that creates a feeling of mystery and also provides strong, interesting patterns.

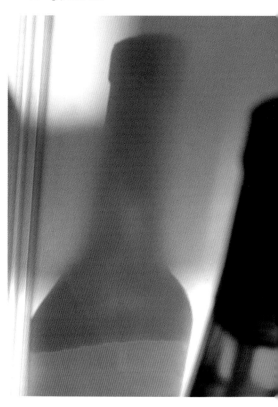

▲ SOFT-EDGED SHADOW
Shadows can be soft-edged or hard-edged, depending on the light source in relation to the subject – the smaller the light, the sharper the edge. I asked one of my students to sit on a chair, arranged a floodlight to the right of the camera and shone it on him so it cast a shadow on the background. I added a diffuser gel (which resembles tracing paper) to soften the edge of the shadow slightly, then a blue filter gel to colour the light. You could simply use a desk lamp and create any colour you like in post-production. **1/60 second at f8, 72mm, 800 ISO. GH**

▲ SHARP-EDGED SHADOW
This is a shadow pattern found in my house – the bottle of rosé wine was on the kitchen bench. The clouds cleared and the sun made this colour reflection on the side of the refrigerator. I framed it tightly, keeping enough of the bottle in to form the double-image shape with the shadow. I wanted a sharp shadow and an out-of-focus bottle, so I used a wide aperture. **1/250 second at f5.6, 35mm, 400 ISO. GH**

▲ YOUR OWN SHADOW

I noticed my shadow mixed with the tree shadows on my street and shot this on my iPhone. Images from an iPhone have their own special quality and having one means you are never without a camera. Putting yourself into your shadow pictures can add another element to the composition. **1/280 second at f2.8. JG**

▲ USING SHADOWS FOR DRAMA

This image is about using shadow to dramatize inner-city squalor. It was taken in the late afternoon when the buildings were backlit and in deep shadow; if I had shot this scene front-lit and shadowless the atmosphere would have been far less foreboding. It was shot on film, with a red filter to lift the contrast and darken the clouds. **1/500 second at f8, 35mm, 1600 ISO film. JG**

INCLUDING PASSERS-BY (right)

Two men came past and stopped to talk, I took a few shots, then waited until one of them turned his head so that I could see the shadow of his cap. The peak of his cap defines the shadow shape as a person. **1/400 second at f8, 82mm, 200 ISO. GH**

TAKING A DIFFERENT VIEW (left)

Looking at the picture later on the computer I saw another picture possibility. I cropped it to a square and turned it upside down, transforming it into a new picture. The steps look like railings and the paving like a ceiling. I increased the contrast to finish it. **1/400 second at f8, 82mm, 200 ISO. GH**

FINDING SHADOWS (above)

I found myself a high vantage point above some steps and waited. Looking down assured me of seeing some long shadows. **1/500 second at f8, 65mm, 200 ISO. GH**

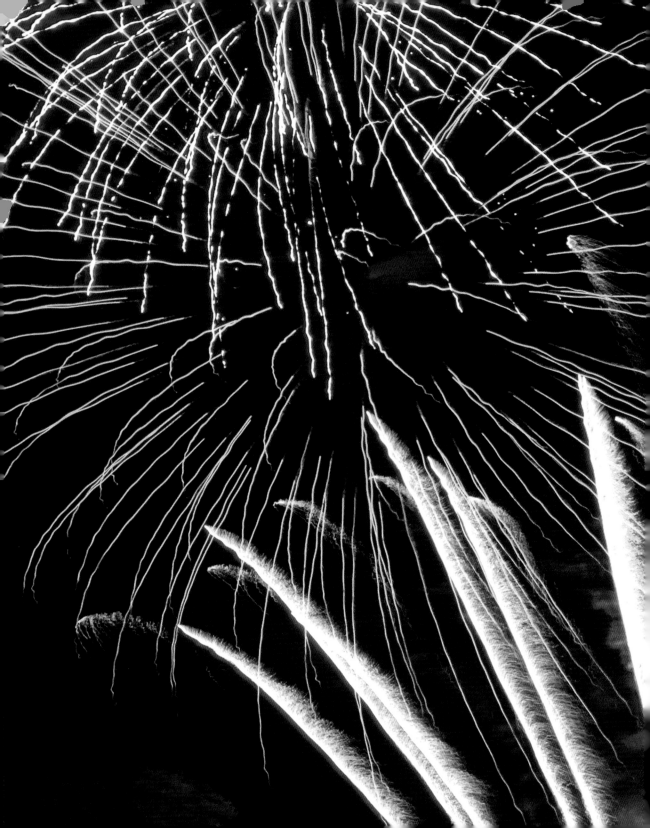

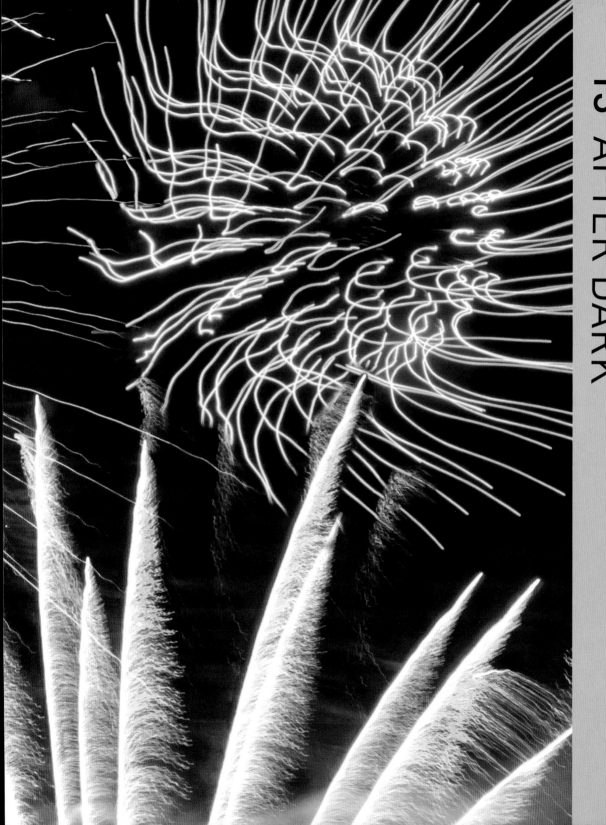

13 AFTER DARK

Night photography is a very popular theme, but to do it successfully you need to pick the right subjects and understand how to expose for contrasting lights and darks. The projects in this chapter should put you on the right path.

In this context, 'night' doesn't necessarily mean late at night – it also covers dusk and dawn, when the sky has some tone in it rather than being jet black. In fact, before dawn and after sunset while there is a little light, the sky photographs a beautiful blue, even if it is overcast with cloud.

So try out this magic time – you are in for a treat, as you will be able to produce some remarkable images, finding subjects that you didn't notice in the light of day. It's important to plan cityscapes and get to the location early while there is still some daylight so you can make a series of shots as the sun goes down, picking the ones you like best later. You will need a tripod for these projects, since slow shutter speeds are required.

FIREWORKS NIGHT (previous page)
This was taken on a cold fireworks night in my local park. So much can be done to capture these colourful bursts of light. I used Bulb exposure mode and captured three explosions on this frame, then added the green explosion later with Photoshop to fill up a black space and make it more exciting. **Bulb at f8, 36mm, 200 ISO, GH**

▲ LAMP AGAINST THE SKY
I saw this shot but had to wait for it until the lamp was lit. I walked up close to it and used a wide-angle lens so that I could include the house in the background of the picture. I was even lucky enough to get some sunset and the tiny moon in the shot. **1/30 second at f4.5, 20mm, 400 ISO. GH**

PINK CLOUD
I was attracted to the almost surreal minimal composition of the harvest moon over a rooftop in Pennsylvania. There was still some blue left in the sky. I steadied the camera on the car roof for the 1 second exposure. I just had a go, and the shot turned out more interesting than I imagined – the only post-production work was to enhance the pink of the cloud in Lightroom. **1 second at f5.6, 105mm, 400 ISO. JG**

1

NIGHT TRAFFIC

If you haven't tried shooting moving traffic at night, set off with a tripod and have a go – it isn't as difficult as it looks.

To photograph long trails of light, find a high viewpoint and let them streak into the distance. Exposure times are usually as the meter reads them. If most of the picture area is dark you may get overexposure, and conversely if you're shooting into bright lights the meter may be fooled and underexpose. If you're having trouble, try using spot meter mode, set manual (M) mode and take the exposure from a mid-tone item in the shot.

It can be interesting to include some sky in the picture as it usually goes blue until it becomes very dark. You will have to try different shutter speeds to vary the length of the light trails, which will depend on the speed of the traffic. The digital camera is great as you can check what you're getting as you go.

SHOOTING LONG LIGHT TRAILS ▶
This is the shot I had in mind before I got there – traffic lights leaving long streaks of light against the dark road during the slow exposure. I took a number of shots like this using different shutter speeds. The length of the light trails depends on the shutter speed and the speed of the traffic. **1.5 seconds at f16, 70mm, 200 ISO. GH**

SLOWER TRAFFIC, FASTER SHUTTER ▼
The heavy traffic on the left banked up and more or less stopped, changing the look completely and telling a very different story. This has a shorter shutter speed time, with smaller headlight streaks compared to the main shot. **1/2 second at f8, 70mm, 200 ISO. GH**

▼ CHECKING OUT THE SCENE AT DUSK
This is what the scene looked like from a bridge when I arrived at dusk. I used this time to search for the ideal place to shoot, which is always best decided on while there's still some daylight left. Once darkness fell I moved along the bridge a bit to get a better angle. **1/25 second at f4.5, 40mm, 400 ISO. GH**

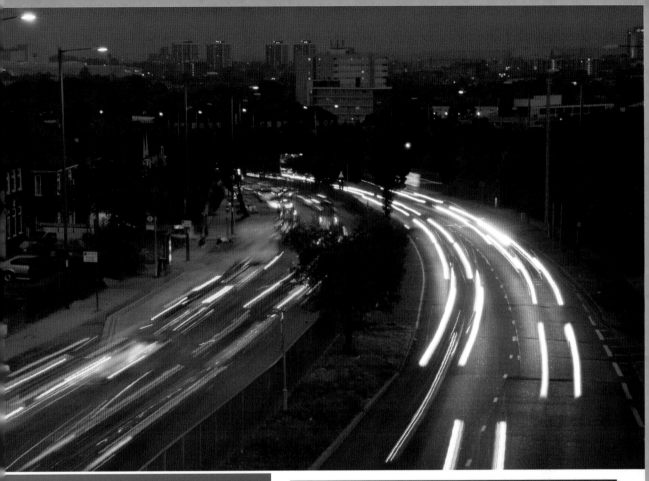

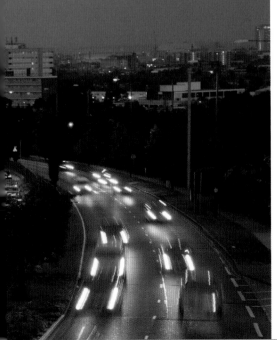

QUICK TIP

- A tripod or sturdy object to put your camera on is imperative or you will get camera shake.

- A remote control is good for tripping the shutter to avoid camera vibration.

- Unless automatic exposures are unsuccessful, shutter (S or TM) priority mode is best here – you choose the time and the camera sets the aperture.

- Try to shoot before it gets too dark or you will get a black sky.

- Daylight WB is a good start. If you want the shot to look blue and colder, use the Incandescent WB setting.

FIREWORKS

Firework displays are fun to shoot, and you can make them look much more exciting than just one burst of light.

One way to do this is to zoom during the exposure. Set the ISO to 200, WB to Daylight and exposure to 1 second at f11. Using your zoom lens, start off on a telephoto setting – try 150mm to start with. When you see a great firework burst, quickly frame it in the centre of the viewfinder, fire the shutter and immediately zoom out to wide angle throughout the exposure.

A more creative choice is to use manual (M) exposure and select the B (bulb) setting. In this mode the shutter will stay open as long as you keep your finger on the button, or the remote control switched on. This is where it gets tricky. You will need a piece of black card big enough to cover the lens – you can hand-hold the camera, but you might find it easier to use a tripod at first. Aim the camera in the direction of the fireworks and when one goes off, press the shutter button and hold it down. About ½ second later (keeping your finger on the shutter button), cover the lens with the card to stop the sky exposing between explosions and wait for the next explosion. When it comes, remove the card and replace it again.

You can build up a few explosions on the same frame this way – try three or four to start with. If you do more exposures than that you may find that the picture becomes very overexposed as a result of so many explosions layered on top of one another.

If you have trouble getting the camera to focus (often a problem with large areas of dark sky), use manual focus. Set the lens to the distance of the explosions – usually infinity – and hold it there with a piece of tape so you don't accidentally move it. Then you can go ahead and shoot without the camera hunting around trying to focus on the moving light patterns.

When there is next a fireworks display in your town, practise the technique of zooming during exposure. Experiment with different shutter speeds and the speed of the zoom, checking the result on your playback. Secondly, make multiple exposures using the black card method. Limit the number until you have built up confidence – if you end up with a black hole in the picture you can add another burst from a different frame using Photoshop Elements (see page 235).

◄ DOUBLE EXPOSURE
This image shows two explosions and was achieved by using the black card and zooming as well. It looks like an asteroid hitting a planet. **1 second exposure at f11, zoom during exposures, 200 ISO. GH**

◀ **MULTIPLE EXPLOSIONS**

There are three or four different explosions here. I moved the camera around to try to place the explosions in different parts of the frame. You will need to shoot lots of pictures to get really good results as it's a very hit-and-miss affair, but great fun. **Bulb at f11, 36mm, 200 ISO. GH**

▼ **SINGLE ZOOM SHOT**

This is a zoom shot which I cropped into a square as there was a lot of black sky on each side. Fireworks are ideal candidates for post-production work – you can change the colours, make them more saturated, or even add explosions from another shot. **1/2 second at f8, 22mm, 200 ISO. GH**

▼ **THE SPARKLER**

One of the fun things about night photography is using a slow shutter speed to capture light that is on the move. Oliver with his sparkler was a not-to-be-missed opportunity. I tried a test shot at 1 second. When I looked at the playback I saw that his face was very blurred, so I added some fill-in flash. While the flash has frozen his face there is still a little blur as a result of the 1 second exposure, but it's quite acceptable. Try taking a similar picture – you could replace the sparkler with a flash light and make other shapes such as a figure of eight. **1 second at f8, 80mm, 400 ISO. JG**

PROJECT

3

This project is to make black and white pictures after dark – there is something about them that colour just can't capture. The aim is to take movie-like shots with real drama in your home town, city or village.

BLACK AND WHITE

Shooting in colour and then converting to black and white on the computer gives you both choices, though if you are still learning to see in monochrome you may find it helpful to shoot in black and white mode so you can see the result on the camera screen. Using black and white film is another option, though digital has the advantage of playback while you experiment and this will be a very good lesson in reading how colour converts to black and white.

You may need to take many pictures before you get a really satisfying result. Look for contrast in a scene – light next to dark then light again will start to create a tonal pattern. It's easier to see such patterns if you can view the elements of a picture such as a house, a lamp post and a car as just areas of tone, ignoring their purpose. You may find it difficult at first since the brain insists on identifying familiar objects, but if you persevere it will eventually become second nature.

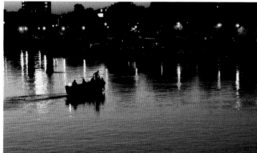

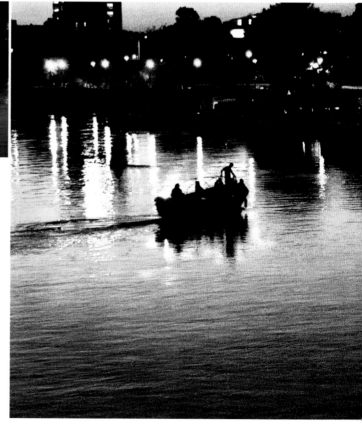

▲ THE RIVER AT NIGHT
This is how it was shot, with the beautiful deep blue of the water reflecting the sky. The boat drifted sideways just in time for me to get the standing man backlit in the highlight on the water. Modern digital cameras aim for high ISO speeds without noise, but sometimes it adds to the atmosphere. I took plenty of shots as the sun dropped well below the horizon. With the camera on the tripod I put the ISO up to 1600, set f5.6 using aperture priority and let the camera take over.
1/2 second at f5.6, 200mm, 1600 ISO. GH

CONVERSION AND CONTRAST ▶
Converting the image to black and white and increasing the contrast has made the image look as if it has been taken on a high ISO black and white film. The gritty, raw look suits the subject. **GH**

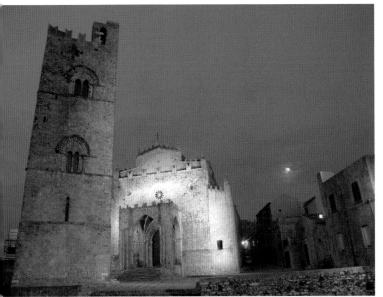

◀ SICILIAN CHURCH

The contrast between the light and dark tones as evening fell in a Sicilian village looked ideal for a black and white picture. This colour version is pretty and the blue that is left in the early night sky is attractive, but it lacks the drama that I felt when I was there. **1/40 second at f5.6, 12mm, 800 ISO. JG**

▼ CONVERTING TO SEPIA

This black and white version is more dramatic and moody. The floodlighting on the church has created a great potential for a strong tonal composition. If the church had not been lit or alternatively, if the street behind the church had been brightly lit, I would not have thought in terms of a black and white image. I converted it to Creative Sepia in Lightroom. No other manipulation seemed necessary. **JG**

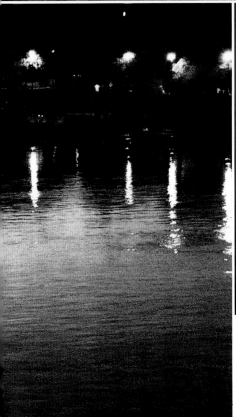

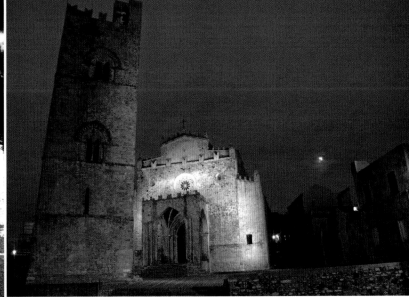

PROJECT

4

PAINTING WITH LIGHT

For most of the projects up to now, you have been keeping the camera on a tripod or other stabilizing surface when using slow shutter speeds. This time, you will be leaving the tripod behind and moving the camera during exposure to make some pretty pictures.

By using the technique of painting with light, you can give an impressionistic effect where the subject can still be seen or even make completely abstract images where the subject is totally obscured. The amount of blur will depend on the shutter speed (the slower, the more blur), and how much you move the camera.

While you can shoot in any sort of light, dusk and night-time shots work well as you can make trails of light – try panning with a moving subject. Also practise flash shots while moving the camera with a slow shutter speed; the flash will freeze the subject and the background will blur (see pages 212–13).

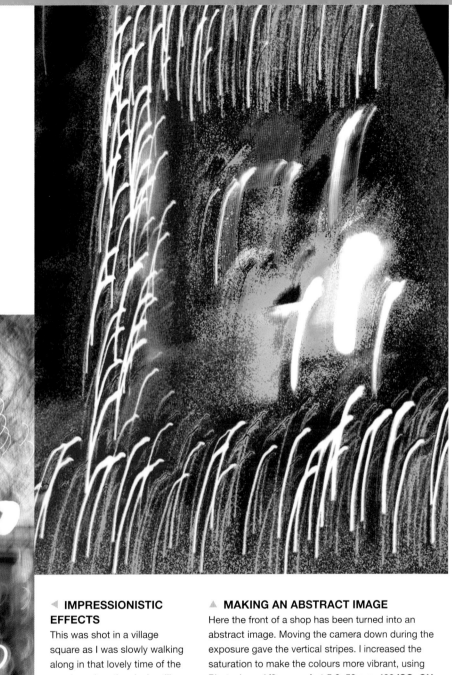

◀ IMPRESSIONISTIC EFFECTS

This was shot in a village square as I was slowly walking along in that lovely time of the evening when the sky is still blue and the lights are just coming on. It has the feeling of the brush strokes of an Impressionist painting. **1/6 second at f8, 45mm, 400 ISO. GH**

▲ MAKING AN ABSTRACT IMAGE

Here the front of a shop has been turned into an abstract image. Moving the camera down during the exposure gave the vertical stripes. I increased the saturation to make the colours more vibrant, using Photoshop. **1/2 second at 5.6, 50mm, 400 ISO. GH**

FLASH PORTRAITS

Most cameras offer you a few options for using the flash at night. Shooting at a fast shutter speed means the background will be dark, but if you use the slow sync (synchronization) setting the shutter speed will balance the background to the flash exposure on the subject.

Your camera will probably have a red-eye reduction setting, but to avoid the exposure delay that the pre-flash adds you may find it preferable to correct red-eye in Lightroom or Photoshop later – and have a look at your camera menu, too, as you may have the choice of removing red eye in-camera.

The front flash sync setting on your camera means that the flash fires first and the shutter completes the exposure after the flash. Rear sync works the opposite way, the shutter completing the exposure and the flash firing at the end. This allows you to create different effects with the flash and moving objects. Rear sync works the best when you want to capture subject movement at night because the blurred movement is behind the subject, which provides a clean subject and a good impression of movement. Front flash is more suitable when you are shooting stationary subjects, since if your subject is moving and you are using a slow shutter speed to expose for background detail the background will streak through the subject, which is particularly undesirable on faces.

Practise taking a range of flash portraits at night, experimenting with both moving and stationary subjects and carefully analysing what worked well and why. Flash can be a tricky thing to handle, and spending some effort at the outset learning how to get it right will save you missing great shots at a more crucial time.

▲ **FAST SHUTTER SPEED**
With a fast shutter speed of 1/250 second, the flash has exposed Jon and Jenny correctly but the background is underexposed, giving no indication of where they are. **1/250 second at f5.6, 62mm, 400 ISO. GH**

▲ **SLOW SYNC**
The flash has been set to slow sync, allowing the camera to choose a shutter speed of 1/15 second which has recorded the background and included Jon and Jenny within their surroundings. If you don't want any background blur while using slow shutter speeds, put the camera on a tripod. **1/15 second at f5.6, 62mm, 400 ISO. GH**

◀ FRONT FLASH SYNC

Jon and Jenny are now walking along with the camera panning. On front flash sync the flash is fired at the very beginning of the slow shutter speed, and because the camera is still panning, the background has exposed through the flashed image. **1/4 second at f4.8, 62mm, 400 ISO. GH**

▼ REAR FLASH SYNC

With the rear flash sync setting the flash is fired at the end of the slow exposure. During the pan the figures have masked the background, which means that their heads have been kept clear of light streaks. **1/4 second at f4.8, 62mm, 400 ISO. GH**

PERFECTING YOUR IMAGES

Today, a good photographer using a digital camera includes post-production in his or her visualizing process before taking a shot, the camera and computer now being inseparable in the creative process.

While photographers using film consider what they will do with the negative in the darkroom, the big difference with digital is that we can change the image profoundly in a few minutes if we so desire.

This chapter deals with a variety of tools and techniques available to tidy up your images or transform them into something else altogether. While Photoshop Elements and Lightroom are used here to do the retouching, most of the tools are available in other image-editing software programs you may be using. Remember to make a copy of your image and work on that, so that if you regret your choices you still have the original one to return to.

As this is a book on how to improve your photography overall, the information in this chapter is only an overview of what can be done to enhance your images. There are often a number of ways in which these effects can be accomplished; we shall simply show you how we learned do it. We are photographers rather than professional retouchers, but we enjoy making our images sing. We reckon that if we can do it, so can you.

We have assumed that you know the working details and tools of the image-editing software you're using. If you're just starting or need more in-depth knowledge than we provide here, there are numerous books available as well as videos on the internet that will show you how to get to grips with it all.

 QUICK TIPS

- Don't be overwhelmed by the scope of all these tools – just take one thing at a time, learn it, then move on to another.

- When you are new to a tool or technique, build up the effect in small stages until you attain the desired result rather than trying to achieve it in one step.

CABBAGE (previous page)
Generally speaking, the best principle to follow is that less is more – but here, playing around with a photograph of a grey-green cabbage in Lightroom, I increased Saturation to maximum. As a graphic it's fun, and it's a demonstration of just how far you can push things. **1/250 second at f6.7, 170mm, 400 ISO. JG**

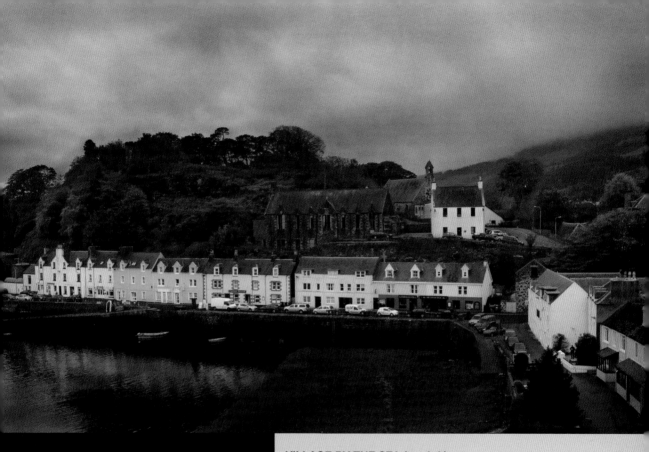

VILLAGE BY THE SEA (top left)

I visited this pretty seaside village on a day when the weather was rainy and the light was dull. I took a photograph anyway, thinking that I could liven it up later. **1/90 second at f5.6, 20mm, 800 ISO. JG**

BOOSTING COLOUR AND CONTRAST (above)

Photoshop has done a good job of saturating the colours. I also darkened the sky, the beach and the curtains in the church windows and increased the contrast. This image is how I felt about the place rather than how it looked in those bleak conditions at the time. **JG**

CROPPING

Traditionalists believe that we should make our compositions in the camera and that should be that – no cropping later. Henri Cartier-Bresson never cropped a picture.

However, while perfect composition at the outset should be the aim, few of us have the genius of Cartier-Bresson and there's no shame in looking again on the screen and improving the picture by altering the composition. You don't need to keep to the format of the image that the camera presents you with; you can make a tall, thin print, or a square one, or go for a panoramic shape – anything goes if it works visually. It's interesting to revisit old pictures, too, and find that you can dramatically change the whole meaning of the image by a creative crop.

TECHNIQUE: CROPPING WITH PHOTOSHOP ELEMENTS

1 Open a copy of the image and select the Crop tool from the toolbox.

2 Choose the aspect ratio and resolution you require in the options bar.

3 Pull the cursor around the picture to make the cropping box.

4 Adjust the size of the box and move it to choose the portion of the picture you want to keep. To rotate the crop box, move the cursor outside the crop area. When the bent arrow appears, click and hold, then move the arrow up and down to revolve the box.

5 When you are satisfied with the crop, click the green arrow and the crop will be made.

▲ **CROPPING TO CHANGE THE STORY**
I encountered this couple in Poland, sitting in front of a poster advertising beer and apparently about to be charged by the bison. I pointed out the juxtaposition to them and they also thought it funny and were happy to pose. Their two little dogs added to the portrait. I cropped in to exclude the lettering that made the true situation clear. **1/640 second at f5, 35mm, 400 ISO. JG**

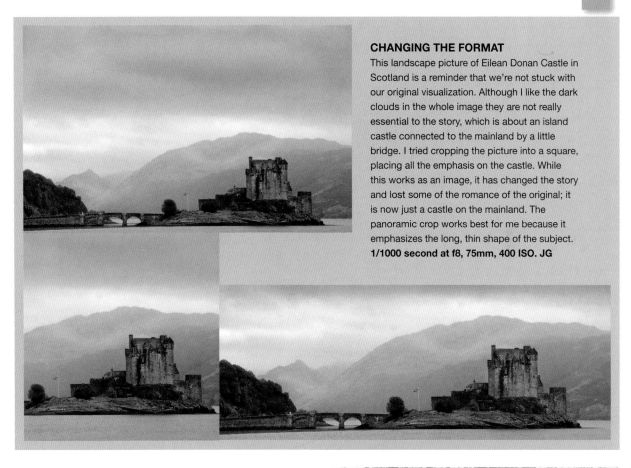

CHANGING THE FORMAT

This landscape picture of Eilean Donan Castle in Scotland is a reminder that we're not stuck with our original visualization. Although I like the dark clouds in the whole image they are not really essential to the story, which is about an island castle connected to the mainland by a little bridge. I tried cropping the picture into a square, placing all the emphasis on the castle. While this works as an image, it has changed the story and lost some of the romance of the original; it is now just a castle on the mainland. The panoramic crop works best for me because it emphasizes the long, thin shape of the subject. **1/1000 second at f8, 75mm, 400 ISO. JG**

MAKING THE IMAGE STRONGER ▼ ▶

The crop here is just a case of getting in closer for a much more dynamic image. I was conscious that I wanted to be closer at the time but the bubble would have floated by while I was zooming in. Don't miss out because you are too far away – shoot while you have the chance and then crop later. **1/400 second at f5.6, 200mm, 400 ISO. JG**

◀ MARATHON RUNNER

Nearing the end of the London Marathon, this runner is showing evidence of his exertions. The picture has the potential for some creative cropping to influence how the viewer will feel about the scene. **1/400 second at f8, 200mm, 200 ISO. GH**

CONVEYING A POSITIVE MESSAGE ▶

Placing the runner at the left side of the frame leaves space for him to run into, so that he can drive himself forward to the finish. The smiling face in the background gives a positive message to the picture. I removed the post in the background because it looked as if it was obstructing his progress. **GH**

◀ CHANGING THE MOOD

There is much said about hitting the wall in marathon running. With most of the space in front of him cropped out, placing him hard against the border, the runner now looks to be struggling and about to hit that wall. The only spectator visible is looking very concerned about him, and that helps to tell a very different story. **GH**

TECHNIQUE:
CROPPING WITH LIGHTROOM

1 Open a copy of the image and select the Develop module.

2 Click the rectangular Crop Overlay box in the tools panel and select the aspect ratio you require.

3 Adjust the size of the box and move it to choose the portion of the picture you want to keep. To rotate the crop box, move the cursor outside the crop area. When the bent arrow appears, click and hold, then move the arrow up and down to revolve the picture.

4 To complete the crop, click the Crop Overlay box again.

⌐◀ BERNARD

I liked the original composition of this shot of Bernard, but when I looked at it on the computer I decided to move in closer by taking the top and bottom off. A second look at a portrait will often prompt you to see a way that a crop, even if slight, can bring out the character of your sitter more strongly than your original shot. Bernard is an intense French chef, and I think it shows – but it looks even more the case when the picture is cropped in tighter. **1/45 second at f5, 82mm 600 ISO. JG**

PROJECT

2

DODGING

The word 'dodging' is carried over from the darkroom printing process and refers to lightening large or small parts of the image. Most pictures benefit from a little dodging, for example where the complexion of a face looks a bit dull, or detail in leaves isn't clear.

In fact, Dodge is the most important tool to give your pictures a sparkle that lifts them off the page. Elements gives you a lot of control here. You can change the size of the Dodge tool to fit the area you are working on and it allows you to work on the shadows, mid-tones and highlights individually. You can also select how much exposure (lightening) you want.

Dodging requires quite a bit of skill, so don't be disappointed if your first attempts are less than perfect. Select a low exposure setting and build up the effect in small stages.

DODGING WITH LIGHTROOM

Lightroom has a Dodge/Burn tool with many more choices than Elements offers. Go to Develop and select the Adjustment Brush. You will then get a dialogue box with infinite choices of dodging and burning with most of the Lightroom effects.

▲ **ADDING DRAMA**

When I shot this cactus the daylight was flat and insipid, and I envisaged a more dramatic look. After cropping, I darkened it, added more contrast and increased the saturation to bring out the colour. Then, using the Dodge tool with a soft brush set on Highlights at a very low 1% exposure, I gradually lightened the area in the centre with many passes of the brush until I achieved the spotlit effect I wanted. **1/125 second at f11, 55mm, 400 ISO. GH**

TECHNIQUE: DODGING WITH PHOTOSHOP ELEMENTS

1 Open a copy of the image and select the Dodge tool in the toolbox. Enlarge the portion you want to work on with the Navigator. Try 100% – it may need to be smaller or larger, depending on the item you are darkening. Select the size of the Dodge tool (with soft edges) to what you want, depending on the size of the image and how much you have enlarged it on the screen.

2 Select the Burn tool, and a soft-edge brush smaller than the item you are burning. In the Range box, select midtones and set the exposure low – 2% is a good setting until you have gained experience. Click and hold the mouse, moving the Dodge tool brush over the area and lightening it. If it's not light enough, continue until it looks right, but don't overdo it or the effect will look false. Should this happen, go back a step or two in the History Box and start again. Dodging should have enlivened the picture without drawing attention to itself, unless you are deliberately using it for a creative effect.

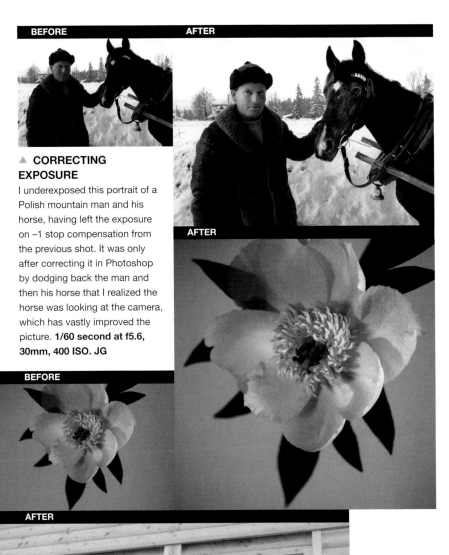

BEFORE AFTER

▲ CORRECTING EXPOSURE

I underexposed this portrait of a Polish mountain man and his horse, having left the exposure on −1 stop compensation from the previous shot. It was only after correcting it in Photoshop by dodging back the man and then his horse that I realized the horse was looking at the camera, which has vastly improved the picture. **1/60 second at f5.6, 30mm, 400 ISO. JG**

AFTER

BEFORE

AFTER

BEFORE

◤ LIFTING HIGHLIGHTS

I suspended this peony in front of a grey paper background, next to a window that provided the main light and with a small LED light from the left to provide the highlights on the flower. I underexposed the picture by −1 stop in order to make sure I didn't overexpose the highlights. To enliven this image, I dodged it to lift the highlights and give it a three-dimensional look, using a soft brush set to midtones with a 2% exposure and working on small areas at a time. **1/60 second at f1, 55mm macro lens, 400 ISO. GH**

▼ LIGHTENING FACES

This family picture was shot in the late afternoon, when the light was from a dull grey sky. The faces are fairly flat and need a lift to bring them forward. This is where dodging can really improve a picture – in fact I do a small amount of dodging on most of my pictures to brighten the main subject and help it stand out. This was done using the midtones setting with 2% exposure. Sometimes a tiny dodge on the highlight setting will brighten a face without affecting the midtones, which also works wonders. **1/160 second at f6.7, 45mm, 400 ISO. GH**

PROJECT

3

BURNING IN

The opposite of dodging is burning in – selectively darkening large or small parts of the image that are too bright, perhaps because they attract your attention more than the main subject.

As with the Dodge tool, Elements gives you a lot of control with the Burn tool. You can change the size of the tool to fit the area you are working on, and it allows you to work on the shadows, midtones and highlights individually. You can also select how much exposure (darkening) you want.

Burning in requires a lot of skill, so don't be disappointed if your first attempts are less than perfect. Try darkening a variety of tones to start with, using the different range and exposure settings. Sometimes the burn process saturates the colours as you burn them darker. To reduce them slightly, set the Sponge tool to desaturate and run it over the area you burned in.

You can also dodge and burn in Lightroom using the Adjustment Brush tool, but it doesn't offer as much control as Elements.

▼ **CREATING DEPTH**

I shot these leaves using window light, lifting the top leaf slightly higher than the other with a piece of Blu-Tack to make a shadow on the bottom leaf. The picture looked a little flat, so I decided to lift out the front leaf by means of burning in and darkening the bottom leaf. **1/8 second at f8, 55mm, 400 ISO. GH**

BEFORE

AFTER

 **TECHNIQUE:
BURNING IN WITH PHOTOSHOP ELEMENTS**

1 Open a copy of the image and enlarge the portion you want to work on with the Navigator. Try 100% – it may need to be smaller or larger, depending on the item you are darkening.

2 Select the Burn tool, and a soft-edge brush smaller than the item you are burning. Setting the exposure to about 2% and the range to midtones is a good start. To darken a highlight select the highlight range; if it's a dark area, Shadows may work better. Click the mouse and hold, then move the brush over the area until it darkens. It's best to build it up by small amounts until it's dark enough. Try to keep the darkened area smooth, without blotches.

STRENGTHENING TONE ▶▶

The light here is from a window and I used a white reflector on Damian's right side to fill in the shadows. When I saw the portrait on the screen I decided I had overdone the reflection, so I burnt in the shadow area to make the image stronger. **1/60 second at f5.6, 60mm, 400 ISO. JG**

BEFORE

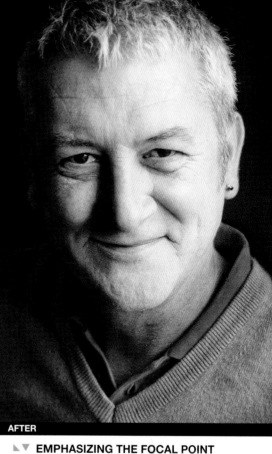

AFTER

BEFORE

AFTER

◣◥ EMPHASIZING THE FOCAL POINT

Nearly everyone will take this kind of birthday picture at some time. As it was Luke's favourite car, I used a very wide-angle lens to make it large in the foreground. Burning in the outer areas of the picture has dramatized the glow of the candlelight and made a much stronger picture. The final touch was a little dodging on his face and the car to brighten them. **1/15 second at f5.6, 10mm, 400 ISO. GH**

BEFORE

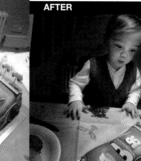
AFTER

◣◥ EQUALIZING TONE

The colour of this woman's dress matched the blue background so well that it was a must-have portrait. I loved the religious picture on the wall but I knew that it would be too bright and would distract from her face. I took the shot and burned in the picture later to match the overall tone. **1/60 second at f4, 35mm, 100 ISO film. JG**

HUE AND SATURATION

Being able to alter the hue and saturation of our pictures later, after we have had time to reconsider how we feel about the image, is a luxury that digital photography has brought.

When you're shooting colour film you can of course control this aspect to an extent with filtration and exposure, but doing it on a large screen after you have taken the photograph is much more effective.

When you first start using these tools, the temptation is to get carried away and overdo the saturation, giving a garish result which is best avoided. It's best to make increases little by little, accustoming your eye to the result each time before pushing things further. However, going over the top sometimes and playing with the colours, as with the cabbage on page 214, can be great fun too.

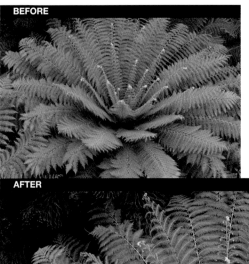

BEFORE

◄ ▼ ADDING A SINGLE COLOUR

I thought this fern picture would look good with a colour treatment in the style of a cyanotype – a printing process developed in the 19th century. I ticked the Colorize box in Adjust Hue/Saturation so that the image changed to a single colour and then used the Hue slider to change the colour to blue, strengthening it with the Saturation slider. **1/150 second at f6.7, 24mm, 400 ISO. GH.**

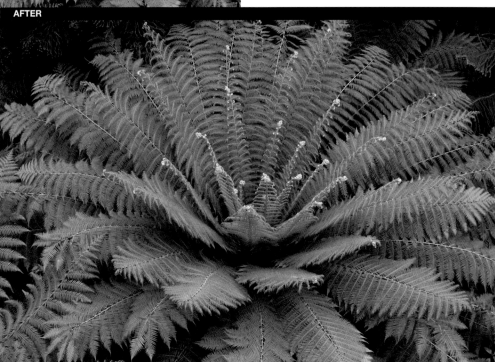

AFTER

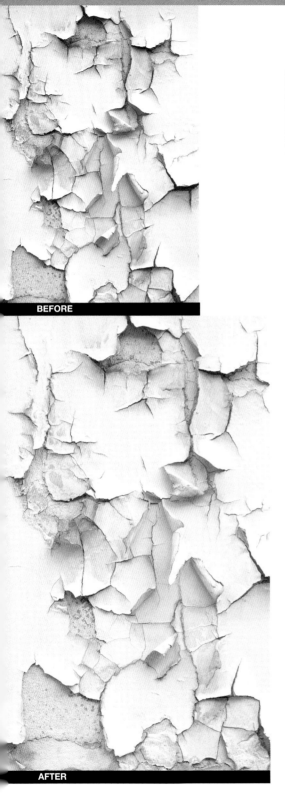

BEFORE

AFTER

 TECHNIQUE:
ALTERING HUE AND SATURATION WITH PHOTOSHOP ELEMENTS

1 Open a copy of your image and go to Enhance → Adjust Color → Adjust Hue/Saturation.

2 The Hue slider allows you to change the overall colour in your picture, or, if you click the Master Box, you can alter individual colours while leaving the rest of the picture unchanged.

3 The Saturation control strengthens or weakens the colours, and if you slide it to the far left it removes the colour completely. Slide it to the far right and you will get some very wacky colours indeed.

4 Another function is the Colorize option in the Hue/Saturation dialogue box. If you tick the box, the image changes to monochrome with one colour selected. This is equivalent to toning the picture in a darkroom. You can then adjust the image using the Hue and Saturation sliders. You will also see a Lightness slider that makes the whole image lighter or darker, but the Brightness/Contrast and Levels controls elsewhere in the program are a better option.

⌐◀ FINDING HIDDEN COLOUR

You might think this shot of flaking paint was a black and white shot; it was a white wall and looks colourless. However, I slid the Saturation control to the right and found that there is colour hidden in the picture. I then used the Hue control to change the colours.
1/180 second at f8, 55mm, 400 ISO. GH

TECHNIQUE: ALTERING HUE AND SATURATION WITH LIGHTROOM

1 Select an image and go to the Develop module.

2 In the Basic panel, use the Saturation slider in Presence. For more saturation slide to the right, for less saturation, to the left.

3 To get the toning effect, convert to black and white in the Basic panel, then in the Split Toning panel, click in the little window in Shadows to open the Colour Picker. Choose the colour you want and adjust the intensity with the Saturation slider.

4 For a split-tone effect, choose a different colour for the highlights, then blend the highlights and shadow colours with the Balance slider.

BEFORE

BEFORE

◀ LIGHT AND MOOD ▶

I shot the ballet shoes in incandescent light, with a cardboard grid from a wine bottle box in front of the light to make the soft shadows on the wall. The WB was set to Daylight and the picture has an 'early morning sunlight' look. To try changing the mood, I slid the Hue control until I got a pink colour. Then, in the Master box, I chose Blue and increased the saturation, deepening the blue in the shadows and giving the feel of an evening sunset. **1/4 second at f11, 55mm, 200 ISO. GH**

AFTER

AFTER

BEFORE AFTER

◤▲ INTENSIFYING COLOUR

After seeing some David Hockney landscapes, I wanted to find out if the intense colours he had seen and painted were actually there. I chose this log picture and moved the Saturation control to the right, and sure enough out came the colours to make a Hockney-like picture. **1/30 second on tripod at f16, 62mm, 400 ISO. GH**

◀◀ DESATURATING COLOUR

This shot of Big Ben was taken at dusk. I set the WB to Incandescent to intensify that deep blue light that the sky makes just before night. I desaturated the same picture as an experiment. This is an example of how the Saturation Tool, slid to the left, can be used to reduce the colour in a picture. The desaturated picture has an antiquated look, like the hand-coloured pictures done in the 1950s. **1/20 second at f5.3, 105mm, 400 ISO. GH**

5

ADDING COLOUR

The technique of adding colour to an image can really give it zip and change it completely. This is not the same as using the Hue/ Saturation tool, which enhances or alters an existing colour – it means adding a new colour, or colours, to create a picture with a different look.

There are several ways of doing this in Photoshop, but here we are going to use the Paint Bucket tool, which will fill any area with the colour you select. The part you want to fill must be a contained area (use one of the selection tools to make a boundary) as otherwise the colour will spill out onto unwanted parts of the image. To start, choose your image carefully. A picture with strong shapes will work well, so try one of your silhouette or shadow pictures as they will give solid shapes that can be filled; you may not need to use the selection tool.

BEFORE

AFTER

◀ ▲ **COLOURING A SILHOUETTE**
The simplicity of this silhouette tempted me to go for a colourful, bold poster effect that would be a print for my wall. The unfussy shapes of the black areas made it very easy to add colour with the Paint Bucket tool. **1/180 second at f5.6, 35mm, 400 ISO. GH**

BEFORE

AFTER

TECHNIQUE: ADDING COLOUR WITH PHOTOSHOP ELEMENTS

1 Open a copy of your image. If it's a black and white picture, go to Image → Mode → RGB colour.

2 Using the Navigator palette, enlarge the section you want to work on.

3 From the toolbar, use the Magnetic Lasso tool or Quick Selection tool to select the area you want to fill with colour.

4 Click on the foreground colour window at the bottom of the toolbox and choose the colour you want.

5 Select the Paint Bucket tool and set it to Color Mode. Place the Paint Bucket icon over the selected area and click to fill with colour. If the colour runs out further than you want, close the gaps with the Clone tool to confine it.

6 Now use Enhance → Adjust Lighting → Brightness/Contrast to fine-tune the coloured area.

7 If you want to change the colour or its richness, use Enhance → Adjust Color → Hue/Saturation.

8 Choose Select → Deselect. Move on to a different area and repeat the process.

◄▲ ADDING SMALL AREAS OF COLOUR

Sometimes things that you see and photographs that you take pop back into your head as inspiration, long after the event. When I photographed this crack in a wall, the paint-spattered beach pebbles that I shot years earlier gave me the idea of using colours in a similar way. This image was perfect as there were broken pieces of cement that I could apply the colour to, using the method described in the Technique box. You can try this with any image, but make sure the added colour has a good reason to be in the picture. I think of this as a fractured Mondrian-style painting. **1/60 second at f2.8, 50mm, 400 ISO. GH**

VIGNETTING

Traditionally, lightening the edges of pictures by vignetting them was used on high-key subjects such as portraits or baby shots to merge them into the background and give them a dreamy look.

In more recent times a dark vignette has been added to pictures to give the edges strength and hold the eye in the centre of the picture.

A pure white on the edge of some pictures, such as a white sky, looks as if the picture is slipping off the page; a touch of dark vignetting puts an edge on the picture to separate it from the white mount or page.

▼◢ STRENGTHENING A FOCAL POINT

At this early-morning shoot in Regent's Park in London, the sun trying to break through the mist created its own natural slight vignette. I increased the vignetted appearance in Lightroom and it helped to direct the eye to the small bird in the centre of the frame. **1/500 second at f8, 300mm, 400 ISO. GH**

BEFORE

AFTER

AFTER

BEFORE

SOFTENING THE EDGES ▶▶

This is a traditional use of the white vignette, giving the appearance that the picture has been bleached around the edges. It works well for baby pictures, giving them a lightness and concentrating the eye on the main detail in the picture, and suggests a retro 1950s look. **1/250 second at f5.6, 55mm, 400 ISO. GH**

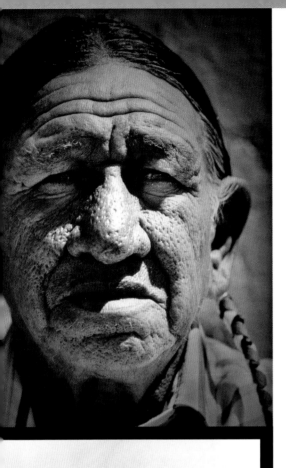

TECHNIQUE: VIGNETTING

In Lightroom you will find the Vignette tool in the Effects Panel of the Develop module. In Elements it's in Filters → Correct Camera Distortion → Vignette.

The Vignette tool works the same way in each program. Use the slider to lighten or darken the corners. The slider will vignette progressively, starting from the corners and gradually progressing to the centre of the picture. This gives you total control of the vignetting, whereas the Presets in Lightroom give you just two choices.

◄◄ **MINIMIZING DISTRACTING ELEMENTS**

This Native American chief allowed me to take his portrait in Taos, New Mexico. The light was blindingly bright, creating very strong shadows, but I decided not to use fill-in flash as it would have killed the lived-in textures of his face. His left eye and the area around it were the most important parts of the picture, so I put a strong vignette around his head which has subdued distractions such as his shirt and the background. I also dodged both eyes, while retaining the strong shadows. **1/2000 second at f8, 100mm, 200 ISO. JG**

AFTER

BEFORE

PROJECT

7

COMBINING IMAGES

Many photographers like to create surreal images, or just to add something that they feel should have been in the picture all along.

Try combining two or more different images, perhaps to add a point of interest to a picture you have taken (see also page 41) or just to have some fun. You can combine as many images as you want, but as you add more and more, so the complications increase. It's a good idea to make a rough sketch of the final image you have in mind or to start with a definite theme and let the picture grow, as I did with my multiple picture.

▼ MULTIPLE IMAGE
My starting point was architecture, chosen because straight edges make it easier to select areas with the Polygonal Lasso tool. Selecting a few images, I started with the side of a building (the purple stripes). Then I cut and pasted the other images over the top, trying to make a good composition. As each new image is on a separate layer, it's easy to move them. I added black lines to give structure and hide joins, using the Lasso tool again to make boxes which I filled with the Paint Bucket tool. **GH**

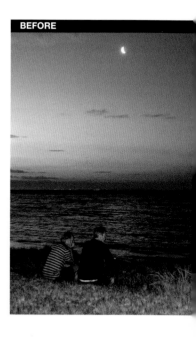

BEFORE

▲ ◥ PUTTING A SCENE TOGETHER ▶
Concerned that the ferry we were waiting to pass would be late, I played it safe while there was still light in the sky and took a few photographs of my friends without the ferry. I used fill-in flash set to −1 stop to add a little light to the foreground and their faces. When the ferry finally came, the sky was much too dark to do the picture that I had imagined, so I photographed it separately to be added to the first picture later. **1/15 second at f4.8, 45mm, 800 ISO. GH**

BEFORE

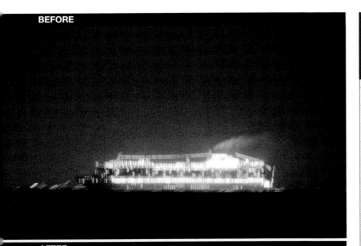

AFTER

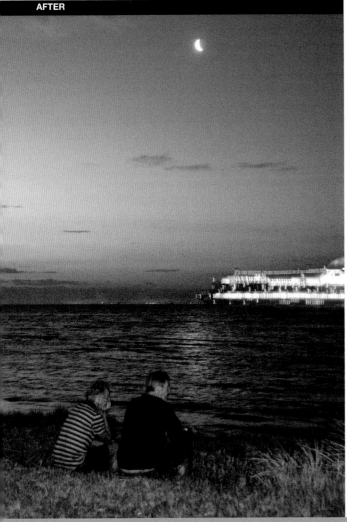

 **TECHNIQUE:
COMBINING TWO IMAGES
WITH PHOTOSHOP ELEMENTS**

1 Open a copy of both images. If necessary, adjust the brightness, contrast and colour of the main image until it looks right.

2 Go to the second image and use one of the selection tools to cut out the portion you want to paste onto the main image – you don't have to be very accurate at this stage. Then Edit → Copy.

3 Open the main image again and Edit → Paste. This will add the second image onto the main one, but on a separate layer.

4 With the layer selected, click the Move tool in the tool box and move the image into place. If it's necessary to resize the second image, click on one corner of the Move box and make sure the Constrain Proportions box in the menu is ticked, then push or pull the corner of the Move box to make the image the right size.

5 Enlarge the image with the Navigator and work on the layer image, using the Eraser tool with a small soft brush to remove all the areas of the second image you don't want. Repeat this procedure with each image you want to include.

6 When you're satisfied with the composition, go to Layers → Flatten Image and combine the images. If you want to rework the image again, save a PDF version with the layers intact before you flatten it, since once it is flattened the layers are lost.

7 Using the Clone Stamp tool, tidy up details around the edges to blend them into the background.

PROJECT

8

PERSPECTIVE CORRECTION

Receding perspective can be really dramatic when you're looking up at a tall building, but there are many times when the leaning verticals don't do justice to a beautiful piece of architecture, be it ancient or modern.

Until recently an expensive and heavy perspective correcting lens (PC lens) was required to correct verticals, but now Lightroom, Photoshop and other image-editing software enable us to straighten the verticals later without the need for equipment that few photographers other than professionals would want to buy.

Reversing the process can also be very interesting from a graphic point of view. Tilting the parallax correction in the opposite direction greatly exaggerates the foreground, pulling it towards you like a super-wide-angle effect.

During the process of altering the perspective part of the image will be lost, so when you're shooting the picture it's important to leave extra space around the object that you'll want to correct or distort. If this isn't done you'll need to restore it by retouching.

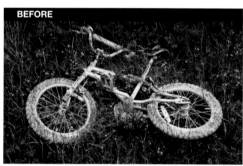

BEFORE

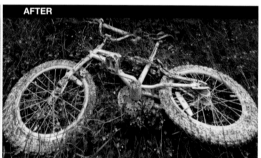

AFTER

📷 **TECHNIQUE: CORRECTING VERTICAL PERSPECTIVE WITH LIGHTROOM**

1 Open a copy of your image and go to the Develop module.

2 Find the Lens Corrections panel and choose Manual.

3 Use the Transform sliders to change the image. The Vertical slider will straighten or exaggerate any verticals depending on which way you slide it.

4 In the Transform process part of the image will be lost. You will have to crop the image or retouch it back in.

◤▲ **EXAGGERATED PERSPECTIVE**

I found this mud-covered old bike abandoned beside a canal. Converted to black and white, and with the contrast increased, it made an interesting graphic picture. To take the image a step forward, I used perspective correction in reverse to pull the wheels towards me and create a wildly elongated form. With the Photoshop Clone Stamp tool, I extended the grass on the top that had been lost during the process (see page 244). **1/60 second at f11, 26mm, 400 ISO. GH**

▼ RESTORING SYMMETRY

While there isn't a lot of perspective distortion here, there's enough to lose the perfect symmetry of the Lincoln Memorial. Correcting the perspective in Lightroom took about five minutes and it makes a big difference to the picture. As the image had a slightly cool tone I decided to warm the colour slightly, which made the building look more approachable. **1/1600 second at f10, 18mm, 200 ISO. JG**

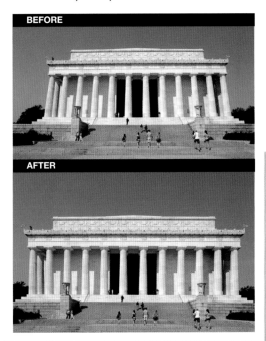

BEFORE

AFTER

TECHNIQUE:
CORRECTING VERTICAL PERSPECTIVE WITH PHOTOSHOP ELEMENTS

1 Open a copy of your image and click on Filter on the menu bar.

2 Select Correct Camera Distortion.

3 In Perspective Control, use the Vertical slider to straighten or exaggerate verticals.

4 Part of the image will be lost. Your choices are to use the Edge Extension slider to repair it, retouch the missing areas or crop the image to a new shape.

CORRECTING EXTREME DISTORTION

When I took this picture of Bibendum at London's Michelin House there was a large truck parked in front of it, preventing me from getting a view from further away – hence the wide-angle shot looking upwards, giving the impression of the building falling backwards. I used the Lightroom Perspective Control to straighten the verticals and show the building squared up in its natural shape. To obtain a similar view in reality I would have had to be further away with a longer lens and up on a ladder to get square on to the building. **1/90 second at f6.7, 18mm, 400 ISO. GH**

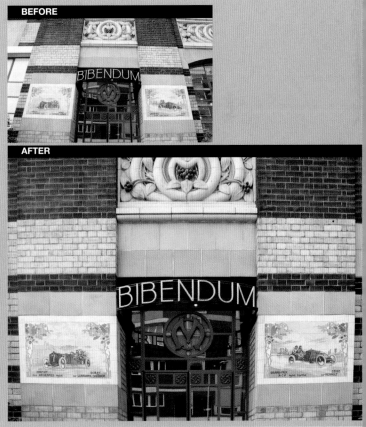

BEFORE

AFTER

PROJECT

9

RED FILTER EFFECT

The red filter has always been the most commonly used filter in black and white film photography; think of all those dramatic landscapes with dark skies and beautiful cloud formations by Ansel Adams, Edward Weston and many others.

This filter makes light tones of the colours in its own end of the spectrum and darkens those in the opposite end, which means that a red house will print as a light grey and a blue sky will be dark grey, exaggerating the presence of any white clouds.

Portraitists also use the red filter to great effect as it eliminates any red spots, smooths the complexion and greatly reduces the tonal range so that the lit areas print white and the shadows print black. We can now get very close to producing classic black and white images with the help of Lightroom. Your camera may have a red filter effect in the retouching menu, too.

 **TECHNIQUE:
THE PORTRAIT RED FILTER
EFFECT WITH LIGHTROOM**

1 Open a copy of the colour image and convert to black and white in the Basic panel.

2 Go to the Black & White Mix panel and click the Target Adjustment tool. Place the tool on the face, click and drag it up to lighten the skin.

3 In the Presence panel, use the Clarity tool to soften the picture and give the skin a glow. Try –50 and adjust to your taste.

4 Increase the Contrast and adjust the Brightness until the effect is achieved.

◀ **BLACK AND WHITE FILM**
The portrait here was made on black and white film with a red filter on the lens. The light from a small spotlight created a high-contrast negative that enabled me to make this high-key print. **1/125 second at f5.6, 85mm with red filter, 400 ISO film. JG**

◀◀ **DIGITAL RED FILTER EFFECT**
This colour portrait has very similar lighting to the film portrait. Giving it the digital treatment for red filter effect has produced a similar image with high contrast and bleached skin. **1/250 second at f8, 70mm, 400 ISO. JG**

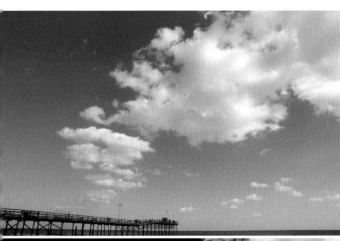

▲ EXAGGERATING TONAL CONTRAST
This is an example of the red filter effect but made in Lightroom instead of in the camera. By converting a rather pretty colour skyscape to black and white and applying the red filter effect, I have created a much more dramatic image. **1/1000 second at f11, 18mm, 200 ISO. GH**

**TECHNIQUE:
THE LANDSCAPE RED FILTER
EFFECT WITH LIGHTROOM**

1 Follow steps 1 and 2 in the panel opposite (left).

2 Put the Target Adjustment tool on the sky and pull it down to darken it.

3 Slide the Clarity tool to the plus side if you want to increase the sharpness.

4 Increase the Contrast and adjust the Brightness until it looks right.

**TECHNIQUE:
THE RED FILTER EFFECT WITH
PHOTOSHOP ELEMENTS**

Elements can be used to achieve a similar effect with portraits and landscapes but the result may not be as smooth.

1 Open a copy of the colour image and go to Enhance → Convert To Black and White → Infra Red Effect.

2 Increase Contrast and adjust Brightness until you're satisfied with the result.

3 Soften the portrait image to give it a glow using the minus Clarity slider. Use the plus Clarity slider to sharpen the landscape image, if wanted.

PROJECT

10

LIGHTROOM PRESETS

Located in the Develop module, the Lightroom Presets panel offers a long list of effects that can be applied to your images, including sepia tone, cyanotype, high contrast and infra red.

If you run your cursor over the Presets list the Navigator panel will show you how each setting will affect your image. You can also create your own presets to add to the list for future use.

As well as using Presets on your new images, it's worth checking out how some of your old pictures could look, too. Often you can find a tone or a colour that suits the subject better than your original visualization, giving you a fresh look at your library of photographs.

THE UNEDITED PORTRAIT ▶
My portrait of Dmitri in Siberia was shot in low northern sunlight. This is the original colour picture, unedited. I planned to try some different treatments when I got it onto the computer. **1/250 second at f13, 75mm, 200 ISO. JG**

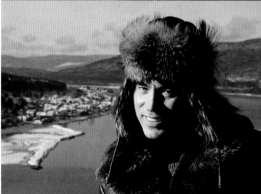

▲ **SEPIA TONE**
This version was made using B&W Creative – Sepia Tone. When you see the Presets up on the screen they usually look over-exposed. I reduced the exposure here to darken the image a little. **JG**

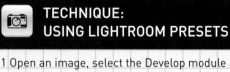

📷 TECHNIQUE: USING LIGHTROOM PRESETS

1 Open an image, select the Develop module and choose Create Virtual Copy.

2 With the Virtual Copy selected, go to the Presets panel on the left and move the cursor down the list of presets. You will see a preview of each preset on the Navigator screen. Choose the one that works for your image and click it.

3 Depending on your image, the preset may need some altering. Use any of the Develop controls to modify it to your liking.

4 To make another version of the same image, make another Virtual Copy and repeat the process.

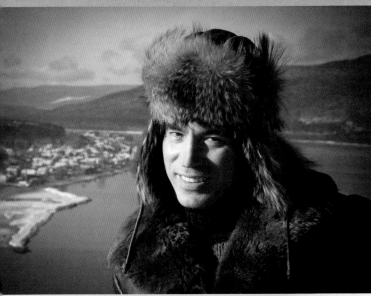

◀ CYANOTYPE

Cyanotype is one of the oldest photographic printing techniques. I applied the B&W Creative – Cyanotype preset here because it seemed to suit the portrait. The effect has a moonlit feel to it, and I added a vignette to increase that atmosphere. **JG**

▼ SPLIT TONE

This split-tone version has added blue to the shadows and sepia to the highlights. Another traditional interpretation, it is listed as Creative – Split Tone 4. **JG**

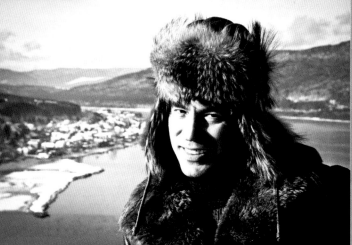

⬈ OLD POLAR

Colour Creative – Old Polar has produced a more contrasty effect that has the look of Technicolor film, reminiscent of movies shot in the 1950s. **JG**

◀ BLEACH BYPASS

This bleached-out hand-coloured effect is achieved with the Colour Creative – Bleach Bypass preset. The interpretations shown here are a matter of personal taste and your own feeling of what best suits the subject will determine your choices. **JG**

RETOUCHING A PORTRAIT

The retouching of portraits is a source of debate among photographers. Sometimes the decision is easy – a temporary scratch or bruise isn't part of how the subject normally looks, so removing it isn't producing a false portrait. After that, it's usually a matter of whether your sitters prefer to look real – which is to say with some flaws – or want to be flattered at all costs.

Retouching isn't usually needed for reportage portraits, but other than that your best plan is to make your subjects look attractive and have them happy with their image without embarking on the excessive retouching that is prevalent on celebrity portraits, giving an effect that's almost like a waxwork. Digital portraits are often brutally sharp, and softening them is a kindness nearly everyone will be grateful for.

You can obtain specialized beauty retouching software programs at reasonable prices; most offer a free trial download. If you will be retouching faces regularly, one of those would be a wise investment as it simplifies the amount of work you will need to do.

◥ THE UNEDITED PORTRAIT

This is the original picture of Jenny. She has a very good complexion, but the camera exaggerates small imperfections no matter how careful you are with the lighting. I used a studio flash with a softbox on the left. A white reflector on the right lightened the shadows. **1/80 second with flash at f8, 105mm, 100 ISO. GH**

◄ USING SPECIALIST SOFTWARE

I used Portrait Professional software to retouch this. It's a program that gives you infinite choices and is quite easy to use. Not only does it smooth the facial tones and remove spots and blemishes, it also slightly sculpts the face. There are separate controls for face, lips, eyes, hair and so forth, and you can apply small or large amounts of retouching. It has smoothed Jenny's skin but not too much – the result is one of a professional make-up job. Be careful not to overdo retouching or you will end up with a plastic look that doesn't resemble the subject. **GH**

 ## TECHNIQUE: PORTRAIT RETOUCHING WITH LIGHTROOM

Lightroom offers a huge range of retouching effects, so this is just a basic starting point. To find more information and possibilities, search the Internet for in-depth lessons.

1 With your image selected and adjusted for Brightness, Contrast and Colour, go to the Develop module and select the Adjustment Brush. The Brush Options box will open, giving a range of choices.

2 Open the Effect box and choose an option – a good starting point is Soften Skin. Select the brush size you want and paint over the areas that you want to soften; you can check what you have painted by hovering over the black target spot you will see on the image. A red mask will appear on the image to show what you have painted. To remove any areas that you have over-painted, press the Alt key and remove them by brushing.

3 You can then use the sliders to adjust the amount of softening, brightness, saturation and so on. Open the Effects box again and choose another option, then repeat the above instructions.

◀ **CONVERTING BLACK AND WHITE**

Jenny and I preferred this black and white conversion of the retouched picture as we felt that it looks more elegant, like a Hollywood portrait of yesteryear. Whether you go for black and white or colour is of course a matter of personal taste – you may prefer the colour version, although black and white is very much back in fashion. **GH**

RETOUCHING UNWANTED DETAILS

No matter how careful we are when shooting a picture, there are usually certain elements in the image that are undesirable and removing them would greatly improve it. This requires a certain amount of skill, gained by practice.

Small areas can be retouched with the Spot Removal or Clone Stamp tools in Elements. For larger areas, using the Spot Removal tool set to Content Aware will save time and you can fine-tune anything that isn't perfect with the Clone Stamp tool. You can also use the Healing Brush tool set to Content Aware to remove larger areas, but you will probably need to tidy up with the Clone Stamp tool.

Even if they are carefully cleaned, transparencies and negatives scanned into the computer will need 'spotting' to remove the dust and small hairs that stick to the surface before the final picture looks crisp and finished.

BEFORE

RETOUCHING FOREGROUND DETAILS ▼ ▶

This photograph was taken in London at the Queen's Diamond Jubilee in 2012. There were some leaves obscuring part of the woman's hair and face, so I removed them using the Clone Stamp tool. **1/160 second at f5, 70mm, 400 ISO. GH**

AFTER

BEFORE

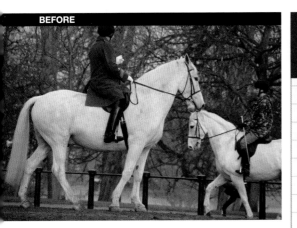

▲▼ **REMOVING BACKGROUND ELEMENTS**
While I liked this image, the railings in the background spoiled the composition. Although photographers try to avoid distracting backgrounds like this it's not always possible, so being able to remove them later using image-editing software is a great advantage. **1/300 second at f8, 65mm, 400 ISO. JG**

TECHNIQUE: RETOUCHING IN PHOTOSHOP ELEMENTS

1 Open a copy of the image and, using the Navigator panel, enlarge the part of the image you want to work on.

2 Click the Clone Stamp tool in the toolbox. Choose a brush size for working on a small area at a time and set the hardness to 35% to give slightly soft edges.

3 Set Mode to Normal and Opacity to 100% and check the Aligned button.

4 Hold down the Alt key, click the area you want to sample then release the key. Move the brush to the part you want to replace, click and move the brush to paint the sampled area over the unwanted portion. Repeat until you remove the object, varying the sampled source area so you blend it in to look as natural as the background around it.

AFTER

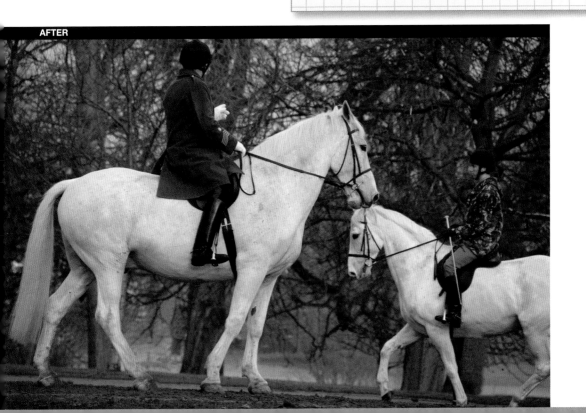

INVIGORATING OLD IMAGES

If you have old colour transparencies, negatives or prints that have faded or gained unwanted colour casts, it's a good idea to get them into digital form as soon as possible before they deteriorate any further.

Even old black and white prints that have faded or yellowed can be greatly improved. If any are torn or scratched, use the Clone Stamp tool to repair the damage (see page 245) after scanning and colour-correcting them.

If you're working on a scan taken from a damaged print, Elements provides the best retouching tools. Use the Spot Removal Tool or the Spot Healing Brush to tidy up dust and scratches or to repair any damage.

▼▶ **VILLAGER IN CORFU**
Shot on transparency film in the 1970s, this portrait had lost much of its colour. After some revitalizing in Photoshop it looks just the way I remember it when it first came back from the lab. As the villagers in Corfu no longer dress in their traditional costume, it is a historic photograph. **1/125 second at f5.6, 35mm, 100 ISO film. JG**

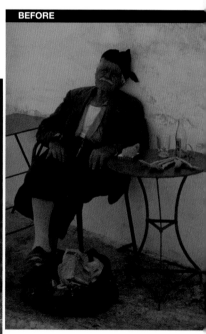
BEFORE

▼▶ **WALKING THE DOG**
This picture was shot on 1000 ISO 3M transparency film, which was very grainy and had a lovely softness to it. Over time the blue dye has faded, leaving a mostly red image. Restoring it has revealed the original. **1/500 second at f5.6, 100mm, 1000 ISO. GH**

AFTER

BEFORE

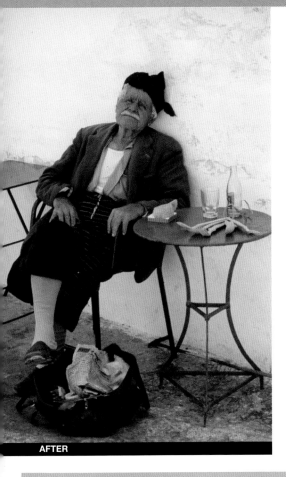

AFTER

 **TECHNIQUE:
RESTORATION WITH LIGHTROOM AND
PHOTOSHOP ELEMENTS**

1 Scan the picture into your computer and open it in your software.

2 In the Lightroom Develop module, use the White Balance eyedropper tool in the WB panel. Find a neutral tone in the picture that is grey, white or black and click it. The colour cast will be removed and the true colour restored. If it isn't quite right, use the WB sliders to correct it.

3 In the Elements menu, choose Enhance → Adjust Color → Remove Color Cast. Click on a neutral tone in the picture to remove the cast.

4 Once you have the colour right, use the Brightness and Contrast tools to fine-tune the picture. The Brightness slider allows you to correct any under- or overexposure problems the image may have. The Contrast slider alters how gloomy (flat) or sparkling (contrasty) the image will be.

FAMILY PORTRAIT

Shown here is a portrait of my grandmother and her sister from about 1908. It is badly faded and yellowed, and has a number of abrasions and creases. I corrected the colour and tone then retouched it to remove the damage, taking care not to do too much and spoil its old-world charm. **GH**

CONCLUSION

If you have worked your way through the book to this last summing up, you have proved already that you possess the stamina and perseverance to be a good photographer. We would like to leave you with a few thoughts.

First, photography should be fun. Don't get bogged down in all that nerdy stuff about numbers of pixels and megabytes and other technological data. As we have said throughout the book, photography is all about you the photographer and your ability to really see the world as an exciting place with unlimited picture possibilities wherever you look – 'look' being the key word.

The great change that has occurred in photography in recent years is that the camera and the computer are now a team. The shoot is part one of the image-making process and the computer has replaced the darkroom as the stage where the picture is completed. The digital file equates with the negative, both containing the information you will use to produce a pleasing image.

The great photographer Ansel Adams, who was also a fine musician, related the image-making process to music; he said that the negative was the score and the print was the performance. Although you can rescue poor digital photographs in your software, it's important that you work at perfecting your shooting and use the computer to enhance rather than save the shot. You can make an acceptable image from a poor file but never a great one; for that you need a good, well-seen image to start with, just as a good score is needed for a fine performance.

Thanks for reading the book; we hope that you become involved and work at the assignments that we have set you. We also hope that you get as much fulfilment as we still do from taking photographs. Good luck, good shooting.

Cheers, John and Graeme

HORSES ▶
These images are from my ongoing series of equine-themed pictures that I have been working on for many years. **JG**

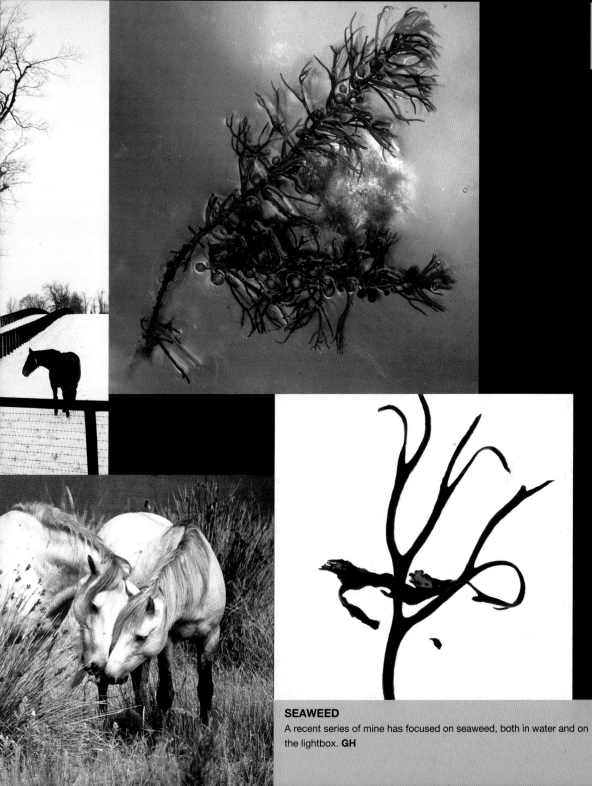

SEAWEED
A recent series of mine has focused on seaweed, both in water and on the lightbox. **GH**

GRAEME HARRIS

Graeme's portrait by Margaret Harris

Graeme's photography career has spanned six decades since its beginnings at Helmut Newton's studio in Melbourne, Australia, where he gained his early photography experience and where his friendship with co-author John Garrett began.

After moving to London in the early 1970s Graeme began freelancing as a photographer of people and studio still-lifes, mainly for the advertising and publishing industries. This then led to corporate annual report photography, with reports for leading companies taking him on photographic assignments around the world. In recent years Graeme has also taught extensively, both at colleges and privately, and it was this that inspired him to write the bestselling book *Collins Complete Photography Course* with John Garrett.

companies such as The Art Group, with many of his studies of leaves, flowers and shells being used extensively on posters and cards for key retailers such as Ikea and Habitat. He has also had three exhibitions in London dedicated to his personal work.

Graeme continues to work on commercial projects for London-based design agencies and is currently producing a range of bespoke images for an interior design company.

For enquiries and print purchases, visit Graeme's website, **www.graemeharris.com**

JOHN GARRETT

John was born in Australia and spent his early working life as a photographer in Melbourne, where initially it was necessary to be an all-rounder to make a living.

John's portrait by Graeme Harris

By the time he moved to London in the 1960s he had already begun to specialize in fashion photography, and in the Swinging Sixties both fashion and advertising offered plenty of opportunities for a young photographer.

However, photojournalism had always been John's first love. Influenced by the great photo stories of *Life* magazine and *Paris Match,* he changed direction and became contracted to *Paris Match* during the 1970s, shooting everything from wars to ballet. He also began contributing regularly to newspapers and magazines such as the *Sunday Times*, the *Observer, Stern* and *Time* and wrote a number of books on photography, including *The 35mm Photographer's Handbook*, co-written with Julian Calder, which sold 2,000,000 copies.

John's other activities include directing 30 television commercials and chairing the judges for a worldwide photography competition sponsored by Ballantine's Whisky, in which capacity he gave workshops and lectures around the globe. Since *Collins Complete Photography Course* was published, John has been shooting portraits of show business celebrities and travelling to produce pictures for this book. The National Portrait Gallery recently purchased some of his portraits for their permanent collection and he is working on a retrospective book of his portraits of the famous and infamous.

For enquiries and print purchases, visit John's website, **www.john-garrett.co.uk**

Books: Inspiration

Here are some examples of the work of photographers we like – a
good place for you to start. If they are not available in local bookshops,
try **www.photoeye.com**, the world's foremost online photography
bookstore, offering over 30,000 fine art photography books.

Adams, Ansel, *Examples: The Making of 40 Photographs* (Bulfinch, 1989)
Avedon, Richard, *Evidence 1944–1994* (Random House, 1994)
Cartier-Bresson, Henri, *Henri Cartier-Bresson* (Masters of Photography)
 (Aperture, 1987)
Eggleston, William, *For Now* (Twin Palms Publishing, 2010)
Erwitt, Elliott, *Son of Bitch* (Thames & Hudson, 1975)
Gibson, Ralph, *Nude* (Taschen, 2012)
Haas, Ernst, *The Creation* (Penguin, 1988)
Jeffrey, Ian, *The Photography Book* (Phaidon Press, 2000)
Lardinois, Brigitte, *Magnum Magnum* (Thames & Hudson, 2009)
Man Ray, *Portraits* (Yale University Press, 2013)
McCullin, Don, *The Impossible Peace: From War Photographs to
 Landscapes, 1958–2011* (Skira Editore, 2012)
McCurry, Steve, *Portraits* (Phaidon Press, 1999)
Penn, Irving, *Still Life* (Little, Brown, 2001)
Salgado, Sebastiao, *Genesis* (Taschen, 2013)
Waite, Charlie, *The Making of Landscape Photographs* (Collins &
 Brown, 1993)

Books: Reference

The Association of Photographers, *Beyond the Lens: Rights, Ethics
 and Business Practice in Professional Photography* (The Association
 of Photographers, 2003)
Evans, John, *Adventures with Pinhole & Homemade Cameras*
 (Rotovision, 2003)
Frizot, Michel, *A New History of Photography* (Konemann UK, 1998)
Garrett, John, *The Art of Black and White Photography* (Mitchell
 Beazley, 1992)
 John Garrett's Black and White Photography Masterclass (Collins &
 Brown, 2000)
 KISS Guide to Photography (Dorling Kindersley, 2002)
 Mastering Black and White Photography (Mitchell
 Beazley, 2005)
Garrett, John & Harris, Graeme, *Collins Complete Photography Course*
 (Collins, 2008)

Kelby, Scott, *The Adobe Photoshop Lightroom 4 Book for Digital Photographers* (Peachpit Press, 2012)
The Photoshop Elements 11 Book for Digital Photographers (Peachpit Press, 2012)

Magazines and e-magazines

The range of magazines on photography is huge. Most have an online magazine as well with a wealth of information available, along with competitions to enter.

Advanced Photographer **www.advancedphotographer.co.uk** Magazine for the more experienced photographer.
Amateur Photographer **www.amateurphotographer.co.uk** The world's number one weekly photography magazine, started in 1884.
Aperture Magazine **www.aperture.org** Premier arts magazine, more than 50 years old.
Black & White Photography **www.thegmcgroup.com** Monthly British magazine on traditional and digital monochrome photography.
British Journal of Photography **www.bjp-online.com** Weekly magazine, started in 1875.
Digital Camera Magazine **www.digitalcameraworld.com** Focuses on new developments in the camera market, with technique articles and reviews.
Image Magazine **www.the-aop.org** The Association of Photographers' monthly magazine.
Photography Monthly **www.photographymonthly.com** Reviews, competitions, suggested locations and so forth.
Popular Photography **www.popphoto.com** American and international news, podcasts, artistic photography and photojournalism.
www.dpreview.com In-depth reviews of equipment.
www.ephotozine.com Book reviews, techniques, forums, galleries and shooting locations.
www.photoanswers.co.uk Digital camera advice, video tutorials, photo galleries and reviews.
www.shutterbug.net Tools, techniques and creativity for the advanced amateur and professional.

ACKNOWLEDGEMENTS

We would like to thank the many people who have been very supportive to us while we have been writing and shooting this book. They are:

Laurence Lavigne and Coco; Matt, Kerry, Isabella and Charlotte Garrett; Nick Garrett; Michelle Garrett; Estelle Lavigne; Richard and Sal; Dmitri and Florence Hvorostovsky and family; Rio; Damien; Bill Bailey; Anna Woodward; Maurice; Stephen Poliakoff; Gabriella Cilmi; Brian Constance; Sophia; Claire; Yamilla; Diego and Susie; Gettysburg Bullets; Agnieszka and Daniel; Brad Cahoon; Margaret Harris; Katherine, Andrew and Luke Spencer; Clare Ferguson; Jon Harris; Jenny Wyman White; Mavis Harris; Phillip Harris; Yan and Sarah Spencer; Mia and Darcy Vissenjoux; Ian Skinner; Terry Wright; Molly and Albe Skinner; George and Barbara Christie; Jenny Craig; Winsome Carroll and family; and to all the others who were in front of our cameras when we fired the shutter.

Special thanks to our commissioning editor, Elen Jones, for her enthusiastic support of the book, to Diana Vowles for doing a great job of editing our material, and to Martin Topping and Joanna MacGregor, the book's designers.

INDEX

A

action, capturing 84–97
Adobe Photoshop 12, 28, 216, 230
Adobe Photoshop Elements 216, 218, 222, 244, 246
 burning in with 224
 colour, adding with 231
 combining two images with 235
 cropping with 218
 dodging with 222
 hue and saturation, altering with 227
 perspective, correcting vertical with 237
 restoration of images with 247
 retouching details with 245
Adobe Photoshop Lightroom 216, 232
 burning with 224
 cropping with 221
 dodging with 222
 hue and saturation, altering with 227
 perspective, correcting vertical with 236
 portrait retouching with 243
 Presets panel 240
 red filter effect, landscape, with 239
 red filter effect, portrait, with 238
 restoration of old images with 247
 vignetting with 233
after dark 200–13
 black and white photography 208–9
 flash portraits 212–13
 landscape mode 15
 portrait mode 15
 traffic 204–5
animals 174–87

aperture 15, 20–1
 f-stops 18–19, 20
aperture priority mode 14, 20

B

babies 19, 164–7
beauty portraits 124–5
black and white photography 34–5, 208–9
body beautiful 136–47
B(ulb) settings 14, 22
burning in 224–5
Burn tool 222, 224

C

camera
 choosing a new 11
 movement 22
card, memory 12
carnivals and parades 156–7
celebrations 148–59
children 19, 160–73
Clarity tool 28, 238
Clone Stamp tool 235, 236, 244, 246
close-ups 15, 25
colour
 adding 230–1
 balance 15, 26
combining images 234–5
composition 32–3, 48–9
Crop tool 218
cropping 126–7, 218–21

D

depth of field (DOF) 20–1, 24, 224
digital capture 12–13
Dodge tool 222
dodging 222–3

E

exposure 18–19, 20
 compensation 19
 correcting 18, 223
 mode dial 14–15
 modes 14

F

file formats 12
filters 28–9
 close-up 25
 graduated neutral-density 28
 polarizing 28, 39
 red, effect 238–9
flash 15, 30–1
 automatic 30
 bounce head 31
 built-in 30, 31
 fill-in 30
 guns 30, 65
 off-camera 31
fireworks 206–7
F-stops 18–19, 20
focal length 14, 24, 70
focal points 32, 33, 40–1, 225
focus 15, 24, 92
food 110–13

G

gardens 46–7
glamour 146–7
great outdoors, the 36–51
group portraits 132–5

H

Healing Brush tool 244
highlights 18, 223
hue/saturation 226–9

INDEX

I
image editing software 12, 18, 217, 236, 245
interiors 64–5
ISO settings 16–17, 30, 158

J
jewellery 102–3
JPEG format 12

L
landscapes 28, see also great outdoors, the
 mode 15
 seasonal 50–1
Lasso tool 234
lenses 24–5
 fixed focal length (prime) 24, 70–1
 telephoto 22, 24
 wide-angle 24
 zoom 24
light, working with 44–5, 56–7

M
manual mode 14, 22
memorials and sculptures 58–9
movement, see action

N
night, see after dark
noise 15, 16
nudes 140–5

O
old images/photos 246–7
out and about 66–83

P
Paint Bucket tool 230
panning 23, 89, 96

parties 158–9
patterns 188–99
people 74–5, 114–35
perspective 33
 correction 236–7
pets, see animals
Photoshop, see Adobe Photoshop
portraits 114–35
 mode 15
 retouching 242–3
Preset scenes 15
Preset scenes dial 14–15

R
RAW format 12
red-eye 31
red filter effect 238–9
reflections 196–7
 reducing 28
removing elements 245
reportage 68
retouching 242–7
rule of thirds 32–3

S
saturation, see hue/saturation
shadows 198–9
shutter prority mode 14, 20, 22
shutter speed 14, 15, 17, 19, 20, 22–3, 86, 93, 94, 95, 96
sightseeing and cities 52–65
silhouettes 194–5
sports 86–93
 mode 15
still life 98–113

T
team games 90–1
TIFF files 12
tone, adjusting 225, 239

tools 217
 Burn 222, 224
 Clarity 28, 238
 Clone Stamp 235, 236, 244, 246
 Crop 218
 Dodge 222
 Healing Brush 244
 Lasso 234
 Paint Bucket 230
 Split Tone 120
 Sponge 224
 Spot Removal 244, 246
tripods 15, 22

V
vignetting 232–3

W
weather 42–3
wedding
 guest, as 152–3
 official photographer, as 154–5
White Balance (WB) 26–7